ETTERHEAD + LOGO DESIGN⑤

ROCKPORT
PUBLISHERS

ROCKPORT PUBLISHERS
GLOUCESTER, MASSACHUSETTS
DISTRIBUTED BY NORTH LIGHT BOOKS,
CINCINNATI, OHIO

FIRST PUBLISHED IN THE UNITED STATES OF AMERICA BY:
ROCKPORT PUBLISHERS, INC.
33 COMMERCIAL STREET
GLOUCESTER, MASSACHUSETTS 01930-5089
TELEPHONE: (978) 282-9590
FACSIMILE: (978) 283-2742

DISTRIBUTED TO THE BOOK TRADE AND ART TRADE IN THE UNITED STATES BY:
NORTH LIGHT BOOKS, AN IMPRINT OF
F & W PUBLICATIONS
1507 DANA AVENUE
CINCINNATI, OHIO 45207
TELEPHONE: (800) 289-0963

OTHER DISTRIBUTION BY:
ROCKPORT PUBLISHERS, INC.
GLOUCESTER, MASSACHUSETTS 01930-5089

ISBN 1-56496-366-7

10 9 8 7 6 5 4 3 2 1

DESIGNER: ARGUS VISUAL COMMUNICATION, BOSTON
FRONT COVER IMAGES: LEFT TO RIGHT FROM TOP, P. 14, 19, 121, 122, 34, 28
BACK COVER IMAGES: P. 42, 136, 74
PRINTED IN HONG KONG BY MIDAS PRINTING LIMITED.

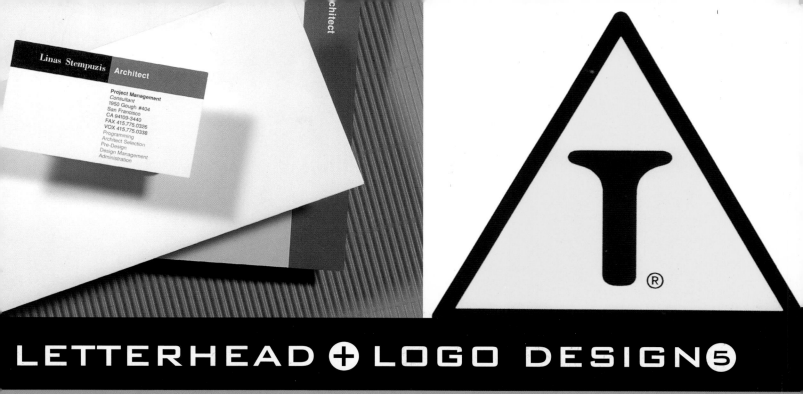

Linas Stempuzis | Architect

Project Management
Consultant
1950 Gough #404
San Francisco
CA 94109-3440
FAX 415.775.0026
VOX 415.775.0038
Programming
Architect Selection
Pre-Design
Design Management
Administration

®

LETTERHEAD ✛ LOGO DESIGN⑤

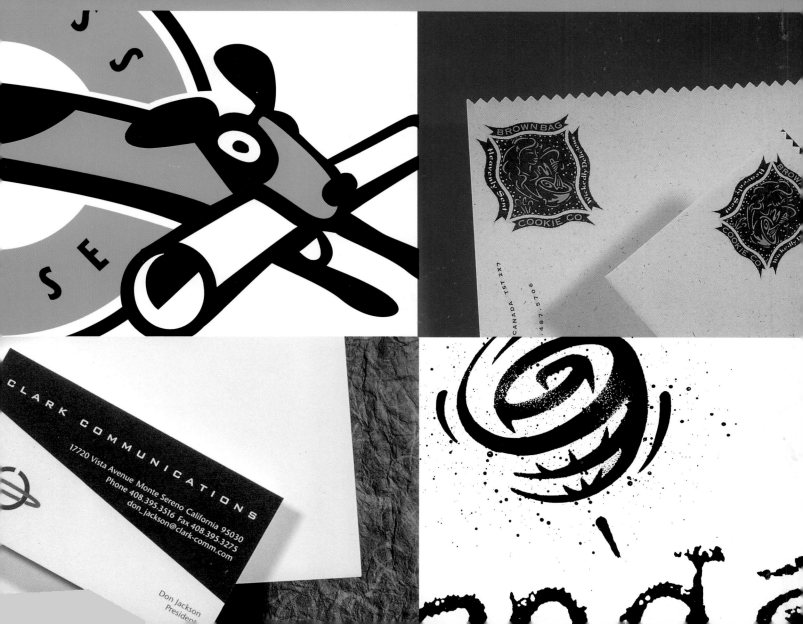

BROWN BAG
Heavenly Delicious
Wickedly Sen
COOKIE CO.

CANADA T5T 2X7
487.5706

CLARK COMMUNICATIONS
17720 Vista Avenue Monte Sereno California 95030
Phone 408.395.3516 Fax 408.395.3275
don_jackson@clark-comm.com

Don Jackson
President

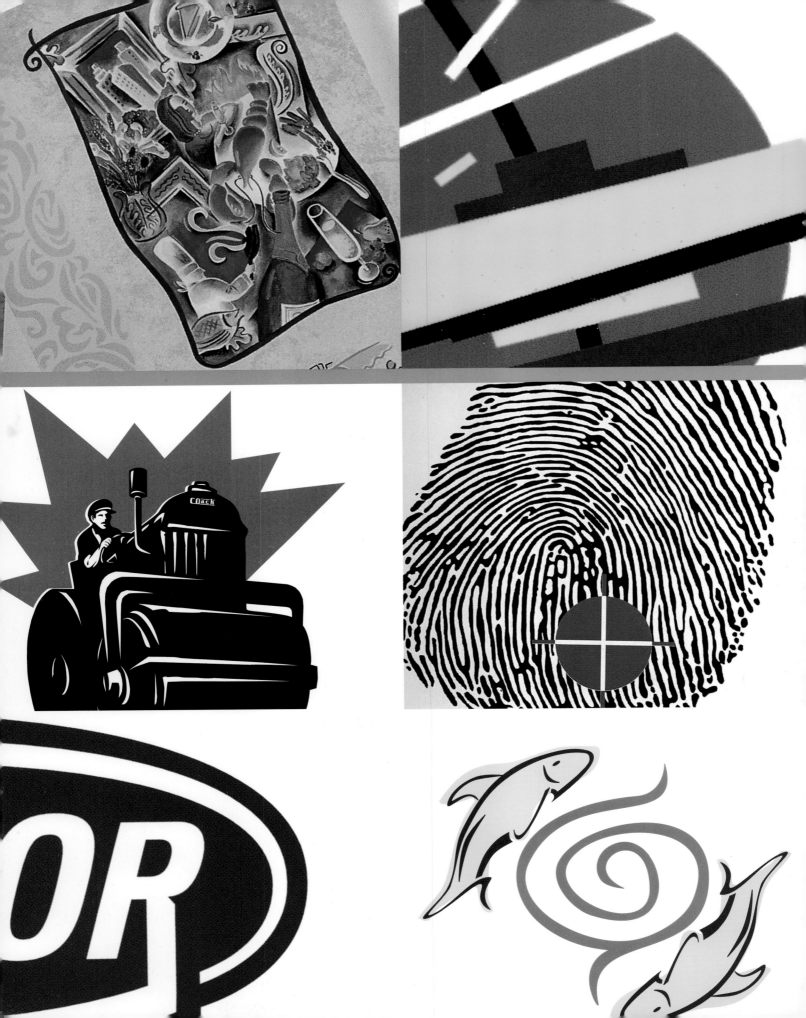

Contents

DESIGN FIRM | TRACY SABIN GRAPHIC DESIGN
ART DIRECTOR | ANDRÉ DUGGIN
ILLUSTRATOR | TRACY SABIN
CLIENT | YOU CAN SOAR, INC.
TOOLS | ADOBE ILLUSTRATOR

INTRODUCTION

Who can deny the importance of a logo? A good brand identity will sell a product or confirm the legitimacy of any project. In designing this graphic element to be successful in the global marketplace, flexibility is key. A logo must translate on paper, over a fax, over the Internet, and be easily recognizable in every language. Colors and shapes must carefully be considered in order to effectively cross all cultural barriers. It must be timeless in its style and not be caught in current trends.

The logos presented in this book are exciting, new, and varied. Most have successfully met the requirements of a successful global design, others are on the way. While this book shows the logos presented on letterhead, it is clear that the business world is moving away from paper to electronic media.

Assuredly, the next volume in this collection will show more electronic examples of interactive logos, plus fantastic aspects that only the creative genius of the graphic design world could imagine.

ROY ALDEN, DESIGNER

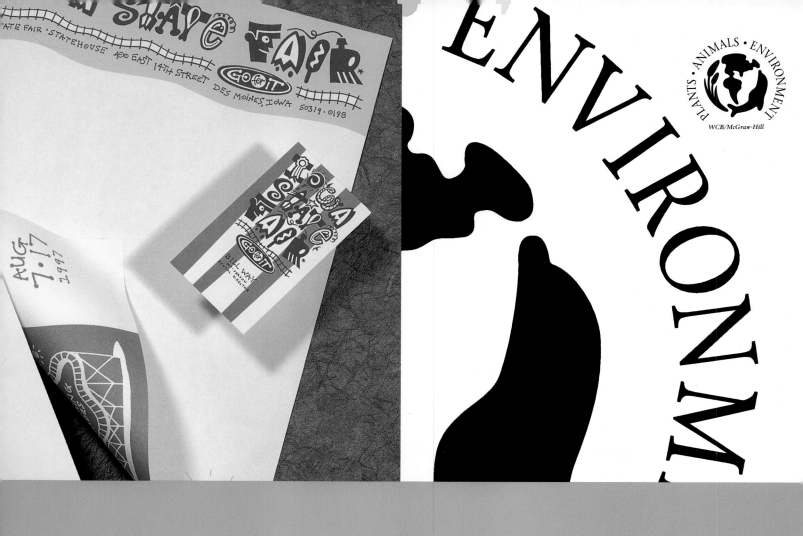

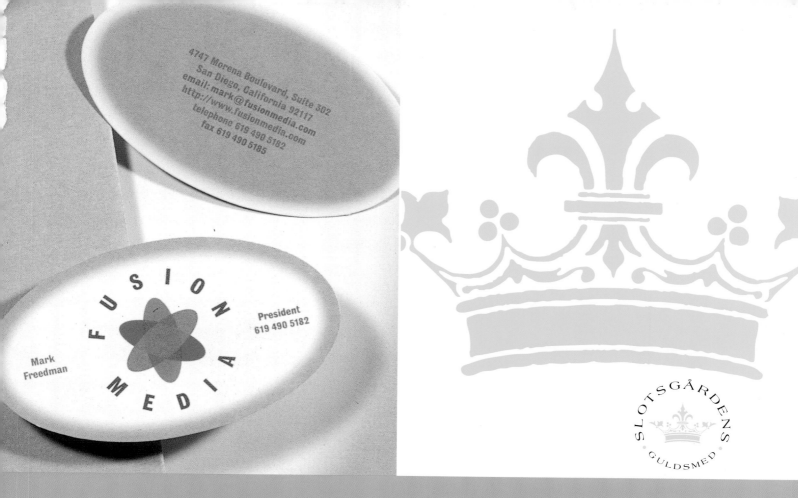

4747 Morena Boulevard, Suite 302
San Diego, California 92117
email:mark@fusionmedia.com
http://www.fusionmedia.com
telephone 619 490 5182
fax 619 490 5185

FUSION MEDIA

Mark
Freedman

President
619 490 5182

SLOTSGÅRDENS
GULDSMED

PROFESSIONAL SERVICES

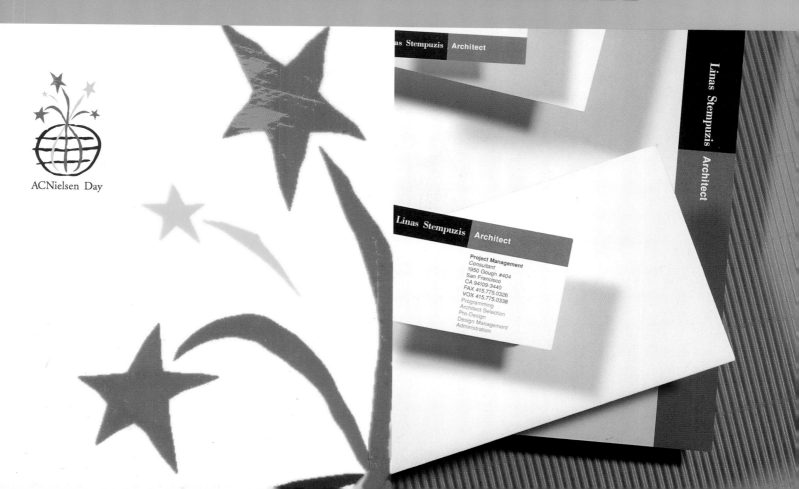

ACNielsen Day

Linas Stempuzis Architect

Linas Stempuzis
Architect

Linas Stempuzis Architect

Project Management
Consultant
1950 Gough #404
San Francisco
CA 94109-3440
FAX 415.775.0326
VOX 415.775.0338
Programming
Architect Selection
Pre-Design
Design Management
Administration

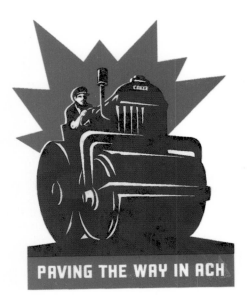

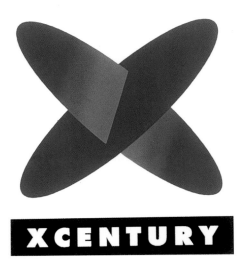

DESIGN FIRM | WEBSTER DESIGN ASSOCIATES
ART DIRECTOR | DAVE WEBSTER
DESIGNER/ILLUSTRATOR | ANDREY NAGORNY
CLIENT | ACH, INC.
TOOLS | MACROMEDIA FREEHAND

DESIGN FIRM | SHIMOKOCHI/REEVES
ART DIRECTORS | MAMORU SHIMOKOCHI, ANNE REEVES
DESIGNER | MAMORU SHIMOKOCHI
CLIENT | X-CENTURY STUDIOS
TOOLS | ADOBE ILLUSTRATOR

DESIGN FIRM | LSL INDUSTRIES
DESIGNER | ELISABETH SPITALNY
CLIENT | JP DAVIS & COMPANY, INTERNET PRESS
TOOLS | ADOBE ILLUSTRATOR

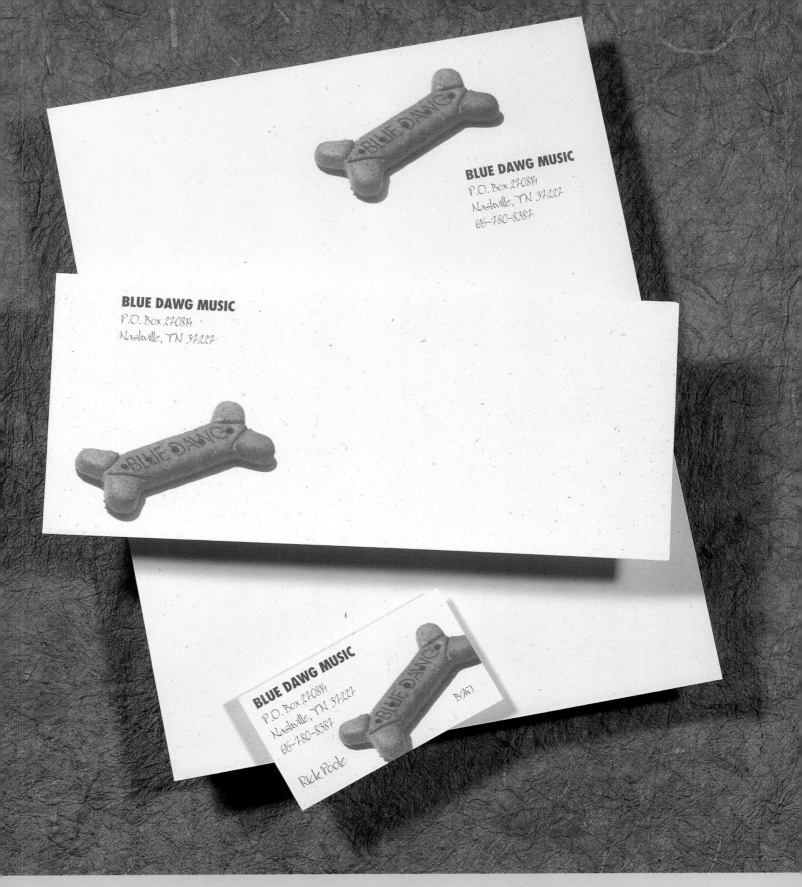

BLUE DAWG MUSIC
P.O. Box 270814
Nashville, TN 37227
615-780-8387

BLUE DAWG MUSIC
P.O. Box 270814
Nashville, TN 37227

BLUE DAWG MUSIC
P.O. Box 270814
Nashville, TN 37227
615-780-8387

Rick Poole

DESIGN FIRM | WORLDSTAR
ALL DESIGN | GREG GUHL
CLIENT | BLUE DAWG MUSIC
TOOLS | ADOBE PHOTOSHOP, ADOBE ILLUSTRATOR

DESIGN FIRM | SULLIVAN PERKINS
ALL DESIGN | BRETT BARIDON
CLIENT | DALLAS PUBLIC LIBRARY

DESIGN FIRM | DESIGN GROUP WEST
ART DIRECTOR | JOAN MALONEY
ILLUSTRATOR | TRACY SABIN
CLIENT | HAHN/TRIZEC
TOOLS | STRATA STUDIO PRO

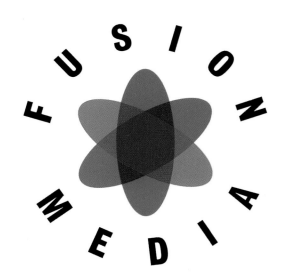

DESIGN FIRM | TANGRAM STRATEGIC DESIGN
ART DIRECTOR/DESIGNER/CREATIVE DIRECTOR | ENRICO SEMPI
CLIENT | ORDINE DEGLI ARCHITETTI DI NOVARA

DESIGN FIRM | MIRES DESIGN
ART DIRECTOR | JOHN BALL
DESIGNERS | JOHN BALL, DEBORAH HORN
CLIENT | FUSION MEDIA

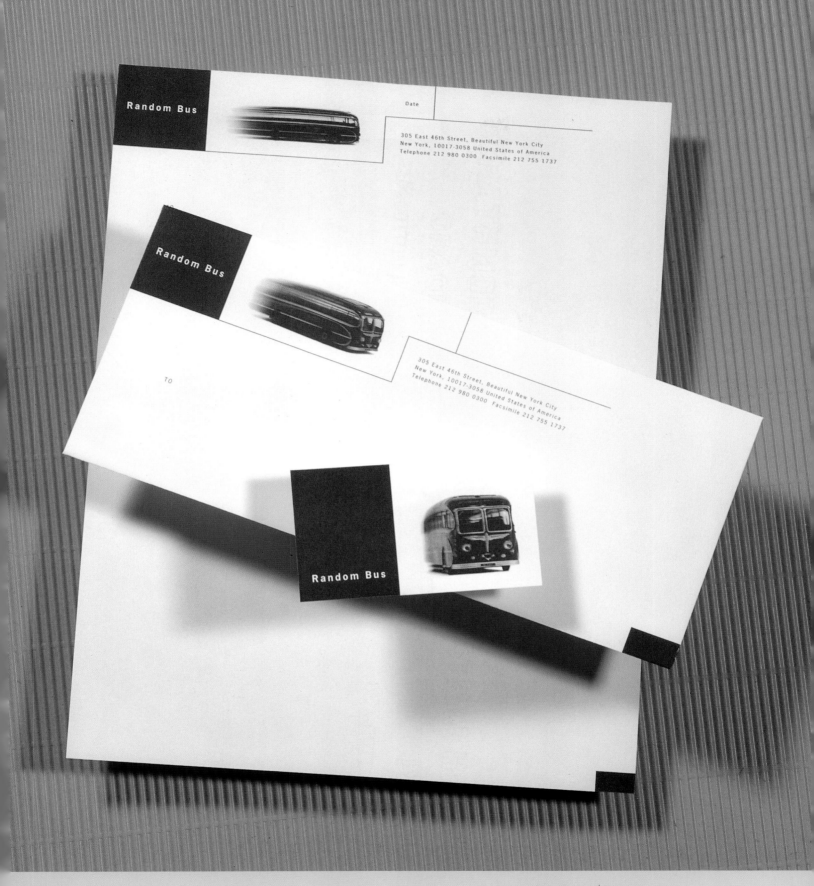

DESIGN FIRM | SAGMEISTER, INC.

ART DIRECTOR | STEFAN SAGMEISTER

DESIGNER | ERIC ZIM

PHOTOGRAPHY | TOM SCHIERLITZ

CLIENT | RANDOM BUS

TOOLS | MACINTOSH, 4 X 5 CAMERA

PAPER/PRINTING | STRATHMORE WRITING 25% COTTON

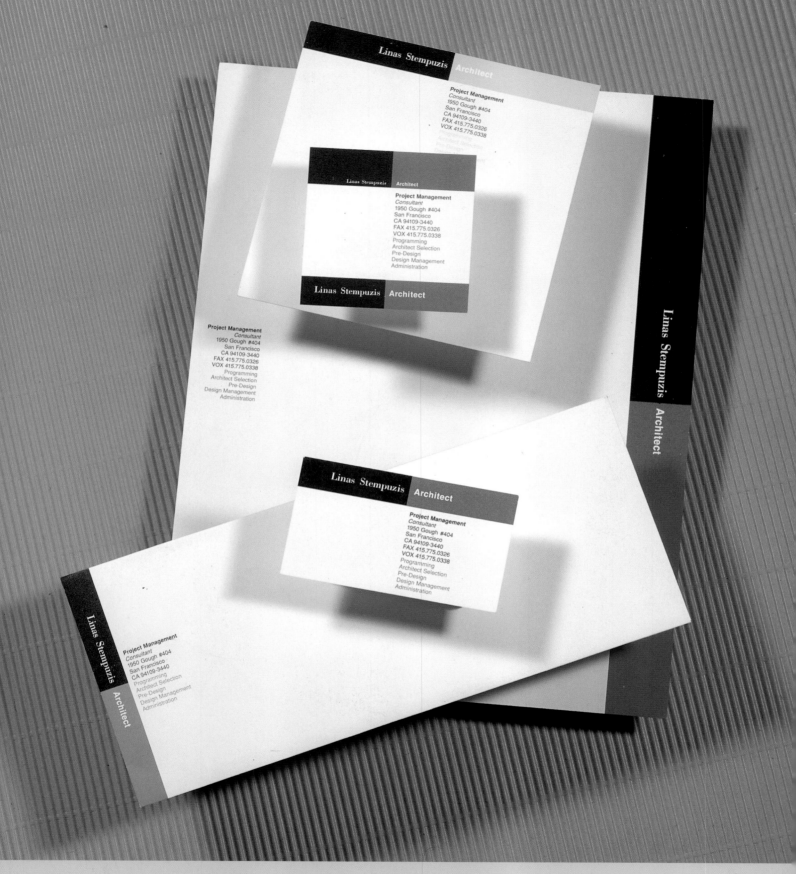

DESIGN FIRM | MELISSA PASSEHL DESIGN

ART DIRECTOR | MELISSA PASSEHL

DESIGNERS | MELISSA PASSEHL, JILL STEINFELD

CLIENT | LINAS STEMPUZIS

PP = MG²

PRINTELLIGENT PEOPLE

CORPORATE COMMUNICATION & PRINT PROJECT MANAGEMENT
ACN 007 074 393 A DIVISION OF PRINTELLIGENCE PTY LTD

Mick Mercieca

SUITE ONE, 20 COMMERCIAL RD MELBOURNE 3004
PH: 03) 9866 4966 FAX: 03) 9866 4164 MOBILE 018 352 827

Garry Furzer

Establishing the Theory of Reliability
Re-Inventing the Laws of Quality

DESIGN FIRM | STORM DESIGN & ADVERTISING CONSULTANCY
ART DIRECTORS/DESIGNERS | DAVID ANSETT, DEAN BUTLER
ILLUSTRATOR | DEAN BUTLER
CLIENT | PRINTELLIGENT PEOPLE
TOOLS | ADOBE PHOTOSHOP
PAPER/PRINTING | SAXTON SMOOTHE/THREE PMS COLORS,
SPECIAL VARNISH, EMBOSSING

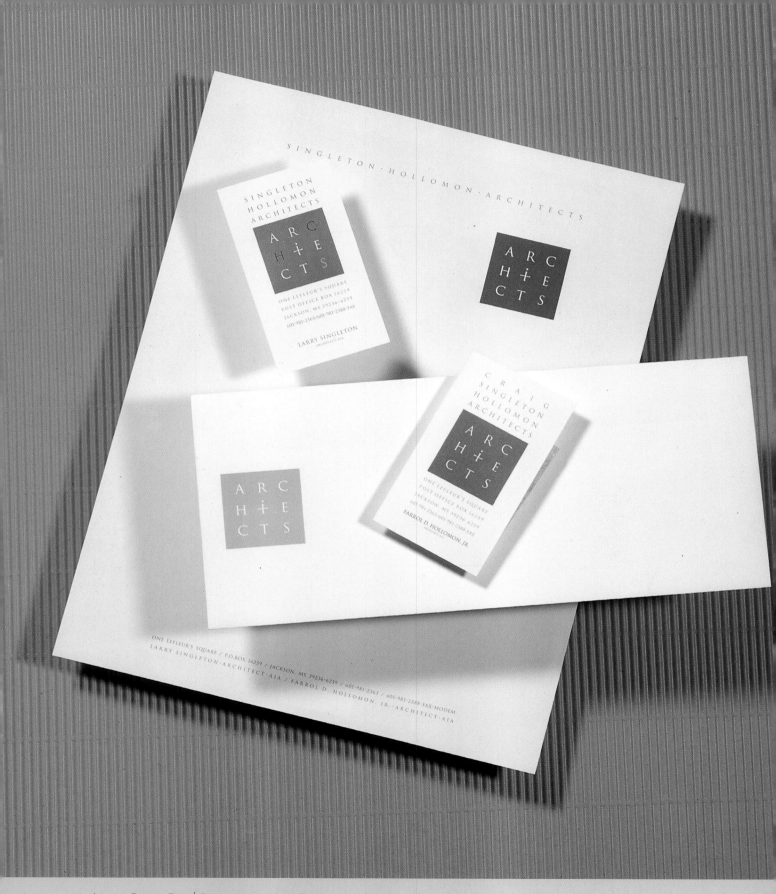

DESIGN FIRM | COMMUNICATION ARTS COMPANY

ART DIRECTOR/DESIGNER | HILDA STAUSS OWEN

CLIENT | SINGLETON-HOLLOMON-ARCHITECTS

TOOLS | MACINTOSH

PAPER/PRINTING | STRATHMORE WRITING/OFFSET LITHO

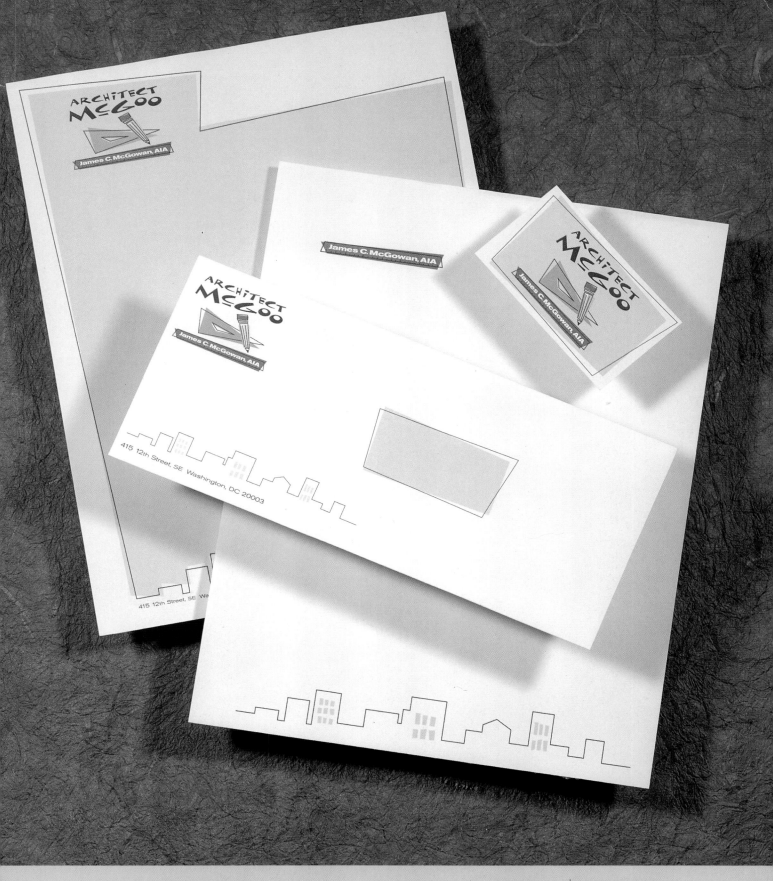

DESIGN FIRM | IMAGINE THAT, INC.

ALL DESIGN | SUE MANIAN

CLIENT | JIM McGOWAN, AIA

TOOLS | MACROMEDIA FREEHAND

PAPER/PRINTING | CLASSIC CREST/CLARKS LITHO

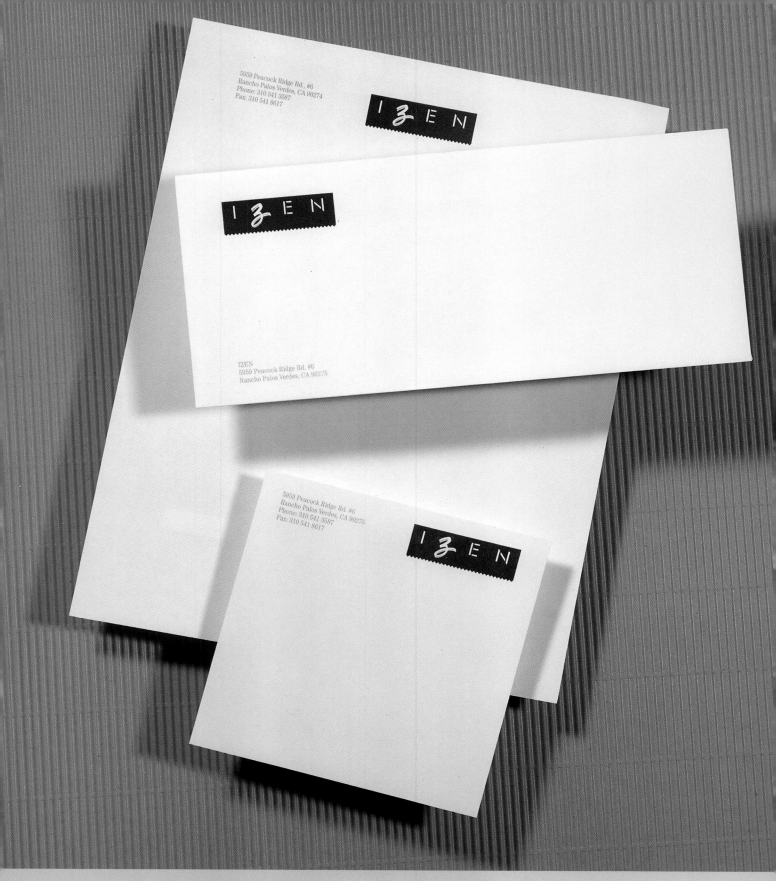

5959 Peacock Ridge Rd., #6
Rancho Palos Verdes, CA 90274
Phone: 310 541 3587
Fax: 310 541 8617

I Z E N

I Z E N

IZEN
5959 Peacock Ridge Rd. #6
Rancho Palos Verdes, CA 90275

5959 Peacock Ridge Rd. #6
Rancho Palos Verdes, CA 90275
Phone: 310 541 3587
Fax: 310 541 8617

I Z E N

DESIGN FIRM | SHIMOKOCHI/REEVES

ART DIRECTORS | MAMORU SHIMOKOCHI, ANNE REEVES

DESIGNER | MAMORU SHIMOKOCHI

CLIENT | IZEN

TOOLS | ADOBE ILLUSTRATOR

PAPER/PRINTING | GRAPHIKA LINEAL

CENTRO INTERCULTURALE
TAVOLINO ROVESCIATO

DESIGN FIRM | TANGRAM STRATEGIC DESIGN
ART DIRECTOR/DESIGNER/CREATIVE DIRECTOR | ENRICO SEMPI
CLIENT | COMPACT
TOOLS | POWER MACINTOSH

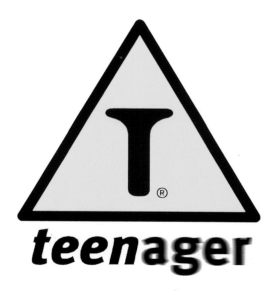

DESIGN FIRM | CATO BERRO DISEÑO
ALL DESIGN | GONZALO BERRO
CLIENT | CRESTA MAGNA/ENTERTAINMENT
TOOLS | ADOBE ILLUSTRATOR

ALL DESIGN | JOSÉ TORRES
CLIENT | TEENAGER BOUTIQUE
TOOLS | ADOBE PHOTOSHOP, MACROMEDIA FREEHAND

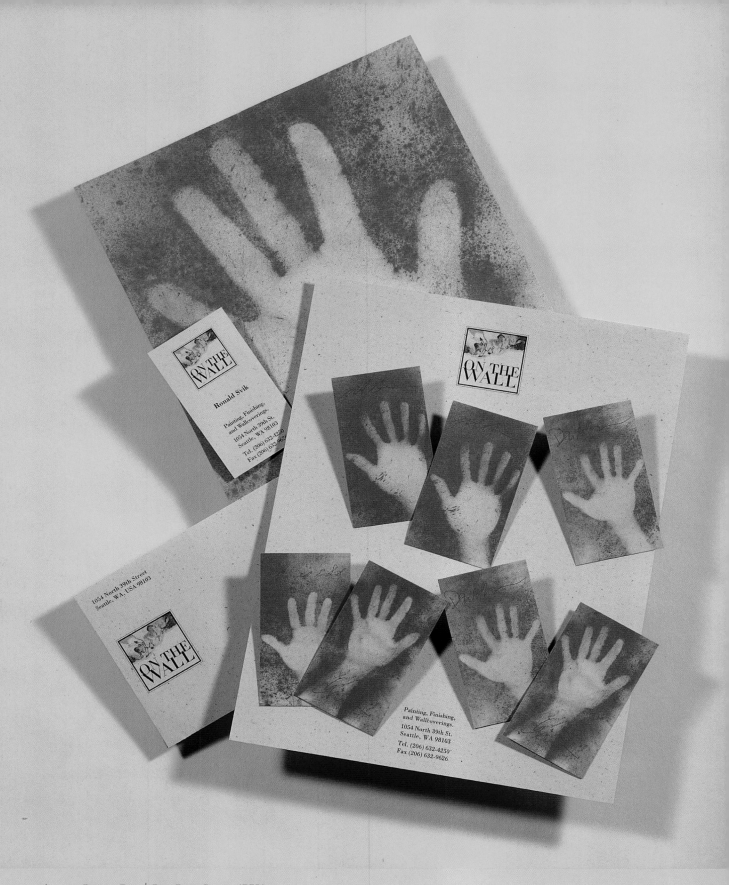

DESIGN FIRM | RICK EIBER DESIGN (RED)

ART DIRECTOR/DESIGNER | RICK EIBER

ILLUSTRATORS | DAVE D. WELLER (LOGO), GARY VOLK (HANDS)

CLIENT | ON THE WALL

PAPER/PRINTING | SPECKLETONE TWO COLOR (ONE METALLIC)
 OVER ONE COLOR

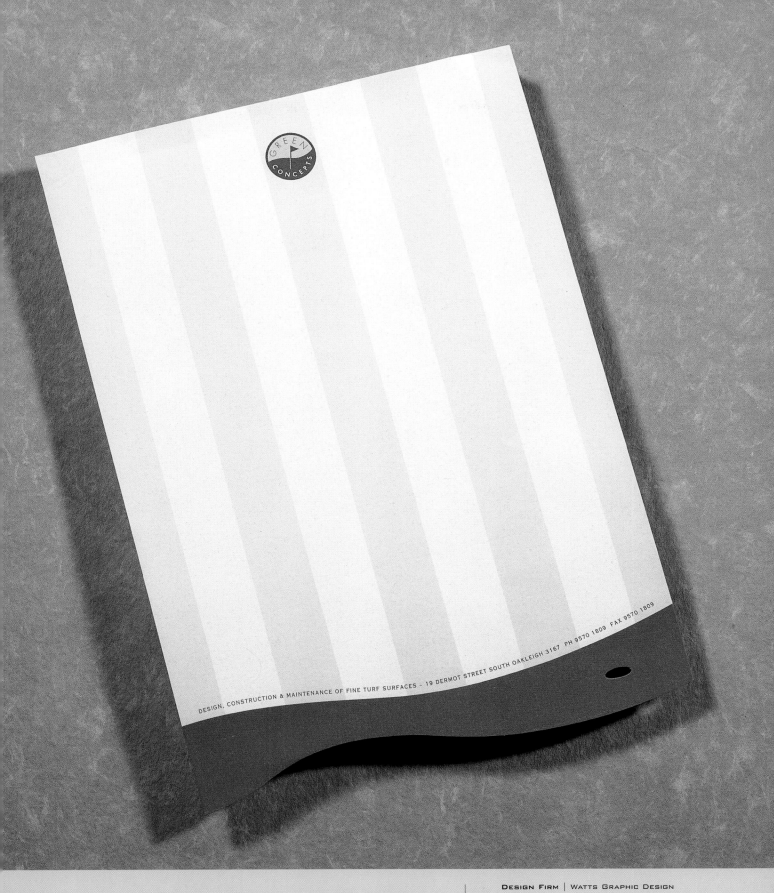

DESIGN, CONSTRUCTION & MAINTENANCE OF FINE TURF SURFACES – 19 DERMOT STREET SOUTH OAKLEIGH 3167 PH 9570 1809 FAX 9570 1809

DESIGN FIRM | WATTS GRAPHIC DESIGN
ART DIRECTORS/DESIGNERS | HELEN WATTS,
 PETER WATTS
CLIENT | GREEN CONCEPTS
TOOLS | MACINTOSH
PAPER/PRINTING | THREE COLOR

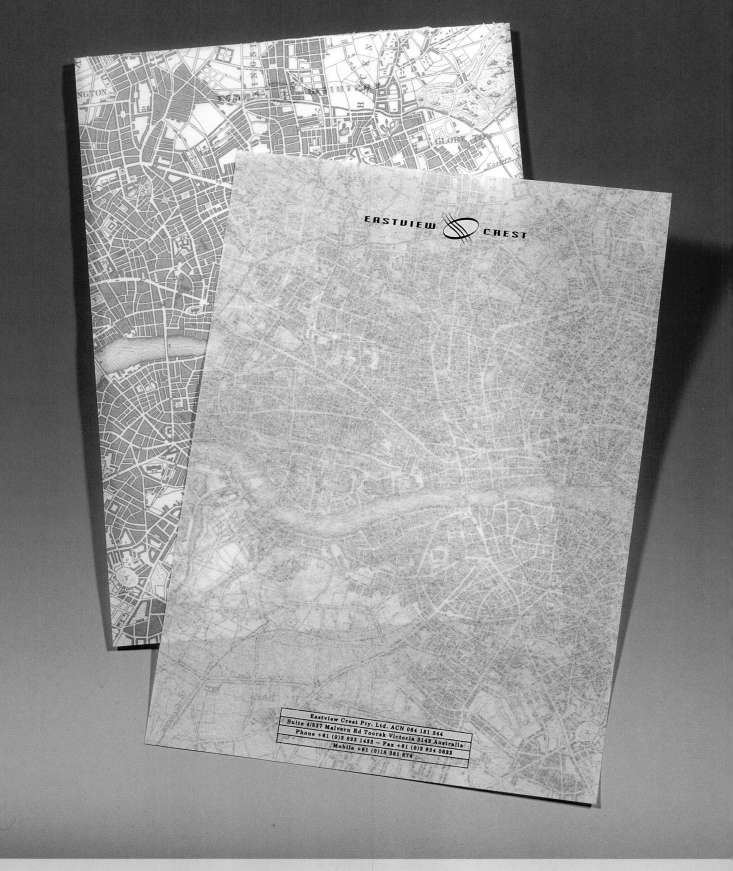

EASTVIEW CREST

Eastview Crest Pty. Ltd. ACN 064 181 344
Suite 4/537 Malvern Rd Toorak Victoria 3142 Australia
Phone +61 (0)3 823 1433 ~ Fax +61 (0)3 824 0822
Mobile +61 (0)18 381 874

DESIGN FIRM | WATTS GRAPHIC DESIGN
ART DIRECTORS/DESIGNERS | HELEN WATTS, PETER WATTS
CLIENT | EASTVIEW CREST
TOOLS | MACINTOSH
PAPER/PRINTING | PARCHMENT/ONE SIDE ONE COLOR,
 ONE SIDE TWO COLOR

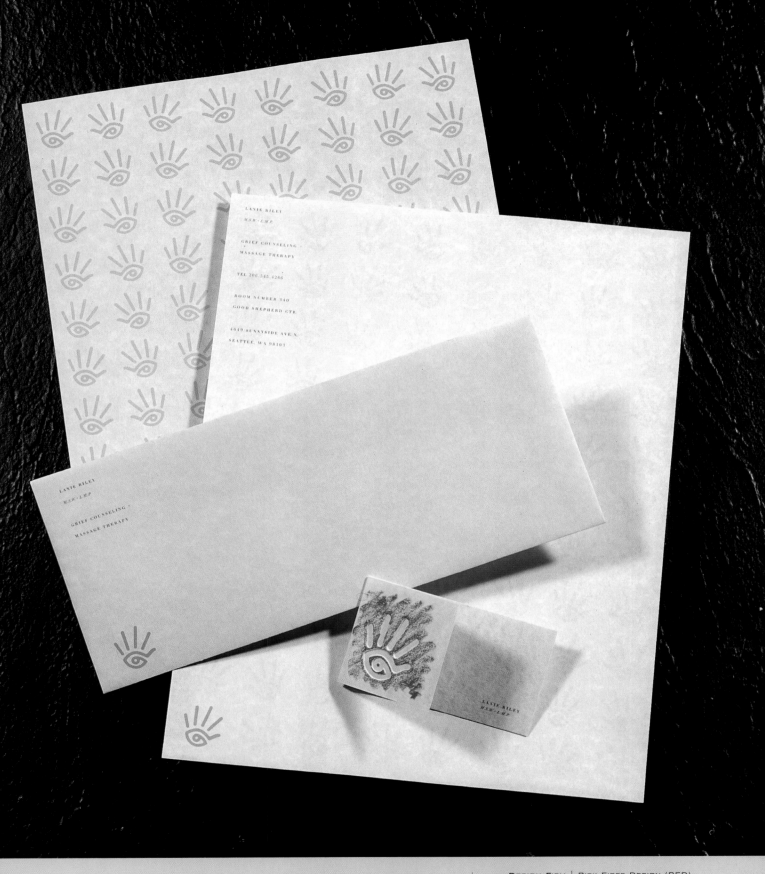

DESIGN FIRM │ RICK EIBER DESIGN (RED)
ART DIRECTOR/DESIGNER │ RICK EIBER
CLIENT │ LANIE RILEY
PAPER/PRINTING │ PARCHTONE

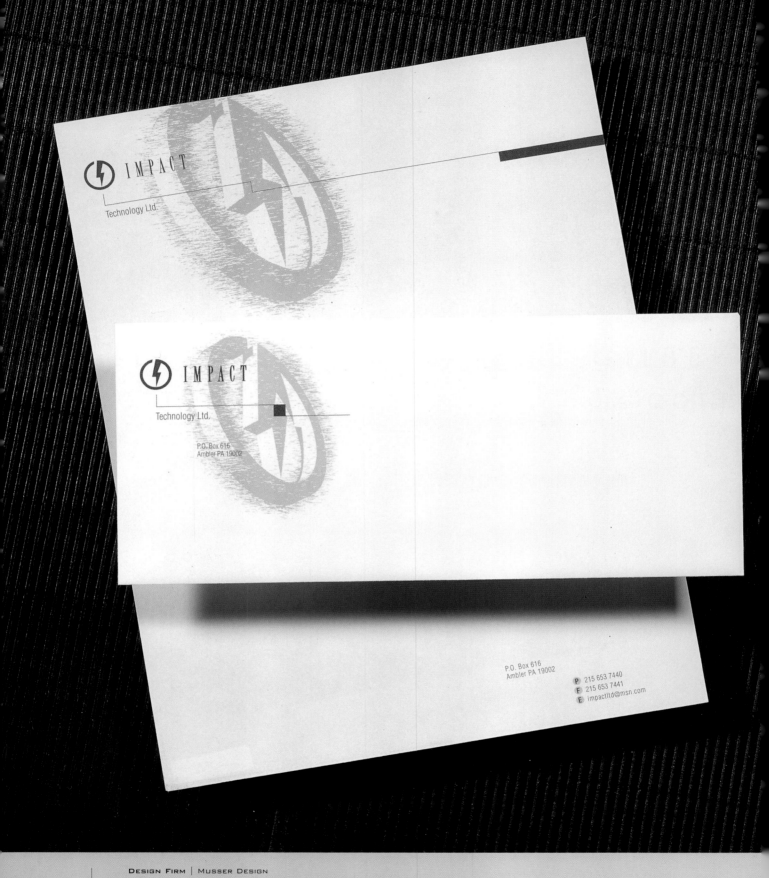

IMPACT
Technology Ltd.

IMPACT
Technology Ltd.
P.O. Box 616
Ambler PA 19002

P.O. Box 616
Ambler PA 19002

P 215 653 7440
F 215 653 7441
E impactltd@msn.com

DESIGN FIRM | MUSSER DESIGN
ART DIRECTOR/DESIGNER | JERRY KING MUSSER
CLIENT | E W AND A
TOOLS | MACINTOSH QUADRA, ADOBE ILLUSTRATOR

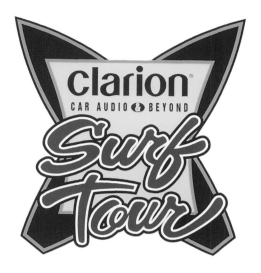

DESIGN FIRM | GILLIS & SMILER
ART DIRECTOR/DESIGNER | CHERYL GILLIS
CLIENT | CLARION SURF TOUR
TOOLS | ADOBE ILLUSTRATOR

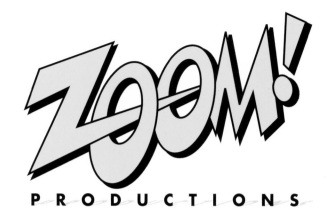

DESIGN FIRM | PENCIL NECK PRODUCTIONS
ART DIRECTOR | GARY HAWTHORNE
CLIENT | ZOOM! PRODUCTIONS
TOOLS | ADOBE ILLUSTRATOR

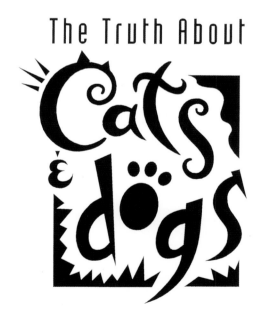

DESIGN FIRM | GILLIS & SMILER
ART DIRECTOR/DESIGNER | CHERYL GILLIS
CLIENT | NEW LINE CINEMA
TOOLS | ADOBE ILLUSTRATOR

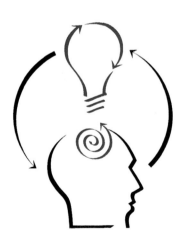

DESIGN FIRM | ROBERT BAILEY INCORPORATED
ALL DESIGN | CONNIE LIGHTNER
CLIENT | IDEA CATALYSTS, INC.
TOOLS | ADOBE ILLUSTRATOR

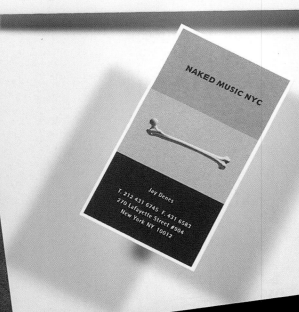

DESIGN FIRM | SAGMEISTER, INC.

ART DIRECTOR | STEFAN SAGMEISTER

DESIGNERS | STEFAN SAGMEISTER, VERONICA OH

PHOTOGRAPHY | TOM SCHIERLITZ

CLIENT | NAKED MUSIC NYC

TOOLS | MACINTOSH, 4 X 5 CAMERA

PAPER/PRINTING | STRATHMORE WRITING 25% COTTON

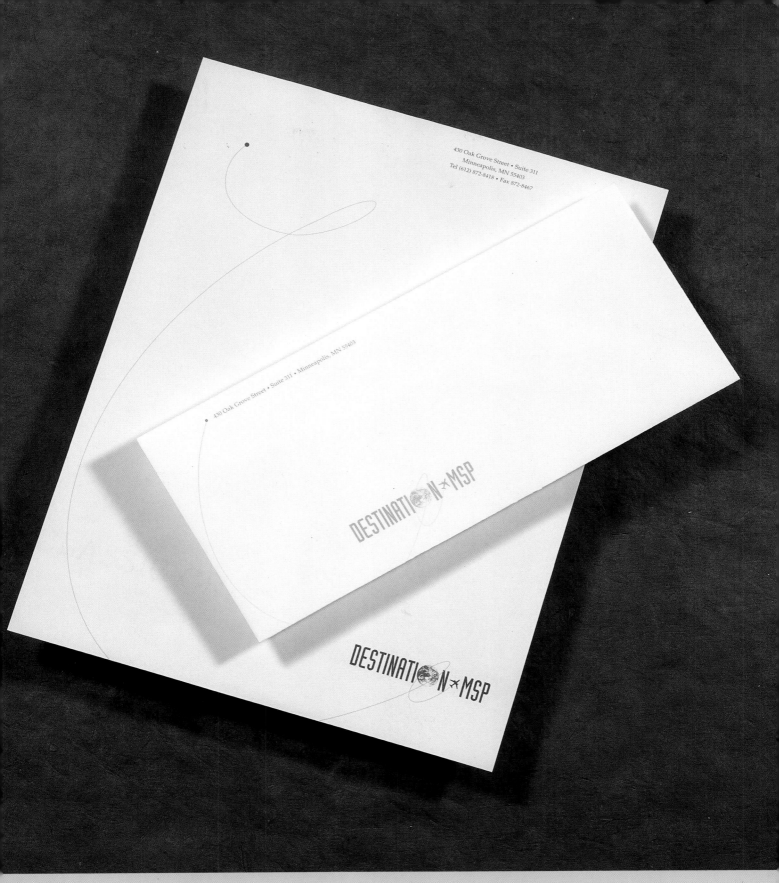

430 Oak Grove Street • Suite 311
Minneapolis, MN 55403
Tel (612) 872-8418 • Fax 872-8467

430 Oak Grove Street • Suite 311 • Minneapolis, MN 55403

DESTINATION✈MSP

DESTINATION✈MSP

DESIGN FIRM | DESIGN CENTER
ART DIRECTOR | JOHN REGER
DESIGNER | SHERWIN SWARTZROCK
CLIENT | DESTINATION MSP
TOOLS | MACINTOSH
PAPER/PRINTING | CLASSIC CREST/PRINTCRAFT

DESIGN FIRM | HORNALL ANDERSON DESIGN WORKS, INC.

ART DIRECTOR | JACK ANDERSON

DESIGNER | JACK ANDERSON, DAVID BATES

ILLUSTRATOR | DAVID BATES

CLIENT | CW GOURMET

DESIGN FIRM | XSNRG ILLUSTRATION AND DESIGN

ALL DESIGN | KEVIN BALL

CLIENT | 8 BALL MUSIC

TOOLS | CORELDRAW

DESIGN FIRM | CREATIVE COMPANY

ALL DESIGN | RICK YURK

CLIENT | LOAVES & FISHES

TOOLS | MACINTOSH

DESIGN FIRM | A1 DESIGN

DESIGNER | AMY GREGG

CLIENT | PETER BELANGER PHOTOGRAPHY

TOOLS | MACINTOSH QUADRA, ADOBE ILLUSTRATOR

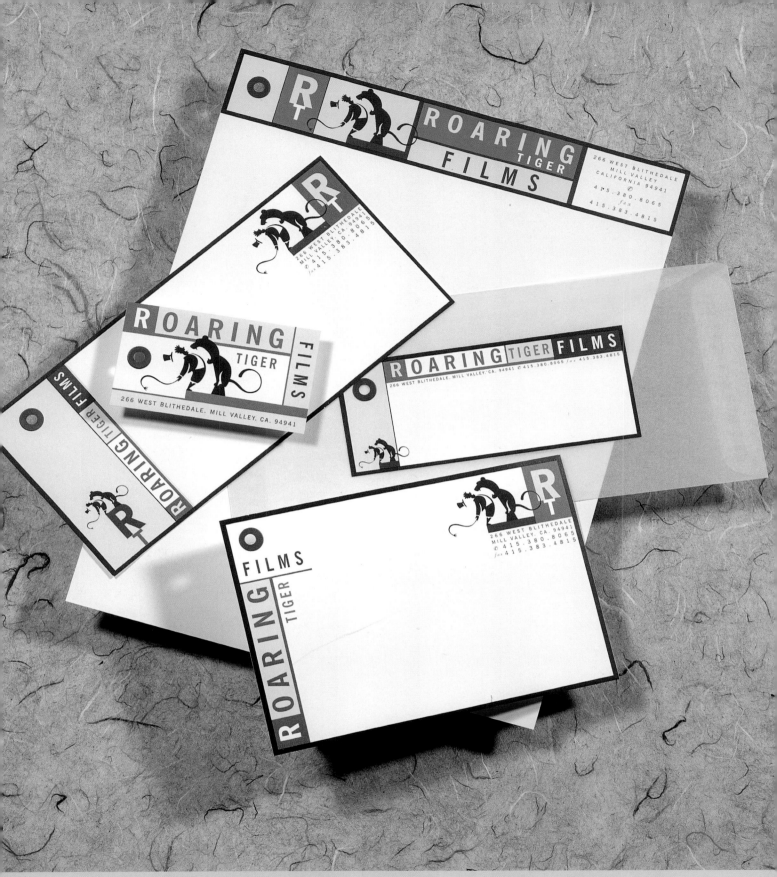

DESIGN FIRM | DOGSTAR

ART DIRECTOR | JENNIFER MARTIN

DESIGNER/ILLUSTRATOR | RODNEY DAVIDSON

CLIENT | ROARING TIGER FILMS

TOOLS | ADOBE ILLUSTRATOR, STREAMLINE,
MACROMEDIA FREEHAND

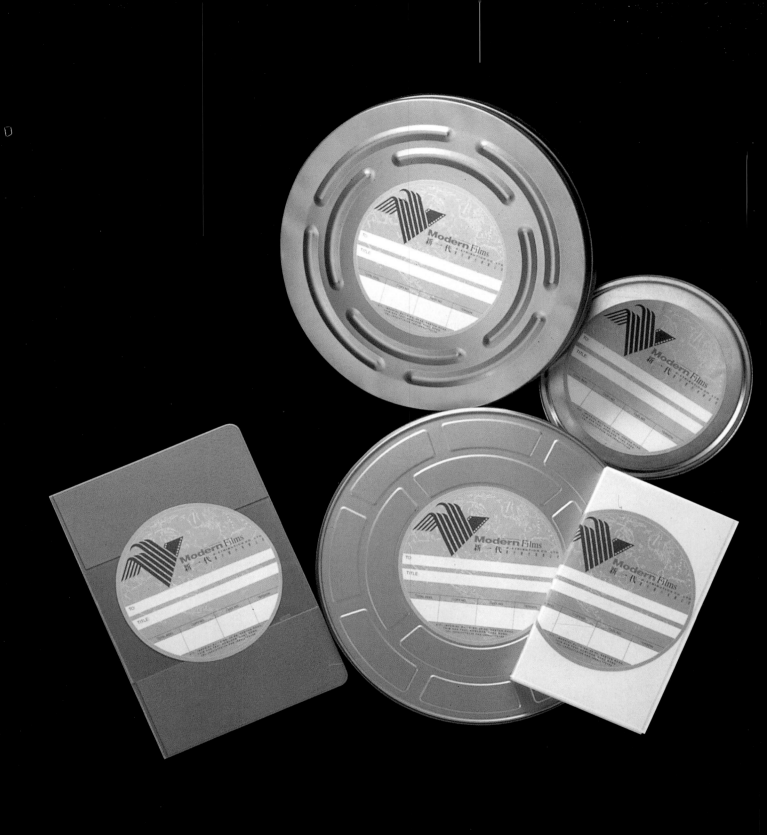

DESIGN FIRM | GRAND DESIGN COMPANY
ART DIRECTOR | GRAND SO
DESIGNER | GRAND SO, KWONG ETTI MAN
ILLUSTRATOR | KWONG ETTI MAN
CLIENT | MODERN FILMS

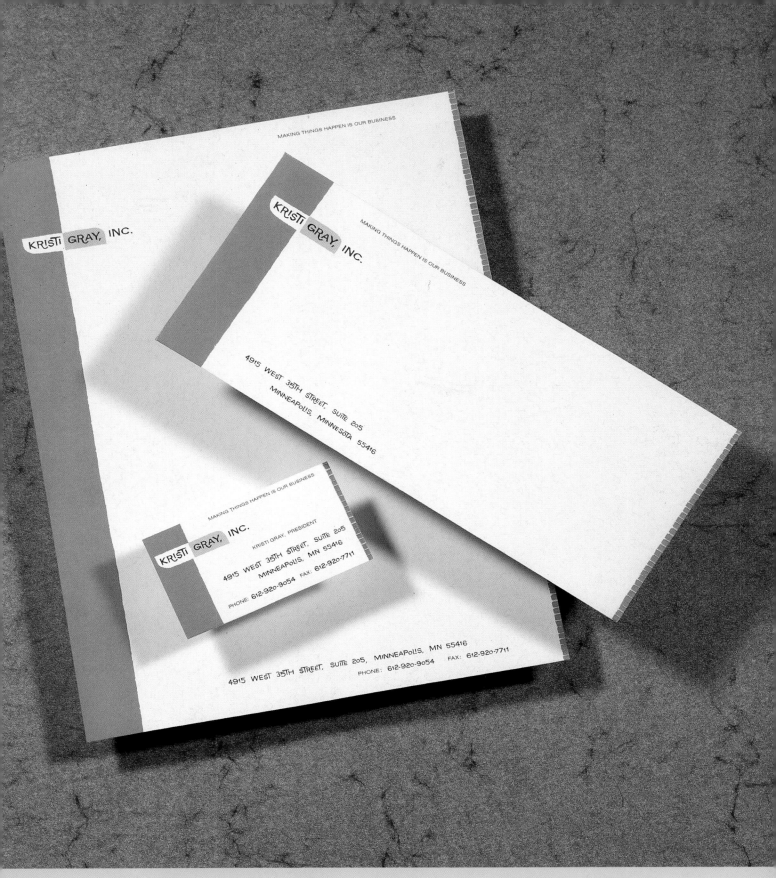

MAKING THINGS HAPPEN IS OUR BUSINESS

KRISTI GRAY, INC.

KRISTI GRAY, INC.

MAKING THINGS HAPPEN IS OUR BUSINESS

4915 WEST 35TH STREET, SUITE 205
MINNEAPOLIS, MINNESOTA 55416

MAKING THINGS HAPPEN IS OUR BUSINESS

KRISTI GRAY, INC.

KRISTI GRAY, PRESIDENT
4915 WEST 35TH STREET, SUITE 205
MINNEAPOLIS, MN 55416
PHONE: 612-920-9054 FAX: 612-920-7711

4915 WEST 35TH STREET, SUITE 205, MINNEAPOLIS, MN 55416
PHONE: 612-920-9054 FAX: 612-920-7711

DESIGN FIRM | ZAUHAR DESIGN
ALL DESIGN | DAVID ZAUHAR
CLIENT | KRISTI GRAY, INC.

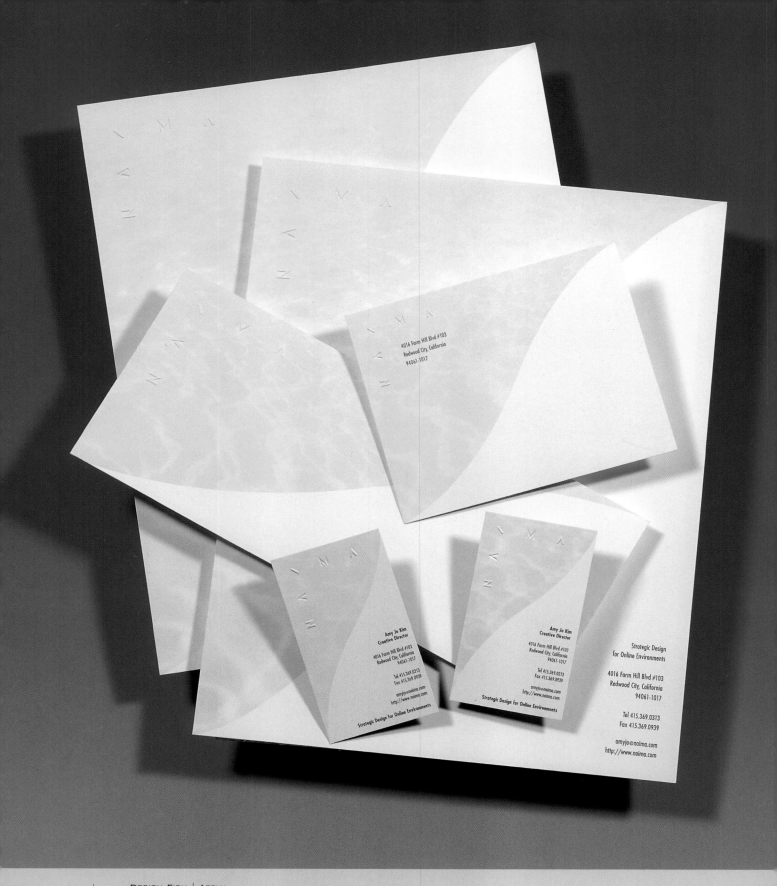

DESIGN FIRM | AERIAL

ART DIRECTOR/DESIGNER | TRACY MOON

CLIENT | AMY JO KIM/NAIMA PRODUCTIONS

TOOLS | ADOBE PHOTOSHOP, QUARKXPRESS

PAPER/PRINTING | CLASSIC CREST SOLAR WHITE 80 LB.

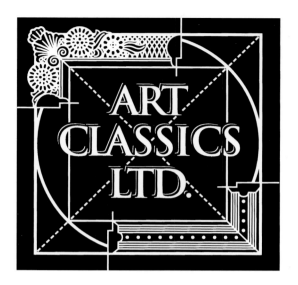

DESIGN FIRM | PHOENIX CREATIVE, ST. LOUIS
ALL DESIGN | ED MANTELS-SEEKER
CLIENT | ART CLASSICS LTD.
TOOLS | MACROMEDIA FREEHAND

DESIGN FIRM | MICHAEL STANARD DESIGN, INC.
ART DIRECTOR | MICHAEL STANARD
DESIGNER | KRISTY VANDEKERCKHOVE
CLIENT | JOHN MANCINI
TOOLS | MACINTOSH, ADOBE ILLUSTRATOR

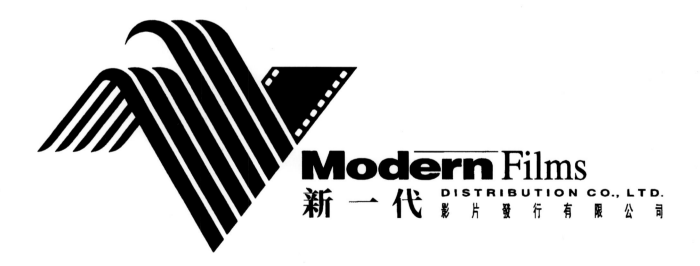

DESIGN FIRM | GRAND DESIGN COMPANY
ART DIRECTOR | GRAND SO
DESIGNER | GRAND SO, KWONG ETTI MAN
ILLUSTRATOR | KWONG ETTI MAN
CLIENT | MODERN FILMS

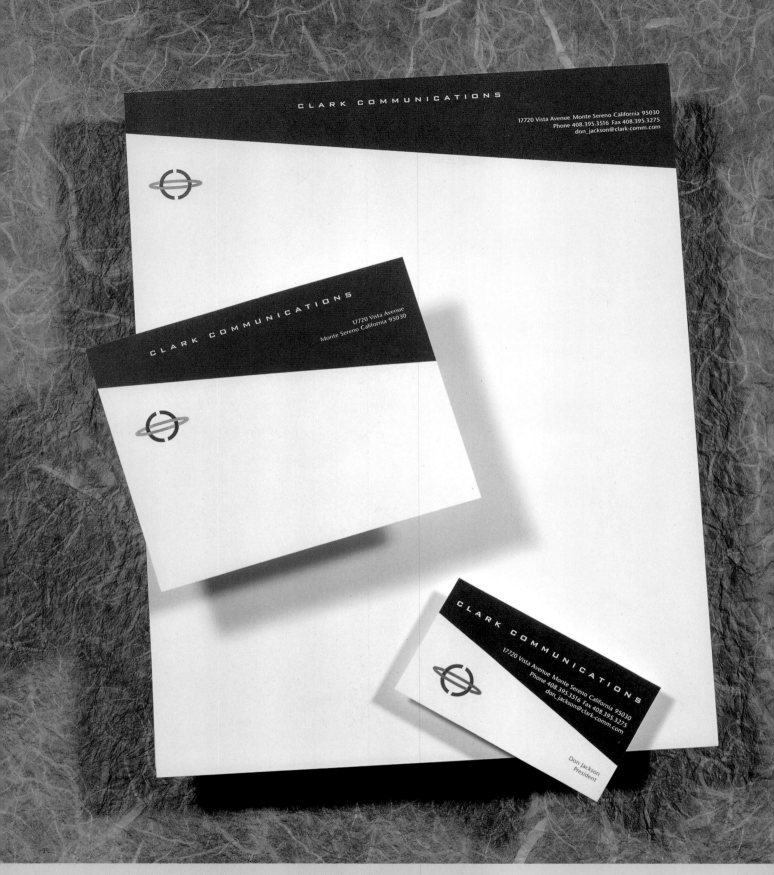

DESIGN FIRM | MELISSA PASSEHL DESIGN
ART DIRECTOR/DESIGNER | MELISSA PASSEHL
CLIENT | CLARK COMMUNICATIONS

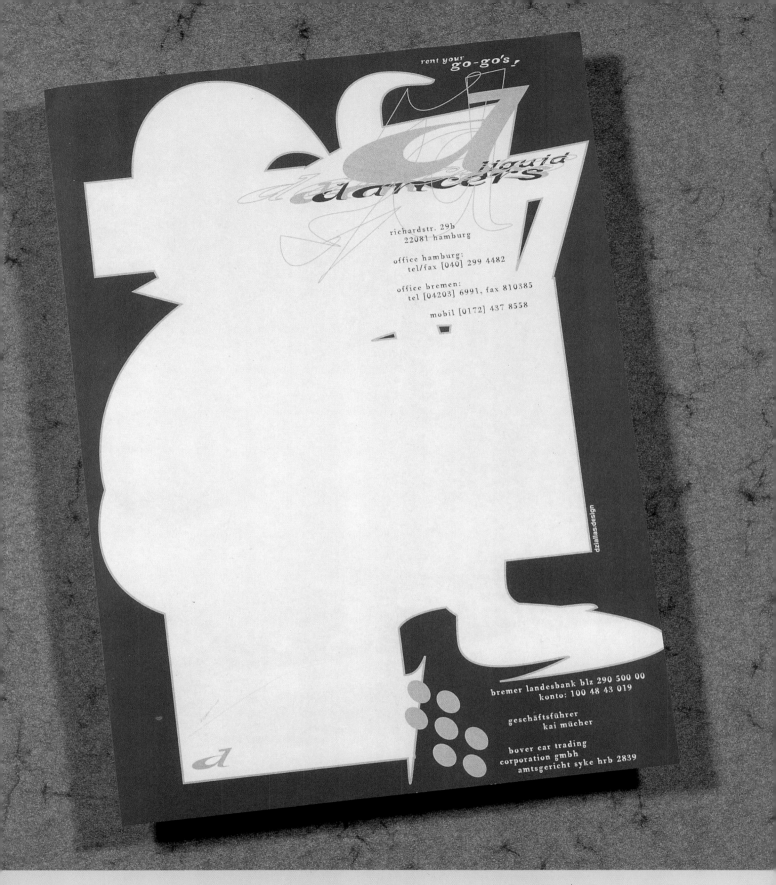

rent your
go-go's!

liquid
dancers

richardstr. 29b
22081 hamburg

office hamburg:
tel/fax [040] 299 4482

office bremen:
tel [04203] 6991, fax 810385

mobil [0172] 437 8558

dziallas·design

bremer landesbank blz 290 500 00
konto: 100 48 43 019

geschäftsführer
kai mücher

bover car trading
corporation gmbh
amtsgericht syke hrb 2839

DESIGN FIRM | STEFAN DZIALLAS DESIGN

DESIGNER/ILLUSTRATOR | STEFAN DZIALLAS

CLIENT | STEFAN DZIALLAS

TOOLS | ADOBE ILLUSTRATOR, QUARKXPRESS,
MACINTOSH

ALCAROTTI

CENTRO SPORTIVO

DESIGN FIRM | TANGRAM STRATEGIC DESIGN
ART DIRECTOR/DESIGNER | ANTONELLA TREVISAN
CLIENT | CENTRO SPORTIVO ALCAROTTI
TOOLS | POWER MACINTOSH

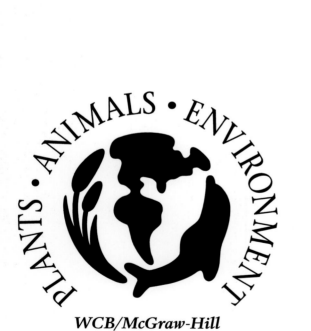

DESIGN FIRM | GET SMART DESIGN COMPANY
ART DIRECTOR | JEFF MACFARLANE
DESIGNER/ILLUSTRATOR | TOM CULBERTSON
CLIENT | WCB/McGraw-Hill PUBLISHERS
TOOLS | MACROMEDIA FREEHAND

DESIGN FIRM | EYE DESIGN INCORPORATED
ALL DESIGN | ROBIN MEYERS
CLIENT | DYNAMIC DECISIONS/PEI-O
TOOLS | ADOBE ILLUSTRATOR
PAPER/PRINTING | PMS 485

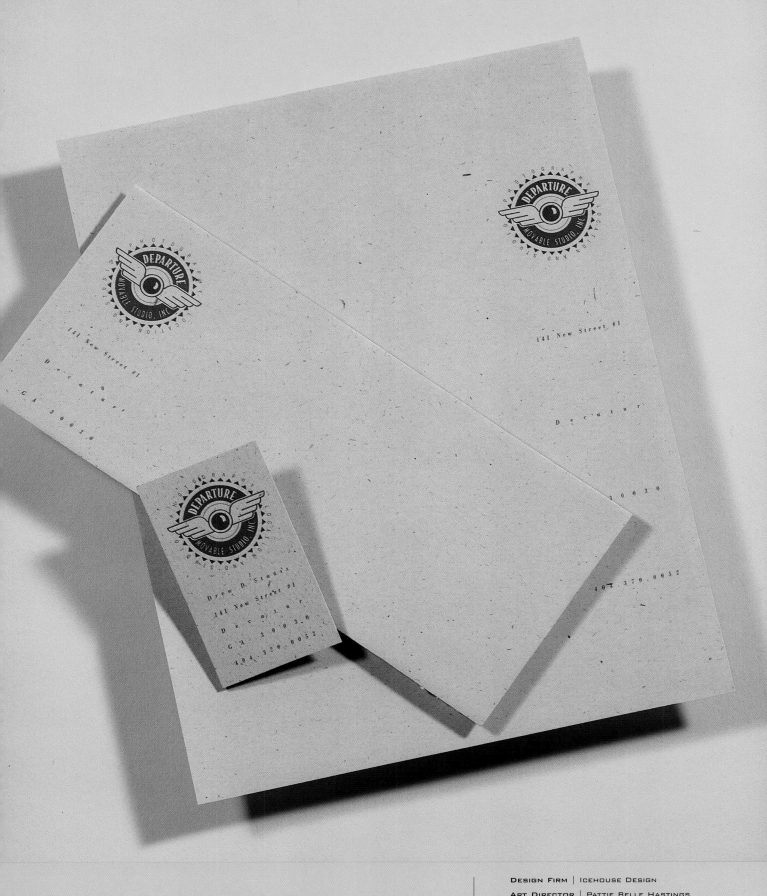

DESIGN FIRM | ICEHOUSE DESIGN

ART DIRECTOR | PATTIE BELLE HASTINGS

DESIGNER/ILLUSTRATOR | BJORN AKSELSEN

CLIENT | DEPARTURE

TOOLS | POWER MACINTOSH

PAPER/PRINTING | FRENCH SPECKLETONE

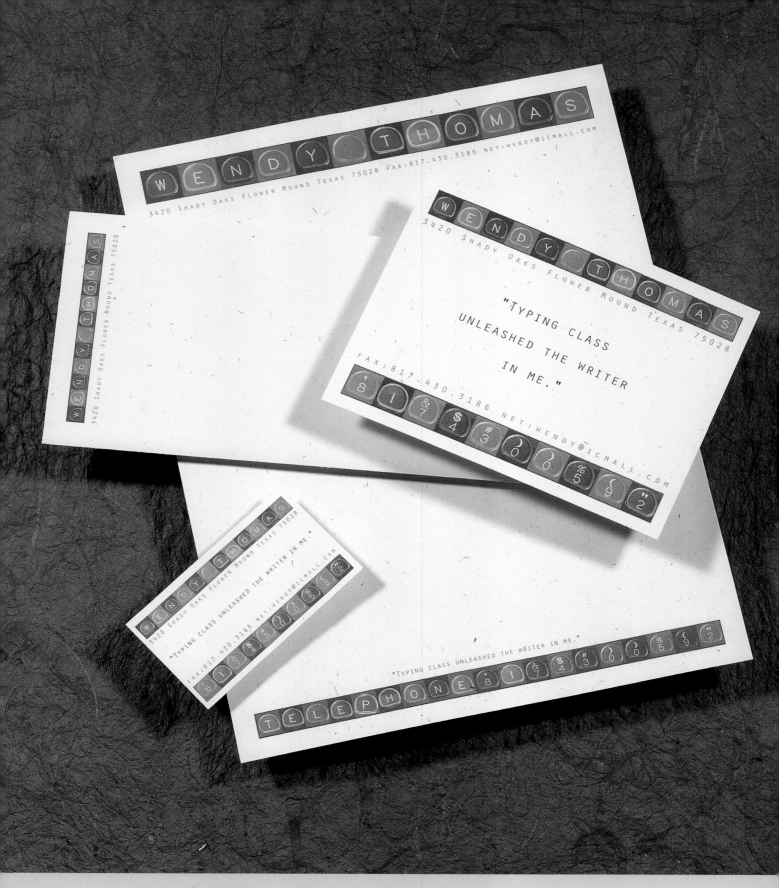

DESIGN FIRM | ELENA DESIGN

ART DIRECTOR/DESIGNER | ELENA BACA

ILLUSTRATOR | PHOTOTONE ALPHABETS

CLIENT | WENDY THOMAS

TOOLS | QUARKXPRESS

PAPER/PRINTING | FRENCH SPECKELTONE

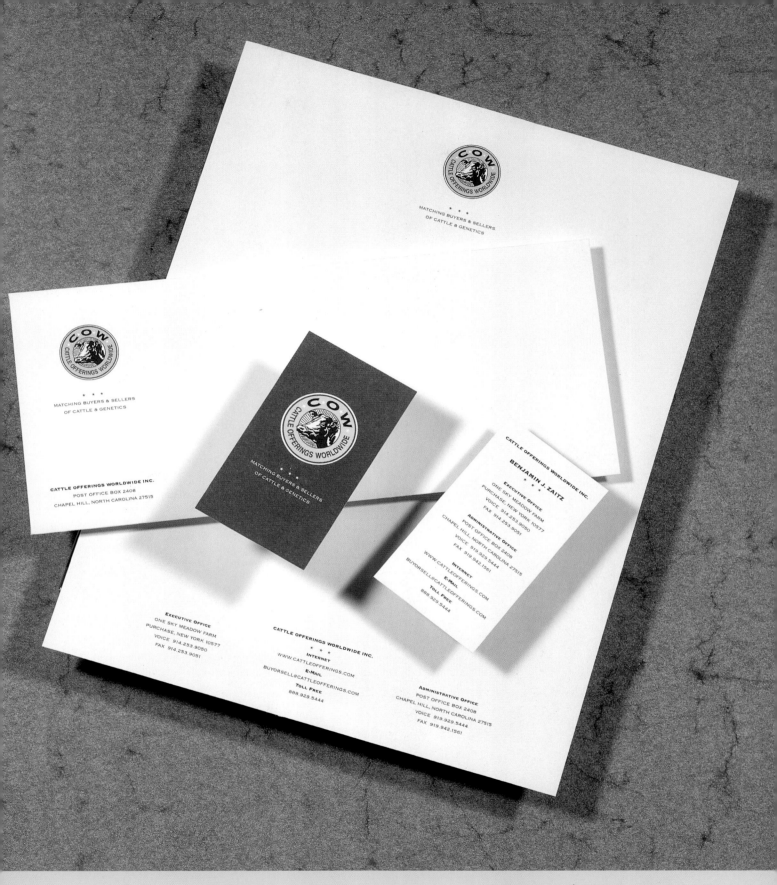

MATCHING BUYERS & SELLERS
OF CATTLE & GENETICS

CATTLE OFFERINGS WORLDWIDE INC.
POST OFFICE BOX 2408
CHAPEL HILL, NORTH CAROLINA 27515

Executive Office
ONE SKY MEADOW FARM
PURCHASE, NEW YORK 10577
VOICE 914.253.9050
FAX 914.253.9051

CATTLE OFFERINGS WORLDWIDE INC.
* * *
Internet
WWW.CATTLEOFFERINGS.COM
E-Mail
BUYORSELL@CATTLEOFFERINGS.COM
Toll Free
888.929.5444

Administrative Office
POST OFFICE BOX 2408
CHAPEL HILL, NORTH CAROLINA 27515
VOICE 919.929.5444
FAX 919.942.1561

CATTLE OFFERINGS WORLDWIDE INC.

BENJAMIN J. ZAITZ
* * *
Executive Office
ONE SKY MEADOW FARM
PURCHASE, NEW YORK 10577
VOICE 914.253.9050
FAX 914.253.9051

Administrative Office
POST OFFICE BOX 2408
CHAPEL HILL, NORTH CAROLINA 27515
VOICE 919.929.5444
FAX 919.942.1561

Internet
WWW.CATTLEOFFERINGS.COM
E-Mail
BUYORSELL@CATTLEOFFERINGS.COM
Toll Free
888.929.5444

DESIGN FIRM | MICHAEL STANARD DESIGN, INC.
ART DIRECTOR | MICHAEL STANARD
DESIGNER/ILLUSTRATOR | KRISTY VANDEKERCKHOVE
CLIENT | CATTLE OFFERINGS WORLDWIDE
TOOLS | MACINTOSH, ADOBE ILLUSTRATOR
PAPER/PRINTING | STRATHMORE WRITING

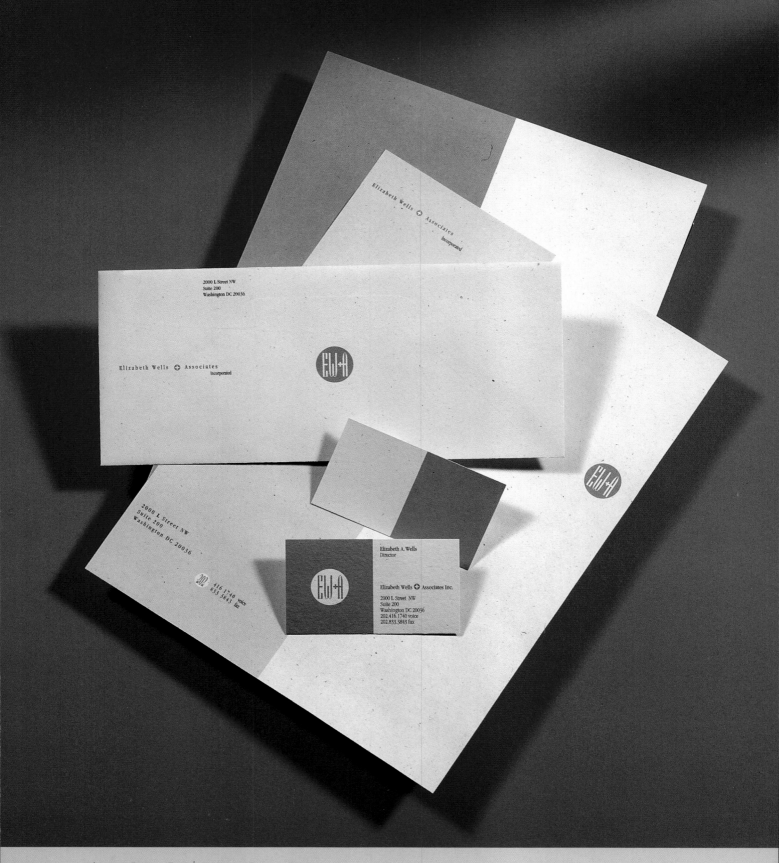

DESIGN FIRM | ANDERSON-THOMAS DESIGN, INC.

ART DIRECTOR/DESIGNER | JOEL ANDERSON

CLIENT | STAR SONG COMMUNICATIONS

TOOLS | QUARKXPRESS, ADOBE ILLUSTRATOR

PAPER/PRINTING | CLASSIC CREST/BLACK PLUS ONE PMS

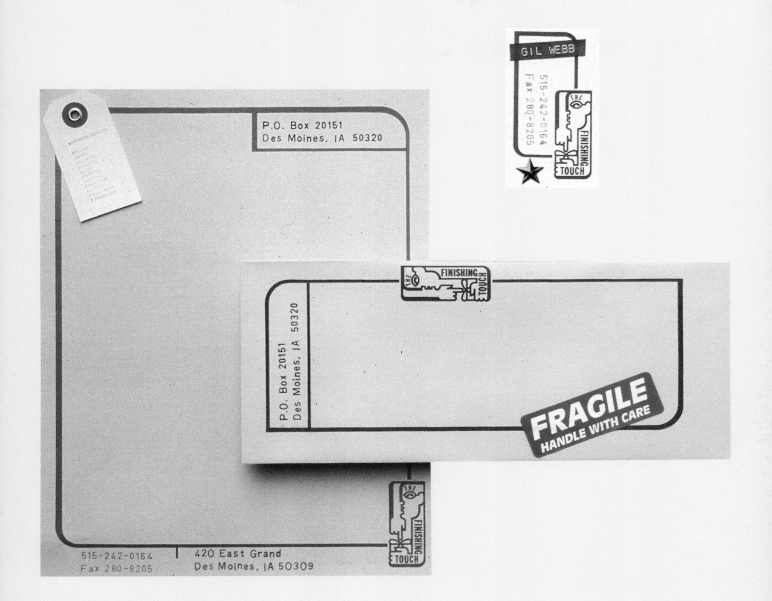

GIL WEBB

515-242-0164
Fax 280-8205

THE FINISHING TOUCH

P.O. Box 20151
Des Moines, IA 50320

P.O. Box 20151
Des Moines, IA 50320

FRAGILE
HANDLE WITH CARE

515-242-0164
Fax 280-8205

420 East Grand
Des Moines, IA 50309

DESIGN FIRM │ SAYLES GRAPHIC DESIGN

ALL DESIGN │ JOHN SAYLES

CLIENT │ THE FINISHING TOUCH

PAPER/PRINTING │ INCENTIVE 100 LB. AND

MANILA TAG/ OFFSET AND RUBBER STAMP

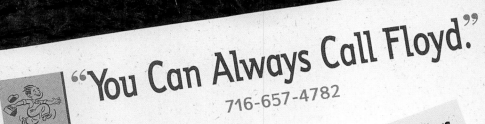

"You Can Always Call Floyd."

716-657-4782

HEATING

PLUMBING

CARPENTRY

ELECTRIC

ROOFING

"You Can Always Call Floyd."

716-657-4782

Floyd Johnson
7796 Rte. 5 & 20, Bloomfield, NY 14469

HEATING
PLUMBING
CARPENTRY
ELECTRIC
ROOFING

 "You Can Always Call Floyd."

716-657-4782

HEATING
PLUMBING
CARPENTRY
ELECTRIC
ROOFING

Floyd Johnson

7796 Rte. 5 & 20

Bloomfield, NY

14469

Floyd Johnson

7796 Rte. 5 & 20

Bloomfield, NY

14469

DESIGN FIRM | LYNN WOOD DESIGN

ART DIRECTOR/DESIGNER | LYNN WOOD

ILLUSTRATOR | MODIFIED CLIP ART

CLIENT | FLOYD JOHNSON

TOOLS | QUARKXPRESS, ADOBE ILLUSTRATOR, POWER MACINTOSH

PAPER/PRINTING | BENEFIT/GRAPHIC BROKERAGE

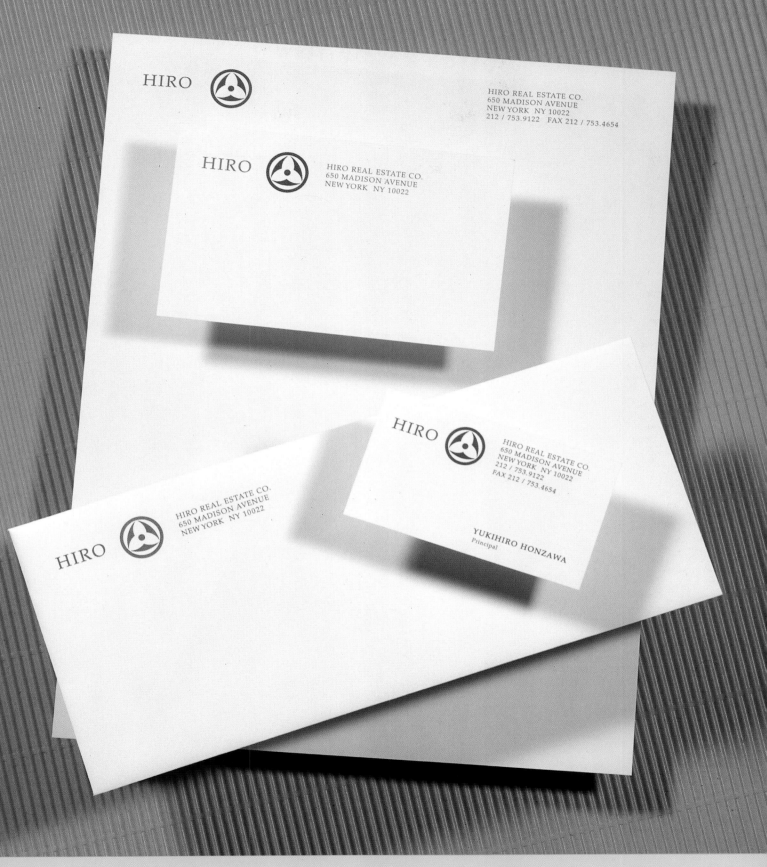

DESIGN FIRM | E. CHRISTOPHER KLUMB ASSOCIATES, INC.

ALL DESIGN | CHRISTOPHER KLUMB

CLIENT | HIRO REAL ESTATE COMPANY

TOOLS | QUARKXPRESS, MACINTOSH

PAPER/PRINTING | STRATHMORE

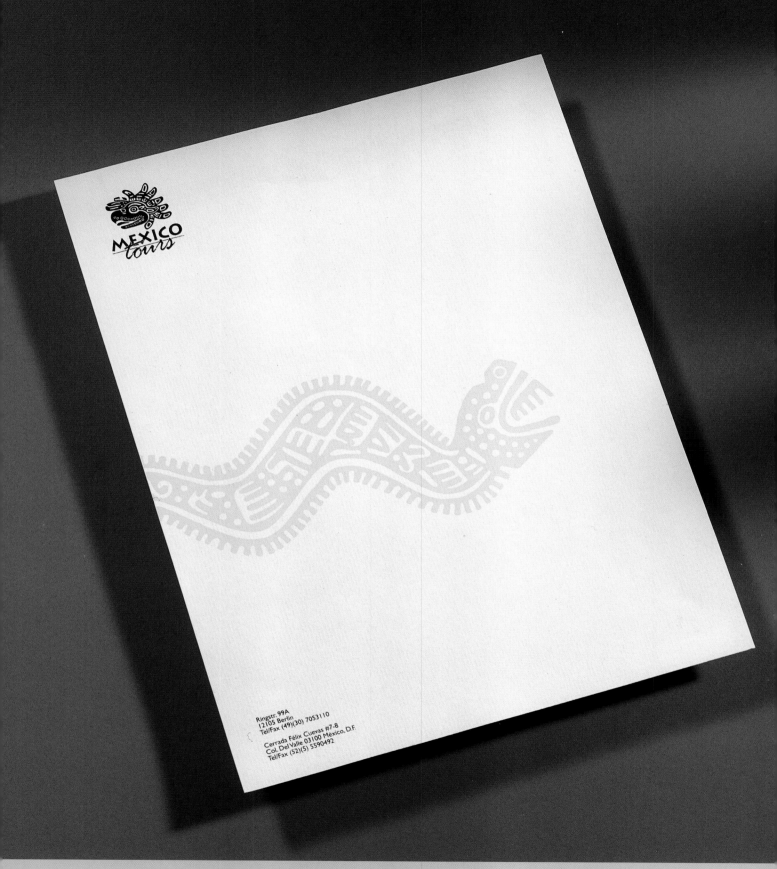

Ringstr. 99A
12105 Berlin
Tel/Fax (49)(30) 7053110

Cerrada Félix Cuevas #7-B
Col. Del Valle 03100 México, D.F.
Tel/Fax (52)(5) 5590492

DESIGN FIRM | ZAPPATA DESIGNERS

ART DIRECTOR/DESIGNER | IBO ANGULO

CLIENT | MEXICO TOURS (TOURIST AGENCY IN GERMANY)

TOOLS | MACROMEDIA FREEHAND

PAPER/PRINTING | RECYCLED/SILKSCREEN

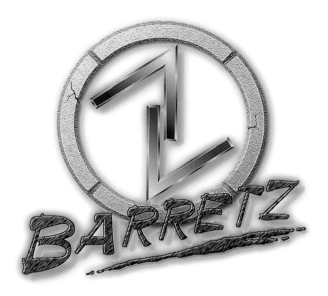

DESIGN FIRM | XSNRG ILLUSTRATION AND DESIGN
ALL DESIGN | KEVIN BALL
CLIENT | BARRETZ
TOOLS | CORELDRAW, PICTURE PUBLISHER

DESIGN FIRM | DOGSTAR
ART DIRECTOR | MARTIN LEEDS/CIGAR AFICIONADO
DESIGNER/ILLUSTRATOR | RODNEY DAVIDSON
CLIENT | CIGAR AFICIONADO
TOOLS | ADOBE ILLUSTRATOR, STREAMLINE, MACROMEDIA FREEHAND

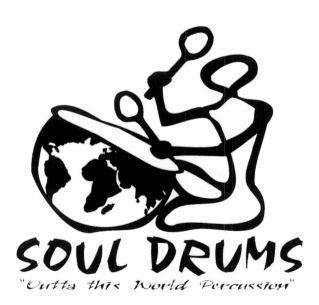

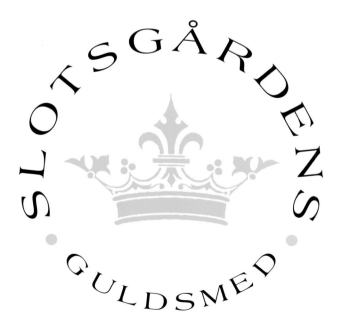

DESIGN FIRM | XSNRG ILLUSTRATION AND DESIGN
ALL DESIGN | KEVIN BALL
CLIENT | SOUL DRUMS
TOOLS | CORELDRAW

ART DIRECTOR/DESIGNER | ATHENA WINDELEV
CLIENT | SLOTSGÅRDENS GULDSMED, GOLDSMITH

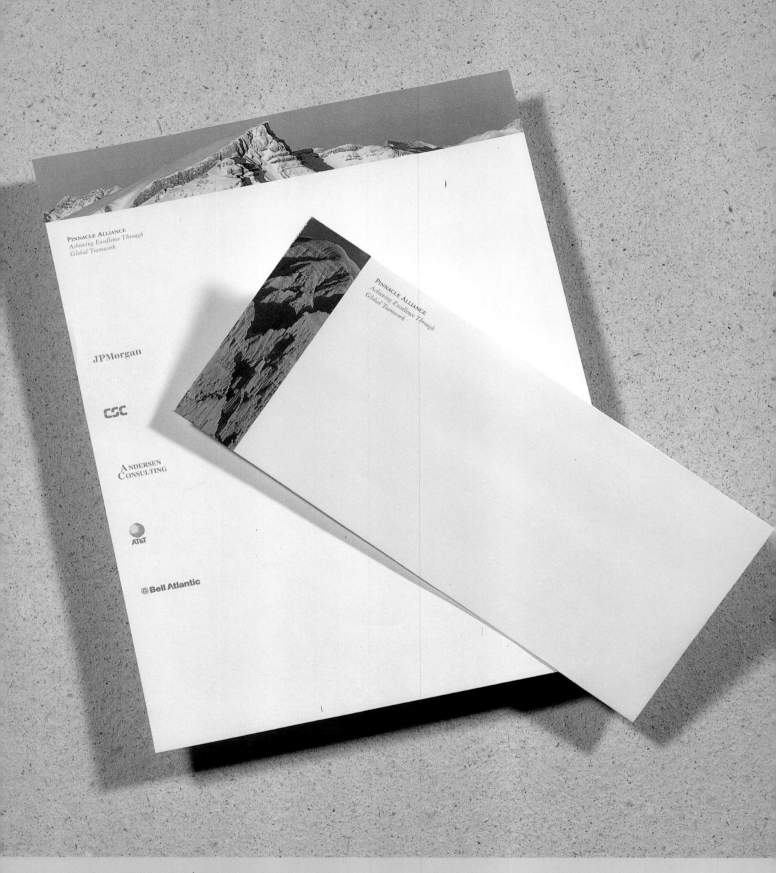

DESIGN FIRM | RAMONA HUTKO DESIGN

ART DIRECTOR/DESIGNER | RAMONA HUTKO

PHOTOGRAPHER | SHAWN HUTKO

CLIENT | PINNACLE ALLIANCE

TOOLS | ADOBE PHOTOSHOP, QUARKXPRESS

PAPER/PRINTING | MOHAWK SUPERFINE WHITE ESS SHELL

FINISH 80 LB. TEXT

JOHN HOWARD & BENJAMIN RODEN-LUPTON

Landscape Architecture
1293 Peachtree Street, Suite 701
Atlanta, Georgia 30309

JOHN HOW

BENJAMIN RODEN-LUPTON

JOHN HOWARD & BENJAMIN RODEN-LUPTON

Landscape Architecture
1293 Peachtree Street, Suite 701 & Atlanta, Georgia 30309

JOHN HOWARD & BENJAMIN RODEN-LUPTON

Landscape Architecture

1293 Peachtree Street, Suite 701
Atlanta, Georgia 30309

404.876.7051

Landscape Architecture

1293 Peachtree Street, Suite 701
Atlanta, Georgia 30309

404.876.7051

DESIGN FIRM | ICEHOUSE DESIGN

ART DIRECTOR/DESIGNER | PATTIE BELLE HASTINGS

CLIENT | JOHN HOWARD/BENJAMIN RODEN-LUPTON

TOOLS | POWER MACINTOSH

PAPER/PRINTING | CLASSIC CREST

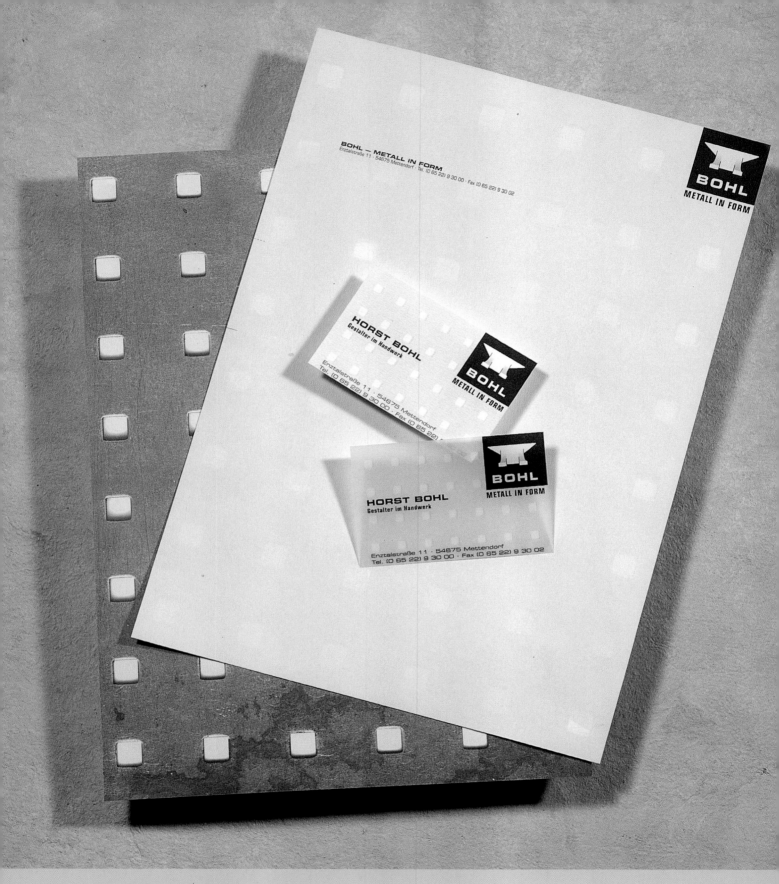

DESIGN FIRM | BOHL
ART DIRECTOR | STEFAN BOHL
CLIENT | BOHL METALL IN FORM
TOOLS | MACINTOSH

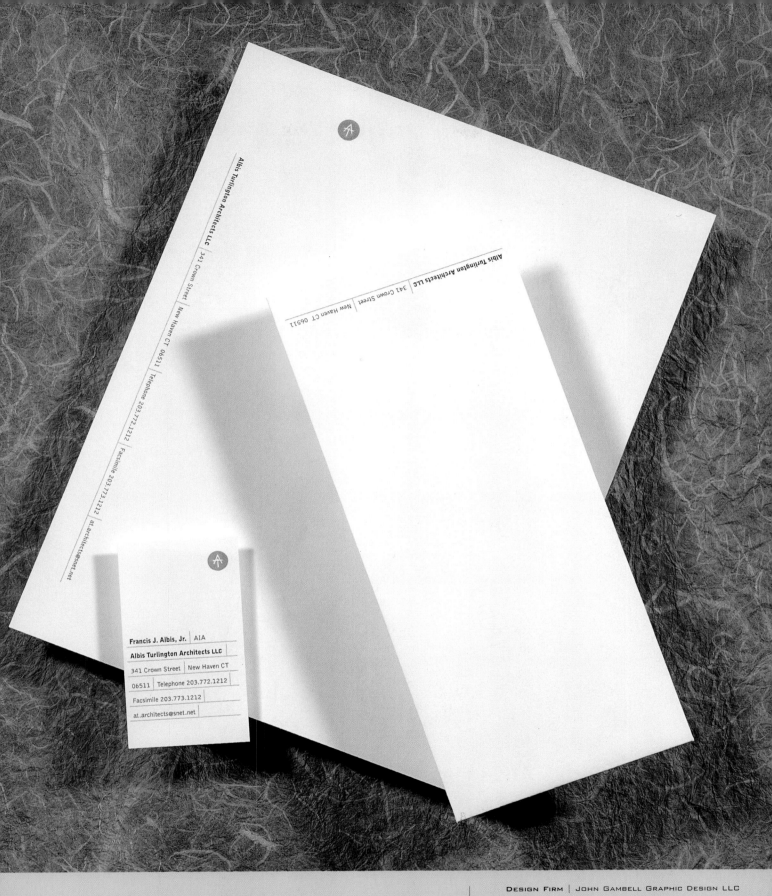

Albis Turlington Architects LLC | 341 Crown Street | New Haven CT 06511 | Telephone 203.772.1212 | Facsimile 203.773.1212 | at.architects@snet.net

Albis Turlington Architects LLC | 341 Crown Street | New Haven CT 06511

Francis J. Albis, Jr. | AIA

Albis Turlington Architects LLC

341 Crown Street | New Haven CT

06511 | Telephone 203.772.1212 |

Facsimile 203.773.1212 |

at.architects@snet.net

DESIGN FIRM | JOHN GAMBELL GRAPHIC DESIGN LLC
ART DIRECTOR | JOHN GAMBELL
DESIGNERS | JOHN GAMBELL, CHARLES ROUTHIER
CLIENT | ALBIS TURLINGTON ARCHITECTS LLC
TOOLS | QUARKXPRESS, ADOBE ILLUSTRATOR
PAPER/PRINTING | CRANES CREST 28 LB. FLOUR
WHITE/LEHAMN BROTHERS, INC., NEW HAVEN

DESIGN FIRM | VOSS DESIGN
ALL DESIGN | AXEL VOSS
CLIENT | ART 'N STUFF

DESIGN FIRM | JEFF FISHER LOGOMOTIVES
ALL DESIGN | JEFF FISHER
CLIENT | SHLEIFER MARKETING COMMUNICATIONS, AGENCY FOR
SAMUELS YOELIN KANTOR SEYMOUR AND SPINRAD
TOOLS | MACROMEDIA FREEHAND

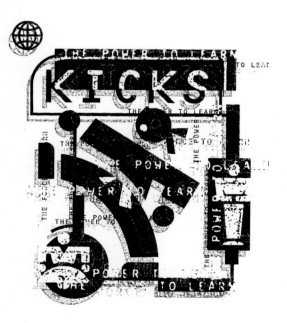

DESIGN FIRM | INSIGHT DESIGN COMMUNICATIONS
ALL DESIGNS | SHERRIE AND TRACY HOLDEMAN
CLIENT | KICKS
TOOLS | POWER MACINTOSH, MACROMEDIA FREEHAND,
ADOBE PHOTOSHOP

DESIGN FIRM | COMMONWEALTH CREATIVE ASSOCIATES
ART DIRECTOR/DESIGNER | ADAM RUDIKOFF
CLIENT | MCGOWAN EYECARE
TOOLS | MACINTOSH

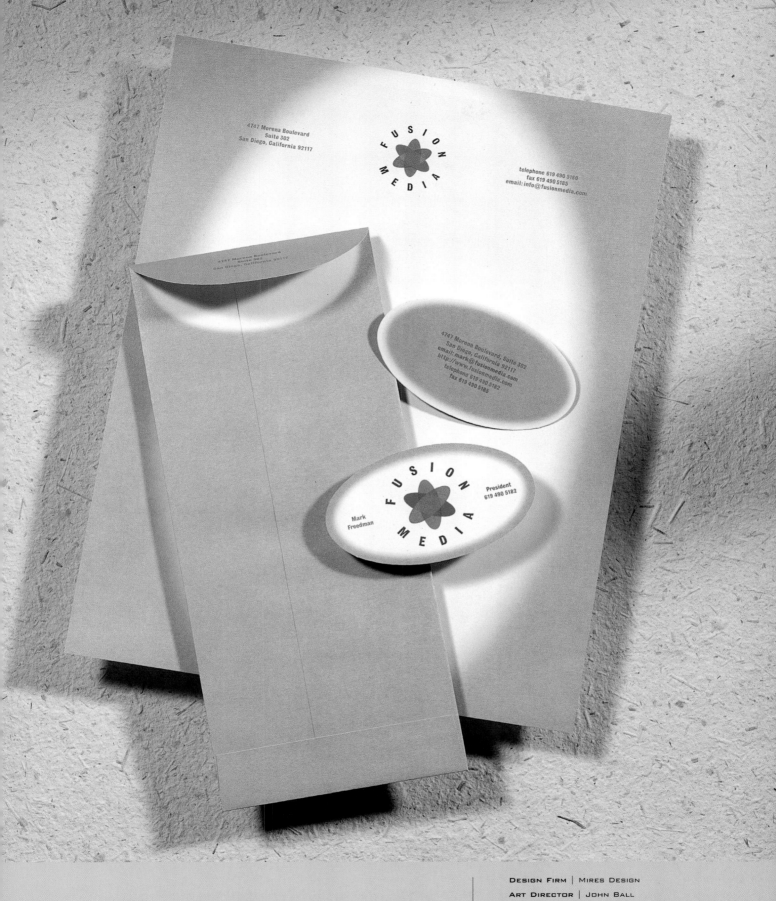

DESIGN FIRM | MIRES DESIGN
ART DIRECTOR | JOHN BALL
DESIGNERS | JOHN BALL, DOBORAH HORN
CLIENT | FUSION MEDIA
PAPER/PRINTING | STARWHITE

DESIGN FIRM | SAYLES GRAPHIC DESIGN

ALL DESIGN | JOHN SAYLES

CLIENT | ACUMEN GROUP

PAPER/PRINTING | GRAPHIKA WHITE PARCHMENT/OFFSET

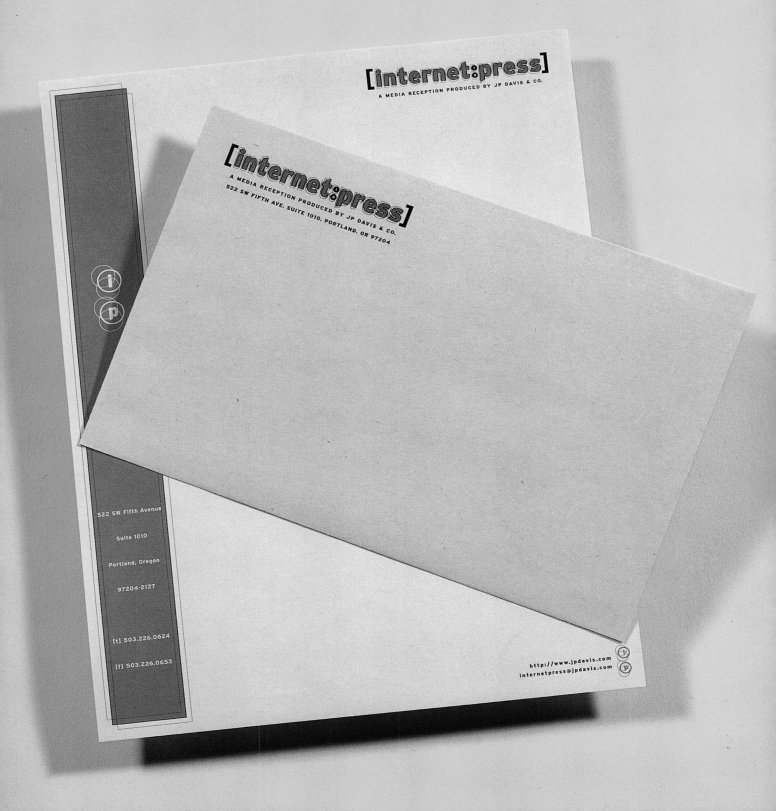

[internet:press]
A MEDIA RECEPTION PRODUCED BY JP DAVIS & CO.

[internet:press]
A MEDIA RECEPTION PRODUCED BY JP DAVIS & CO.
522 SW FIFTH AVE, SUITE 1010, PORTLAND, OR 97204

522 SW Fifth Avenue

Suite 1010

Portland, Oregon

97204-2127

[t] 503.226.0624

[f] 503.226.0653

http://www.jpdavis.com
internetpress@jpdavis.com

DESIGN FIRM | LSL INDUSTRIES
DESIGNER | ELISABETH SPITALNY
CLIENT | JP DAVIS & COMPANY, INTERNET PRESS
TOOLS | QUARKXPRESS, ADOBE ILLUSTRATOR
PAPER/PRINTING | FRENCH NEWSPRINT AGED/OFFSET

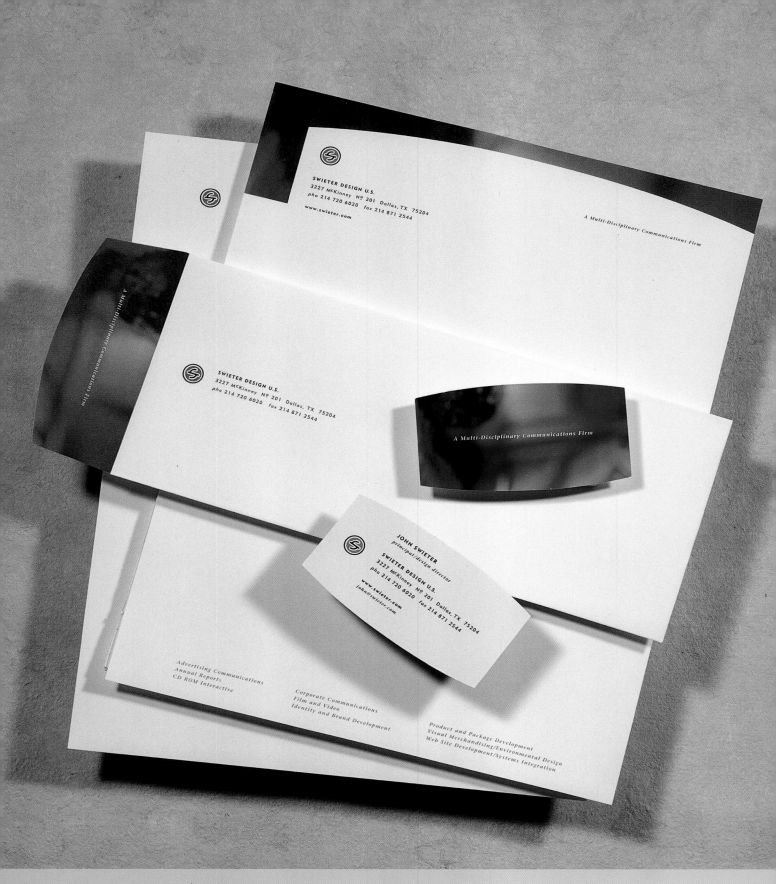

SWIETER DESIGN U.S.
3227 McKinney № 201 Dallas, TX 75204
pho 214 720 6020 fox 214 871 2544
www.swieter.com

A Multi-Disciplinary Communications Firm

SWIETER DESIGN U.S.
3227 McKinney № 201 Dallas, TX 75204
pho 214 720 6020 fox 214 871 2544

A Multi-Disciplinary Communications Firm

A Multi-Disciplinary Communications Firm

JOHN SWIETER
principal/design director
SWIETER DESIGN U.S.
3227 McKinney № 201 Dallas, TX 75204
pho 214 720 6020 fox 214 871 2544
www.swieter.com
john@swieter.com

Advertising Communications
Annual Reports
CD ROM Interactive

Corporate Communications
Film and Video
Identity and Brand Development

Product and Package Development
Visual Merchandising/Environmental Design
Web Site Development/Systems Integration

DESIGN FIRM | SWIETER DESIGN
ART DIRECTOR | JOHN SWIETER
DESIGNER | MARK FORD
CLIENT | SWIETER DESIGN
TOOLS | ADOBE PHOTOSHOP
PAPER/PRINTING | COATED/FOUR COLOR

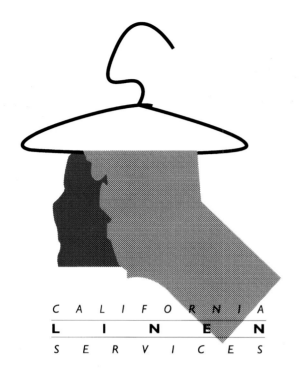

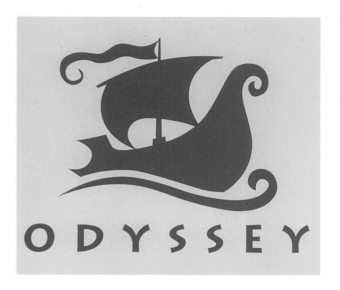

DESIGN FIRM | ADELE BASS + CO. DESIGN
ALL DESIGN | ADELE BASS
CLIENT | CALIFORNIA LINEN SERVICES
TOOLS | ADOBE ILLUSTRATOR

DESIGN FIRM | TRACY SABIN GRAPHIC DESIGN
ART DIRECTOR | ELISABETH PETERS
DESIGNER/ILLUSTRATOR | TRACY SABIN
CLIENT | HARCOURT BRACE & COMPANY/ODYSSEY
TOOLS | ADOBE ILLUSTRATOR

CHALMER ⊕ HVEDEHAVE

DESIGN FIRM | TRANSPARENT OFFICE
ART DIRECTOR/DESIGNER | VIBEKE NØDSKOV
CLIENT | CHALMER + HVEDEHAVE
TOOLS | QUARKXPRESS, ADOBE ILLUSTRATOR

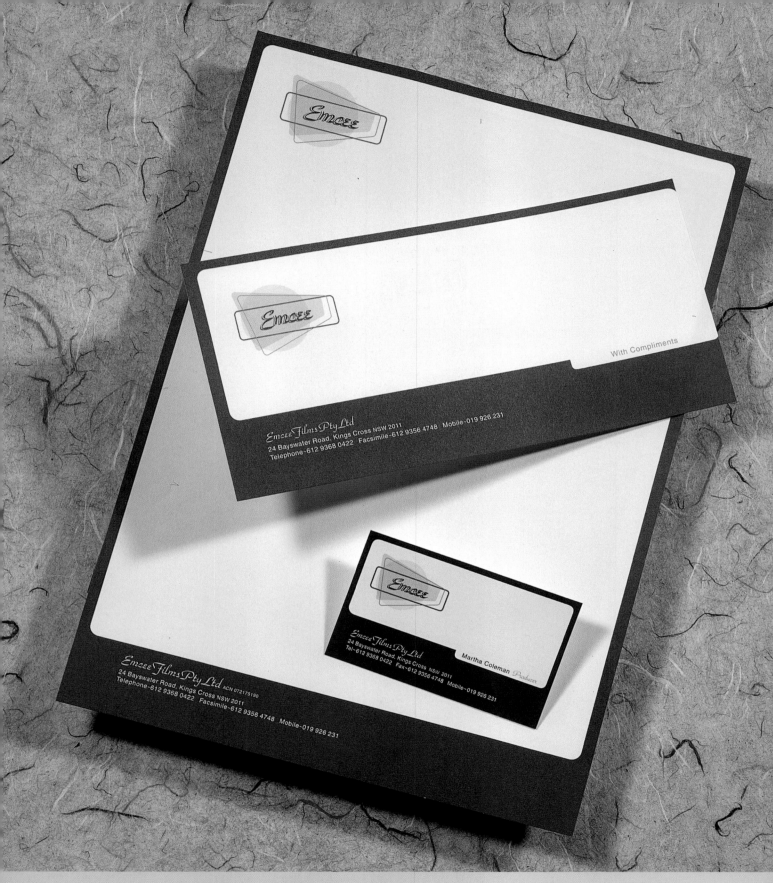

DESIGN FIRM | LUCY WALKER GRAPHIC DESIGN

ART DIRECTOR/DESIGNER | LUCY WALKER

CLIENT | EMCEE FILMS PTY. LTD.

TOOLS | ADOBE ILLUSTRATOR

PAPER/PRINTING | OCM IVORY WOVE

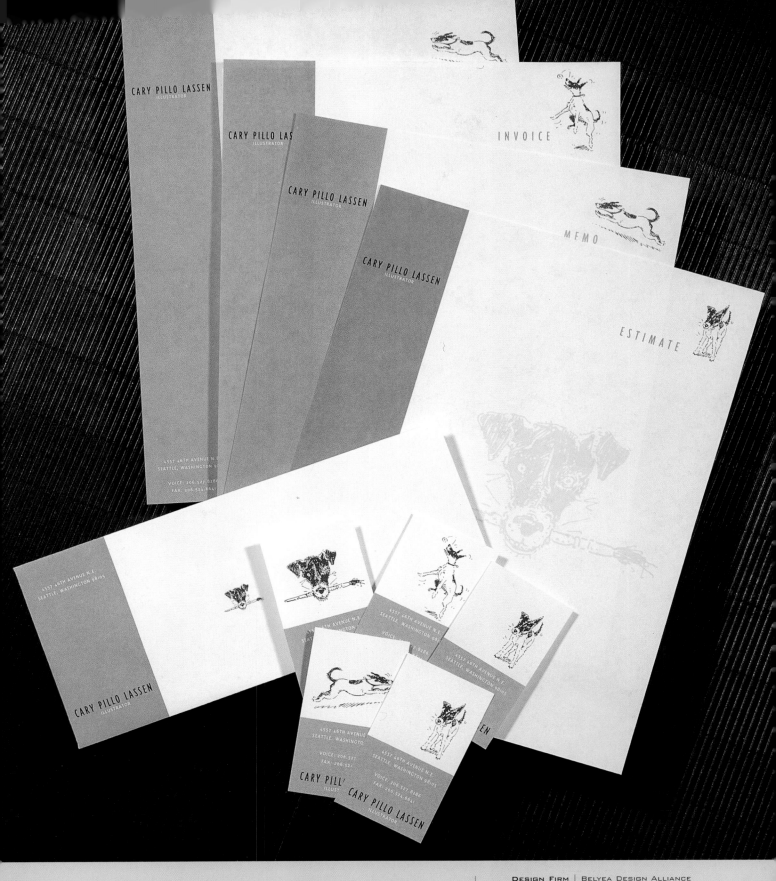

DESIGN FIRM | Belyea Design Alliance
ART DIRECTOR | Patricia Belyea
DESIGNER | Tim Ruszel
ILLUSTRATOR | Cary Pillo Lassen
CLIENT | Cary Pillo Lassen

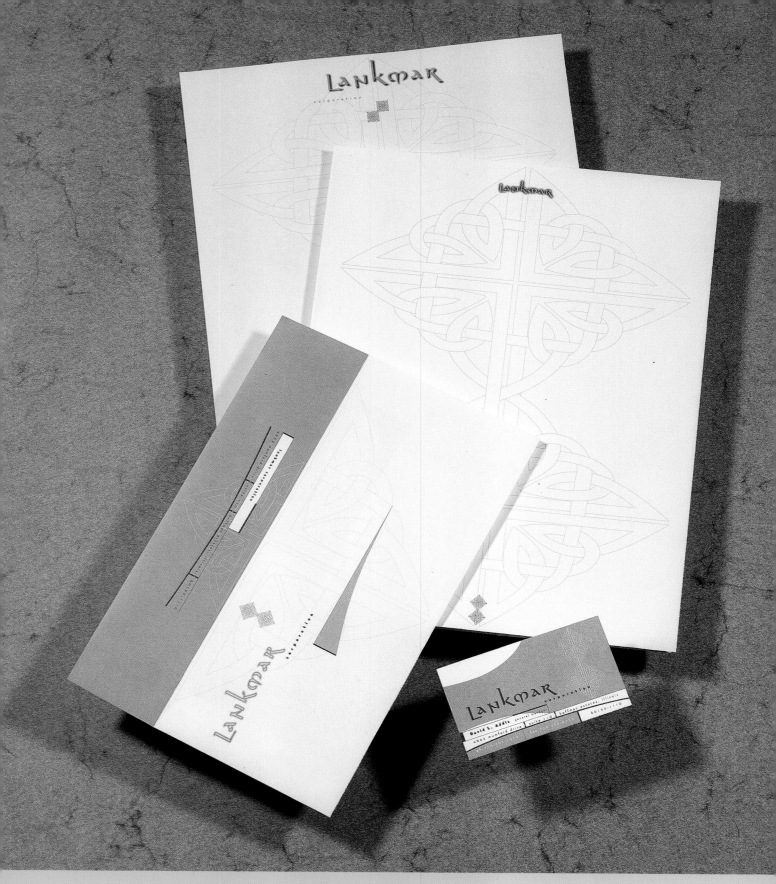

DESIGN FIRM | TANAGRAM

DESIGNER/ILLUSTRATOR | ANTHONY MA

CLIENT | LANKMAR CORPORATION

TOOLS | MACROMEDIA FREEHAND, ADOBE PHOTOSHOP

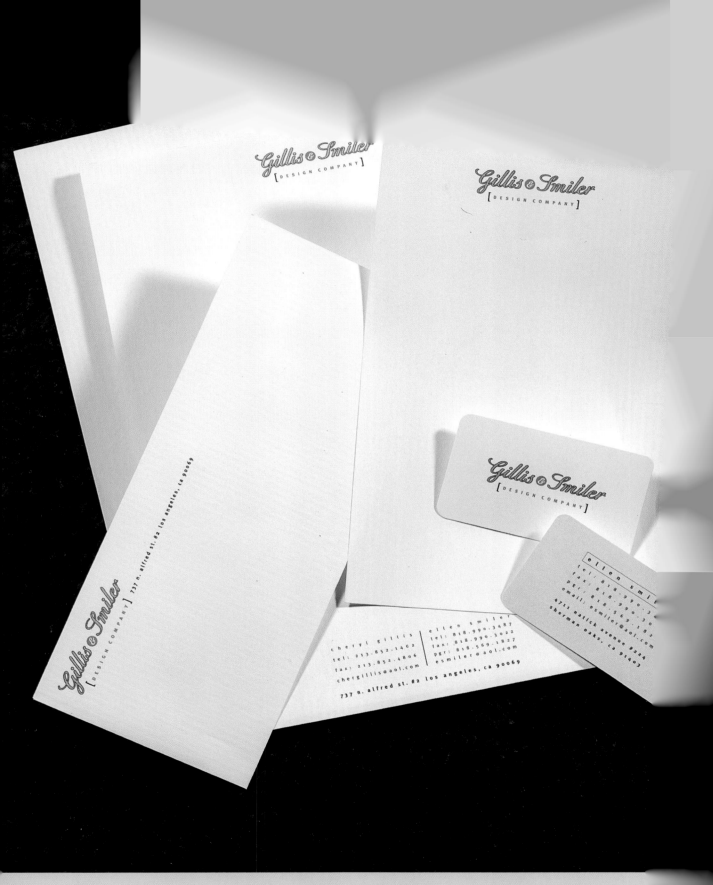

Gillis *&* Smiler
[DESIGN COMPANY]

cheryl gillis
tel: 213.852.1462
fax: 213.852.4806
chergillis@aol.com

ellen smiler
tel: 818.990.3487
fax: 818.990.3022
per: 818.569.1827
esmiler@aol.com

737 n. alfred st. #2 los angeles, ca 90069

ellen smi
tel: 818.990.3
fax: 818.990.30
per: 818.569.18
email: esmiler@aol.com
4711 natick avenue #224
sherman oaks, ca 91403

DESIGN FIRM │ GILLIS & SMILE
ART DIRECTORS/DESIGNERS │
 CHERYL GILLIS
CLIENT │ GILLIS & SMILER
PAPER/PRINTING │ NEENAH CL
 COLUMNS/THREE-COLOR

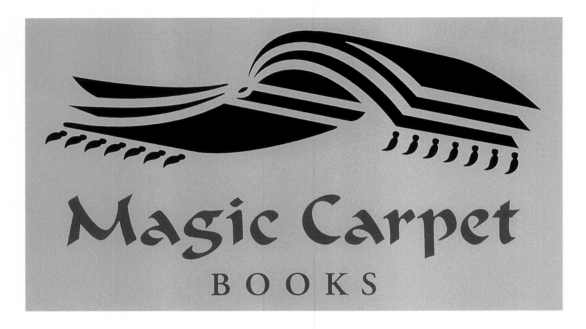

DESIGN FIRM | MIRES DESIGN
ART DIRECTOR | JOSÉ SERRANO
ILLUSTRATOR | TRACY SABIN
CLIENT | HARCOURT BRACE & COMPANY/MAGIC CARPET BOOKS
TOOLS | ADOBE ILLUSTRATOR

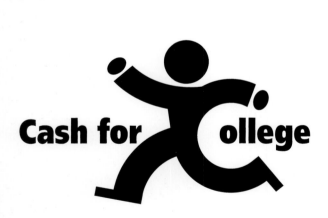

DESIGN FIRM | TIM NOONAN DESIGN
DESIGNER | TIM NOONAN
CLIENT | FIRSTAR BANK
TOOLS | ADOBE ILLUSTRATOR, QUARKXPRESS

DESIGN FIRM | MICHAEL STANARD DESIGN, INC.
ART DIRECTOR | MICHAEL STANARD
DESIGNERS | MICHAEL STANARD, KRISTY VANDEKERCKHOVE
ILLUSTRATOR | KRISTY VANDEKERCKHOVE
CLIENT | CITY OF EVANSTON
TOOLS | MACINTOSH, ADOBE ILLUSTRATOR

ALEXANDER & KIENAST

ARCHITECTURE &

INTERIOR DESIGN

A|K
ALEXANDER
KIENAST

12850 SPURLING, SUITE 290

DALLAS, TX 75230

P: 972.233.3506

F: 972.233.3525

A|K
ALEXANDER
KIENAST

ITE 290

DESIGN FIRM | SULLIVAN PERKINS
ART DIRECTOR/DESIGNER | MARCUS DICKERSON
CLIENT | ALEXANDER + KIENAST
TOOLS | MACINTOSH

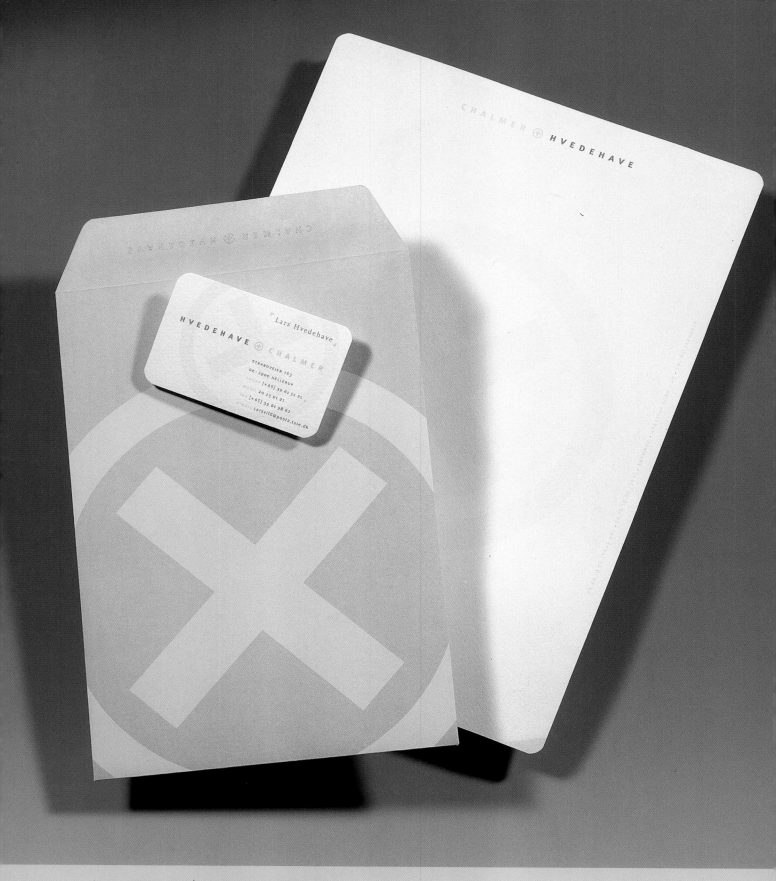

DESIGN FIRM | TRANSPARENT OFFICE

ART DIRECTOR/DESIGNER | VIBEKE NØDSKOV

CLIENT | CHALMER + HVEDEHAVE

TOOLS | QUARKXPRESS, ADOBE ILLUSTRATOR

PAPER/PRINTING | FAUNA RC 100G. IVORY/COLOR IT GREY

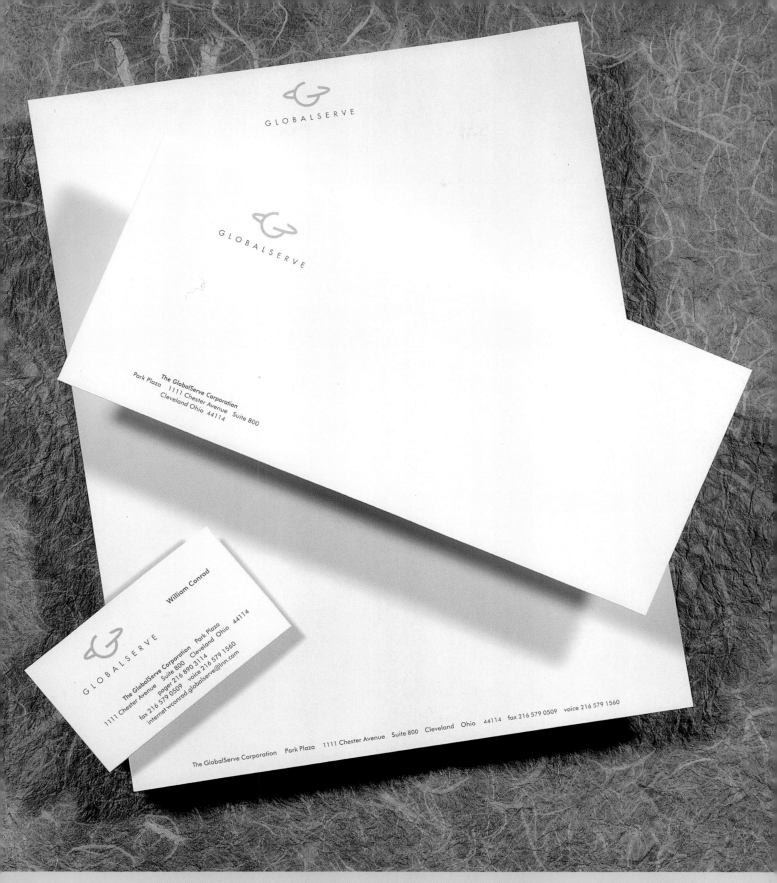

DESIGN FIRM | NESNADNY + SCHWARTZ

ALL DESIGN | GREGORY OZNOWICH

CLIENT | THE GLOBALSERVE CORPORATION

PAPER/PRINTING | MANADNOCK

STROLITE/HEXAGRAPHICS

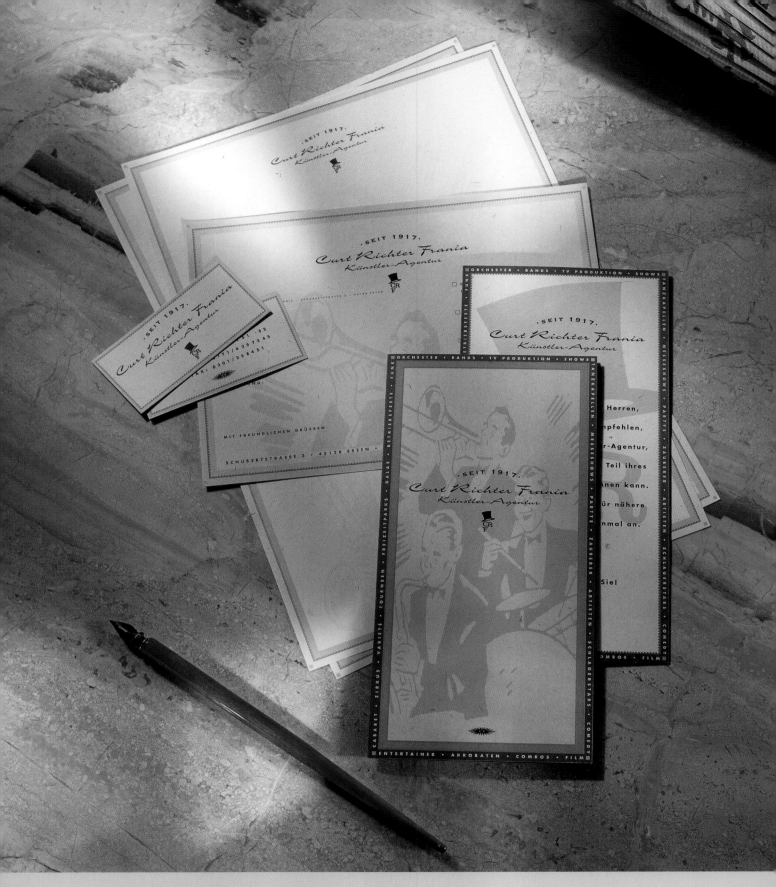

DESIGN FIRM | VOSS DESIGN

ART DIRECTOR/DESIGNER | AXEL VOSS

CLIENT | CURT RICHTER FANIA, ARTIST-AGENCY

PAPER/PRINTING | GMUND SILENCIUM

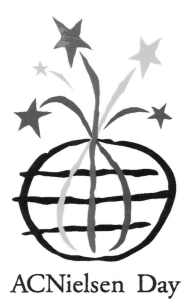

ACNielsen Day

DESIGN FIRM | WEBSTER DESIGN ASSOCIATES
ART DIRECTOR | DAVE WEBSTER
DESIGNER/ILLUSTRATOR | ANDREY NAGORNEY
CLIENT | ACNIELSEN
TOOLS | ADOBE ILLUSTRATOR

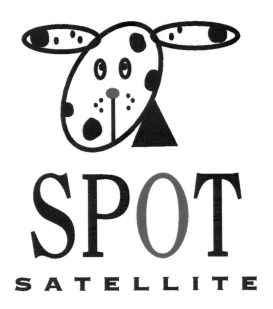

SPOT
SATELLITE

DESIGN FIRM | BARBARA BROWN MARKETING & DESIGN
ART DIRECTOR/DESIGNER | BARBARA BROWN
CLIENT | SPOT SATELLITE

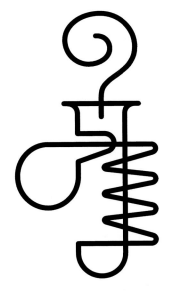

DESIGN FIRM | DESIGN CENTER
ART DIRECTOR | JOHN REGER
DESIGNER | SHERWIN SCHWARTZROCK
CLIENT | MCGINLEY ASSOCIATES
TOOLS | MACINTOSH

DESIGN FIRM | DOGSTAR
DESIGNER/ILLUSTRATOR | RODNEY DAVIDSON
CLIENT | MARK GOOCH PHOTOGRAPHY
TOOLS | ADOBE ILLUSTRATOR, STREAMLINE, MACROMEDIA FREEHAND

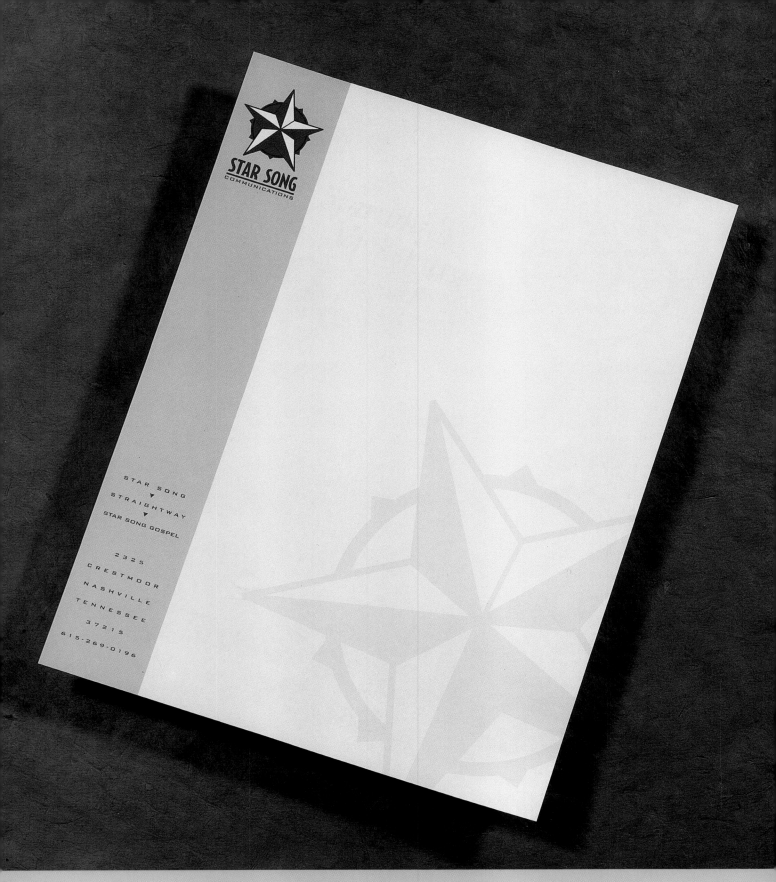

STAR SONG
▼
STRAIGHTWAY
▼
STAR SONG GOSPEL

2325
CRESTMOOR
NASHVILLE
TENNESSEE
37215
615-269-0196

STAR SONG
COMMUNICATIONS

DESIGN FIRM | AXIS DESIGN
ART DIRECTOR/DESIGNER | WILLIAM MILNAZIK
CLIENT | IMPACT TECHNOLOGY LTD.
PAPER/PRINTING | INKS: BLACK/PMS 123

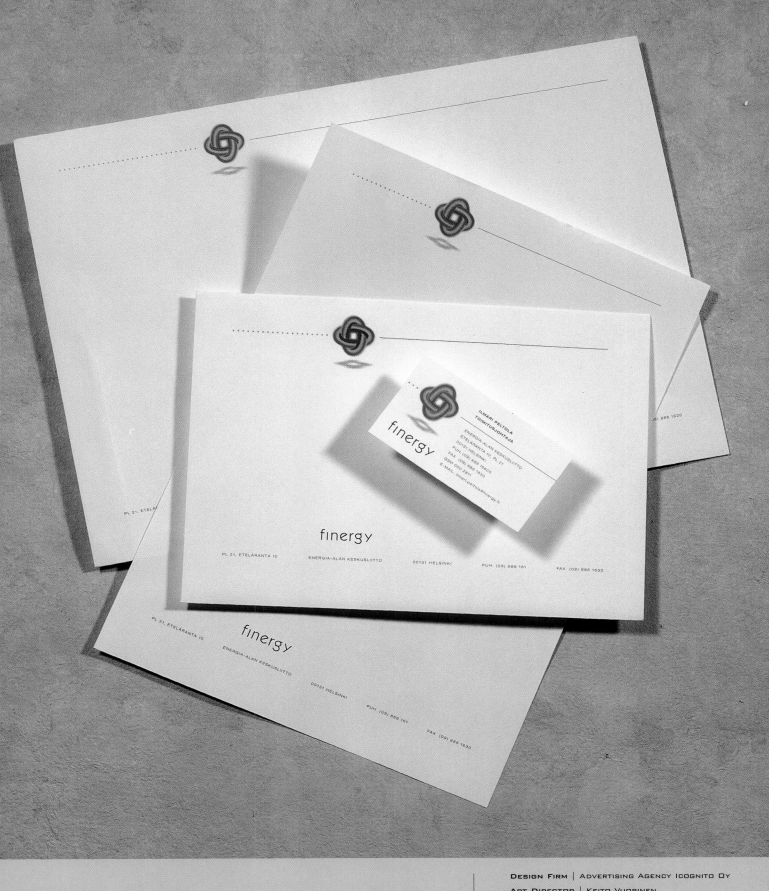

finergy

PL 21, ETELÄRANTA 10 ENERGIA-ALAN KESKUSLIITTO 00131 HELSINKI PUH. (09) 686 161 FAX (09) 686 1630

ILMARI PELTOLA
TOIMITUSJOHTAJA

ENERGIA-ALAN KESKUSLIITTO
ETELÄRANTA 10, PL 21
00131 HELSINKI
PUH. (09) 686 16605
FAX (09) 686 1630
GSM 050 2811
E-MAIL ilmari.peltola@finergy.fi

DESIGN FIRM | ADVERTISING AGENCY ICOGNITO OY
ART DIRECTOR | KEITO VUORINEN
DESIGNER | JP SILTANEN
ILLUSTRATOR | KEITO VUORINEN
CLIENT | ENERGIA-ALAN KESKUSLIITTO
TOOLS | MACROMEDIA FREEHAND, ADOBE PHOTOSHOP
PAPER/PRINTING | F. G. LÖNNBERG

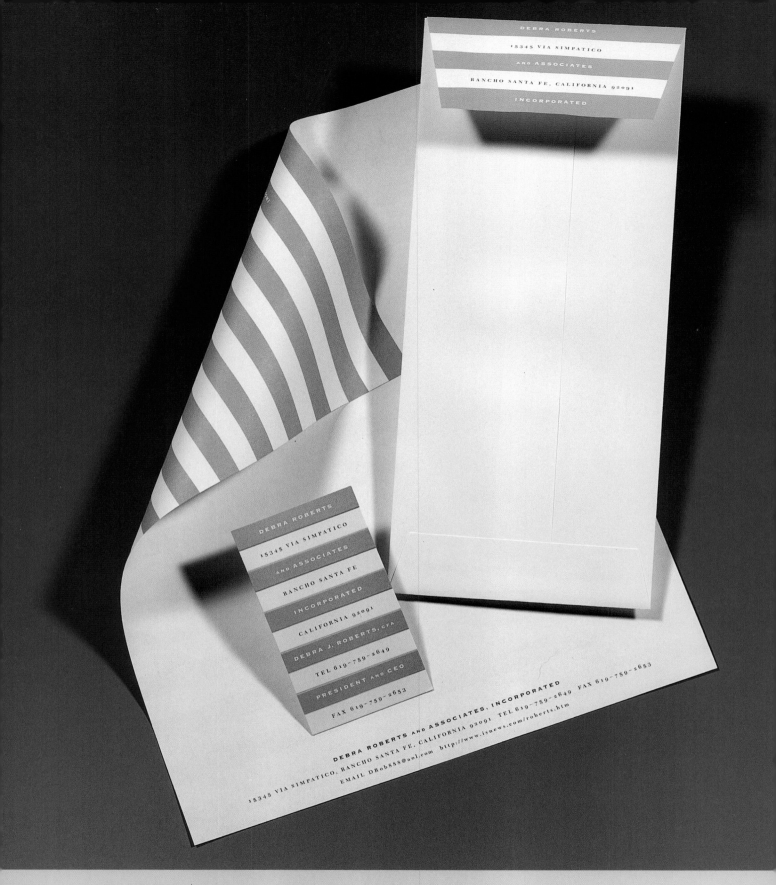

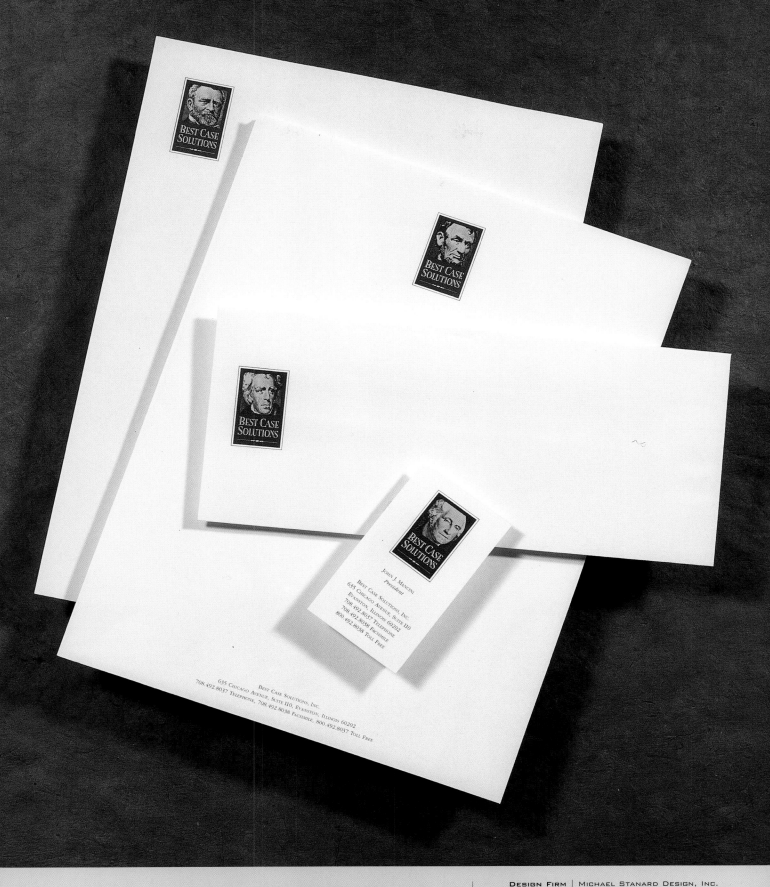

DESIGN FIRM | MICHAEL STANARD DESIGN, INC.

ART DIRECTOR | MICHAEL STANARD

DESIGNER | KRISTY VANDEKERCKHOVE

CLIENT | JOHN MANCINI

TOOLS | MACINTOSH, ADOBE ILLUSTRATOR

PAPER/PRINTING | STRATHMORE WRITING

DESIGN FIRM | JEFF FISHER LOGOMOTIVES
ALL DESIGN | JEFF FISHER
CLIENT | JEFF MAUL, HAIR STYLIST
TOOLS | MACROMEDIA FREEHAND

DESIGN FIRM | MACVICAR DESIGN & COMMUNICATIONS
ALL DESIGN | WILLIAM A. GORDON
CLIENT | FEDERAL DATA CORPORATION
TOOLS | PEN, INK; ADOBE ILLUSTRATOR

Vladimir Svoysky

DESIGN FIRM | CECILY ROBERTS DESIGN
ALL DESIGN | CECILY ROBERTS
CLIENT | VLADIMIR SVOYSKY
TOOLS | MACROMEDIA FREEHAND, QUARKXPRESS
PAPER/PRINTING | 80 LB. COVER ESSE, WHITE SMOOTH

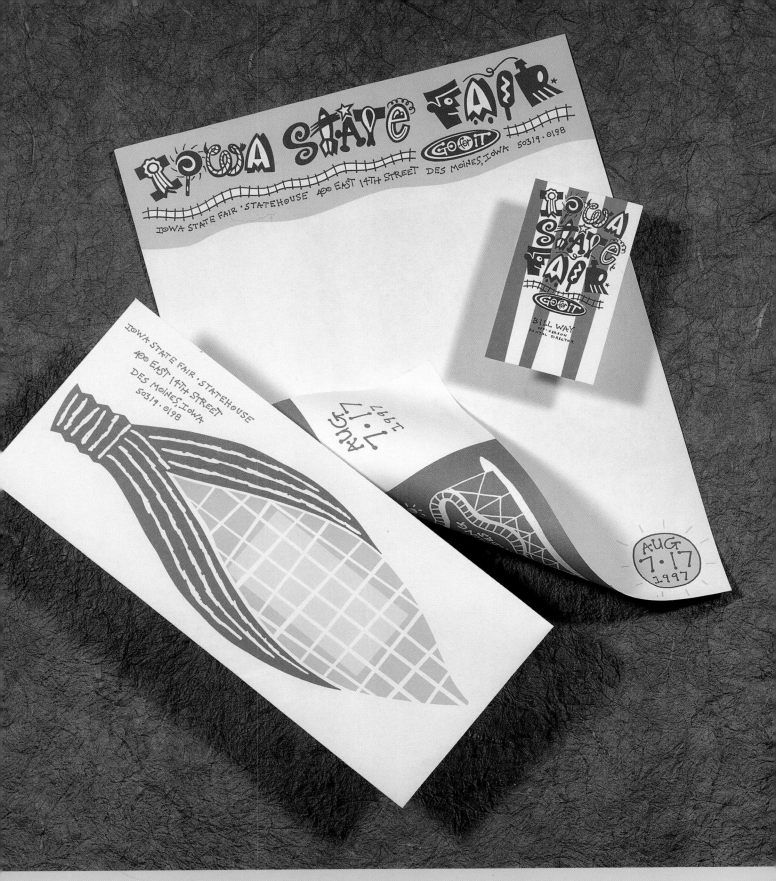

DESIGN FIRM | SAYLES GRAPHIC DESIGN
ART DIRECTOR/ILLUSTRATOR | JOHN SAYLES
DESIGNER | JOHN SAYLES, JENNIFER ELLIOTT
CLIENT | IOWA STATE FAIR

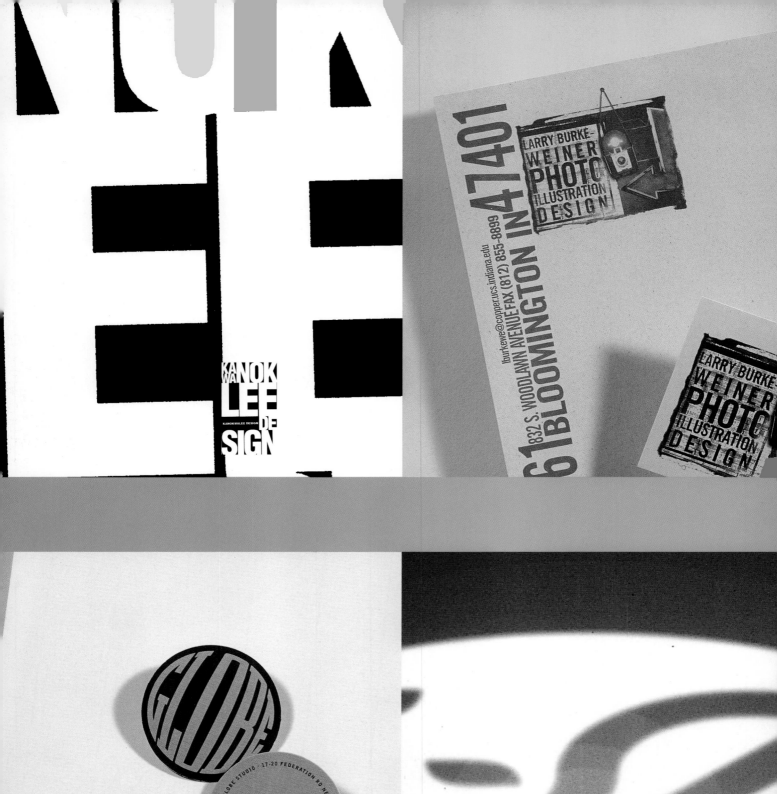

KANOK
WAN
LEE
DE
SIGN

KANOKWALEE DESIGN

LARRY BURKE-
WEINER
PHOTO
ILLUSTRATION
DESIGN

lburkewe@copper.ucs.indiana.edu
FAX (812) 855-8899
832 S. WOODLAWN AVENUE
61 BLOOMINGTON IN 47401

LARRY BURKE-
WEINER
PHOTO
ILLUSTRATION
DESIGN

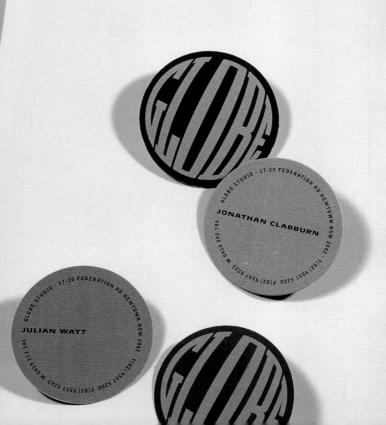

GLOBE STUDIO · 17-20 FEDERATION RD NEWTOWN NSW 2042
JONATHAN CLABBURN
M 0414 242 740 · [02] 9557 5200 · F [02] 9557 5223

GLOBE STUDIO · 17-20 FEDERATION RD NEWTOWN NSW 2042
JULIAN WATT
M 0419 212 706 · [02] 9557 5200 · F [02] 9557 5223

ground zero
interactive

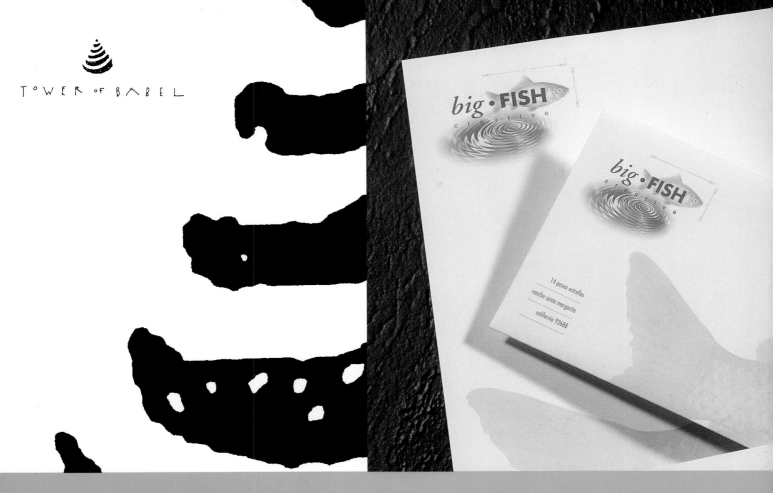

TOWER OF BABEL

big·FISH
creative

14 paseo estrellas
rancho santa margarita
california 92688

CREATIVE SERVICES

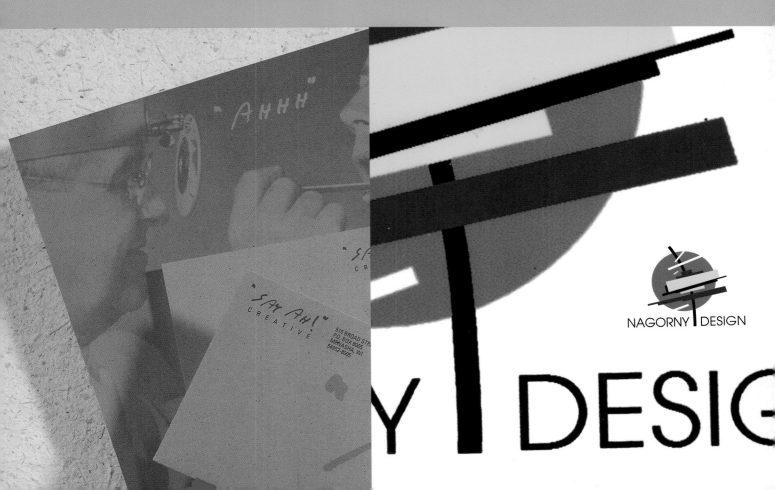

"AHHH"

"SAY AH!"
CREATIVE

515 BROAD STR.
P.O. BOX 8005
MENASHA, WI
54952-8005

NAGORNY DESIGN

Y DESIG

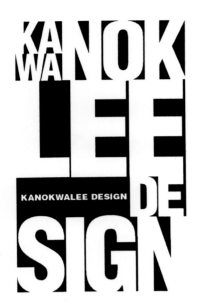

DESIGN FIRM | Kanokwalee Design
ART DIRECTOR/DESIGNER | Kanokwalee Lee
CLIENT | Kanokwalee Design
TOOLS | Adobe Illustrator, QuarkXPress

DESIGN FIRM | Get Smart Design Company
DESIGNER/ILLUSTRATOR | Tom Culbertson
CLIENT | Jody Vanderah/"V" Man
TOOLS | Macromedia FreeHand

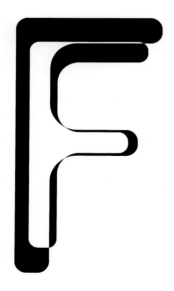

DESIGN FIRM | Fordesign
ALL DESIGN | Frank Ford
CLIENT | Fordesign
TOOLS | Adobe Illustrator

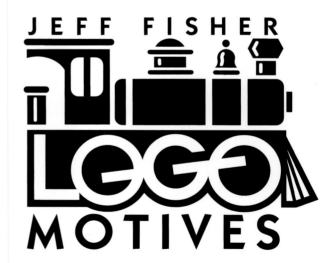

DESIGN FIRM | Jeff Fisher Logomotives
ALL DESIGN | Jeff Fisher
CLIENT | Logomotives
TOOLS | Macromedia FreeHand

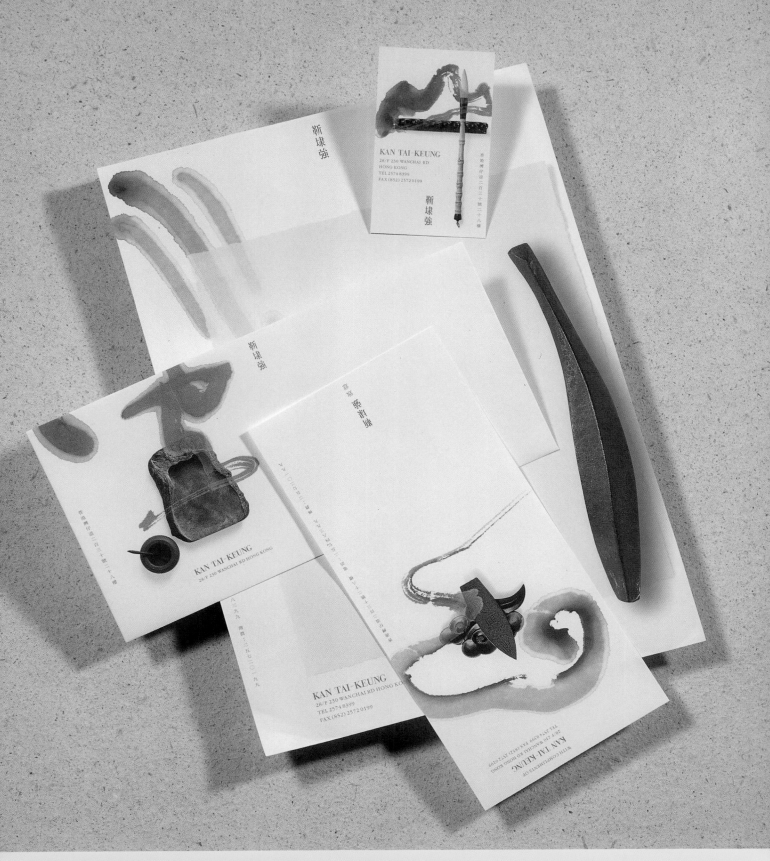

DESIGN FIRM | KAN & LAU DESIGN CONSULTANTS

ART DIRECTOR/DESIGNER | KAN TAI-KEUNG

CLIENT | KAN TAI-KEUNG

TOOLS | NAME CARD: CONQUEROR DIAMOND WHITE
CX22 250GSM; LETTERHEAD: CONQUEROR
DIAMOND WHITE CX22 100GSM; ENVELOPE:
CONQUEROR HIGHWHITE WOVE 100GSM/OFFSET

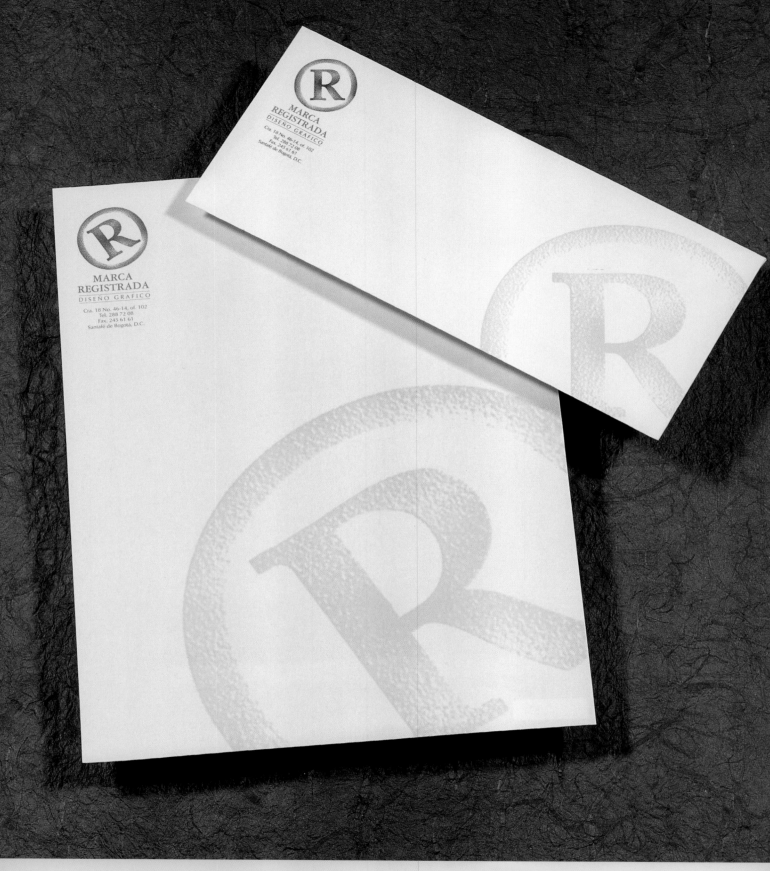

DESIGN FIRM | Marca Registrada Diseño Grafico

ART DIRECTOR | Iván Correa

DESIGNER | Martha Cadena

ILLUSTRATOR | Henry González

CLIENT | Marca Registrada Diseño Grafico

TOOLS | Adobe Photoshop, Macintosh

PAPER/PRINTING | Ediciones Antropos (Torreón Offset)

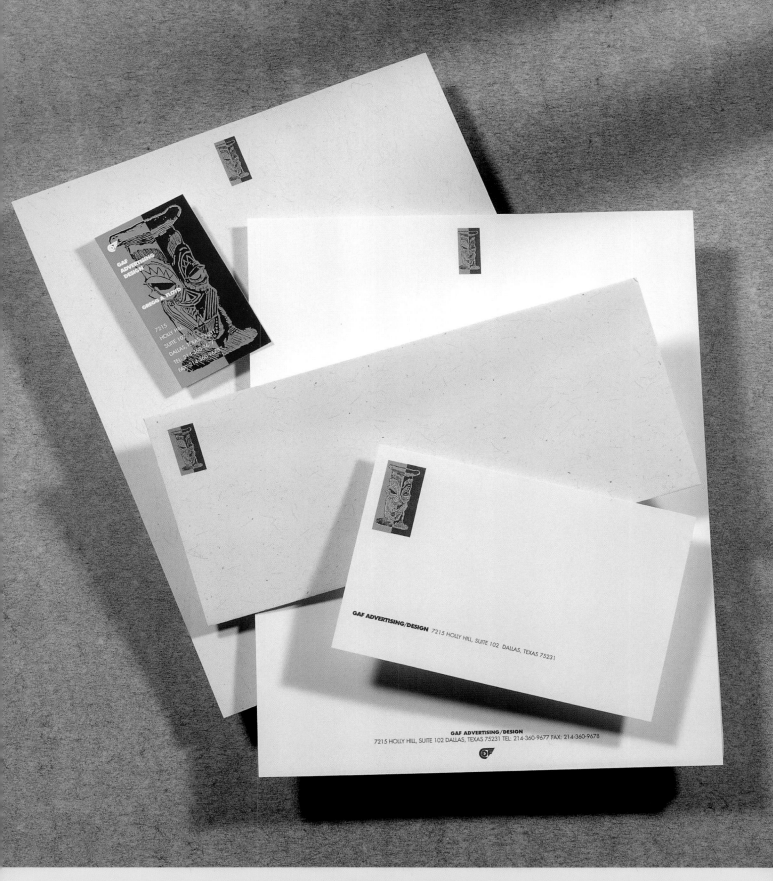

GAF
ADVERTISING
DESIGN

GREGG A. FLOYD

7215
HOLLY HILL
SUITE 102
DALLAS, TEXAS 75231
TEL 214-360-9677
FAX 214-360-9678

GAF ADVERTISING/DESIGN 7215 HOLLY HILL, SUITE 102 DALLAS, TEXAS 75231

GAF ADVERTISING/DESIGN
7215 HOLLY HILL, SUITE 102 DALLAS, TEXAS 75231 TEL: 214-360-9677 FAX: 214-360-9678

DESIGN FIRM │ GAF ADVERTISING DESIGN
ALL DESIGN │ GREGG A. FLOYD
CLIENT │ GAF ADVERTISING DESIGN
TOOLS │ WOODCUT, QUARKXPRESS
PAPER/PRINTING │ CONCRET/TWO COLOR SPOT LITHO

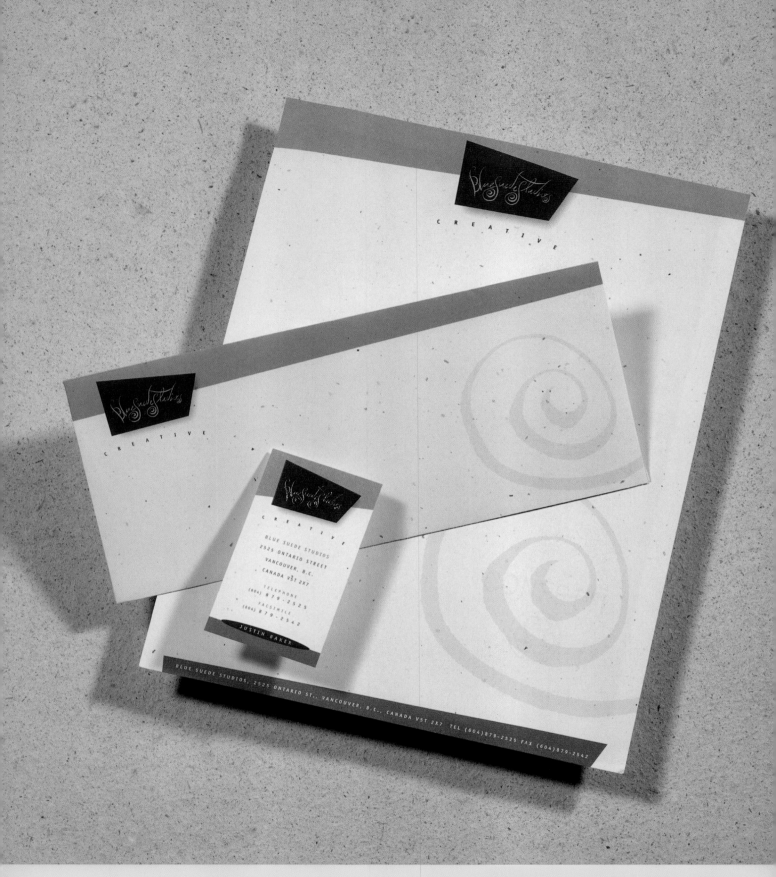

DESIGN FIRM | BLUE SUEDE STUDIOS

ART DIRECTOR | DAVE KENNEDY

DESIGNER/ILLUSTRATOR | JUSTIN BAKER

CLIENT | BLUE SUEDE STUDIOS

PAPER/PRINTING | CONFETTI/ULTRATECH PRINTERS

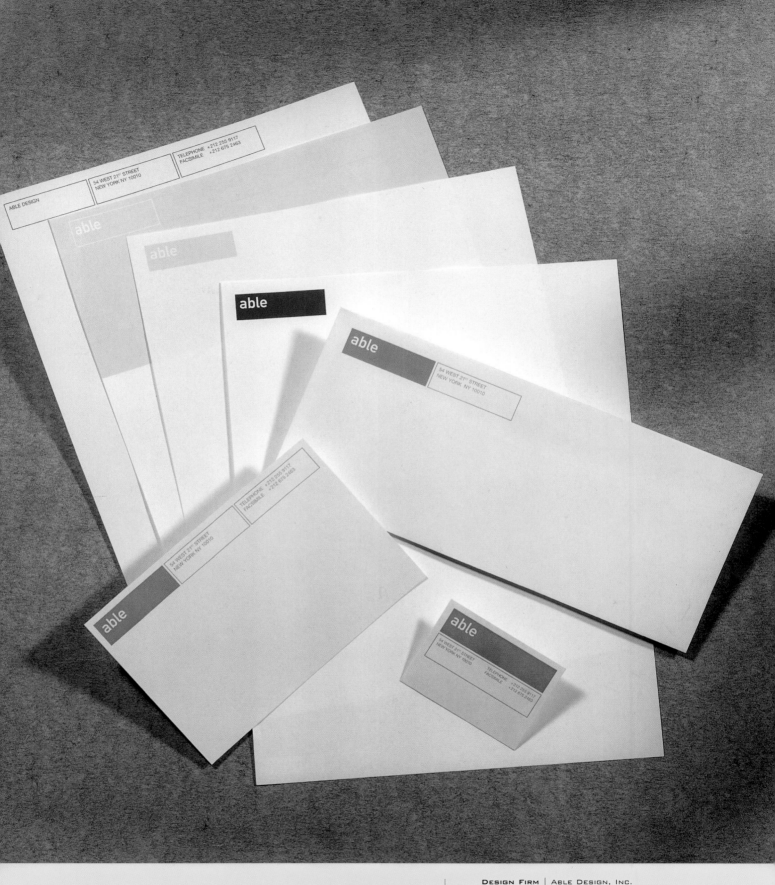

DESIGN FIRM | ABLE DESIGN, INC.

ART DIRECTORS | STUART HARVEY LEE, MARTHA DAVIS

DESIGNER | MARTIN PERRIN

CLIENT | ABLE DESIGN, INC.

TOOLS | POWER MACINTOSH, QUARKXPRESS

PAPER/PRINTING | BECKETT EXPRESSION, ICEBERG, 24 LB.

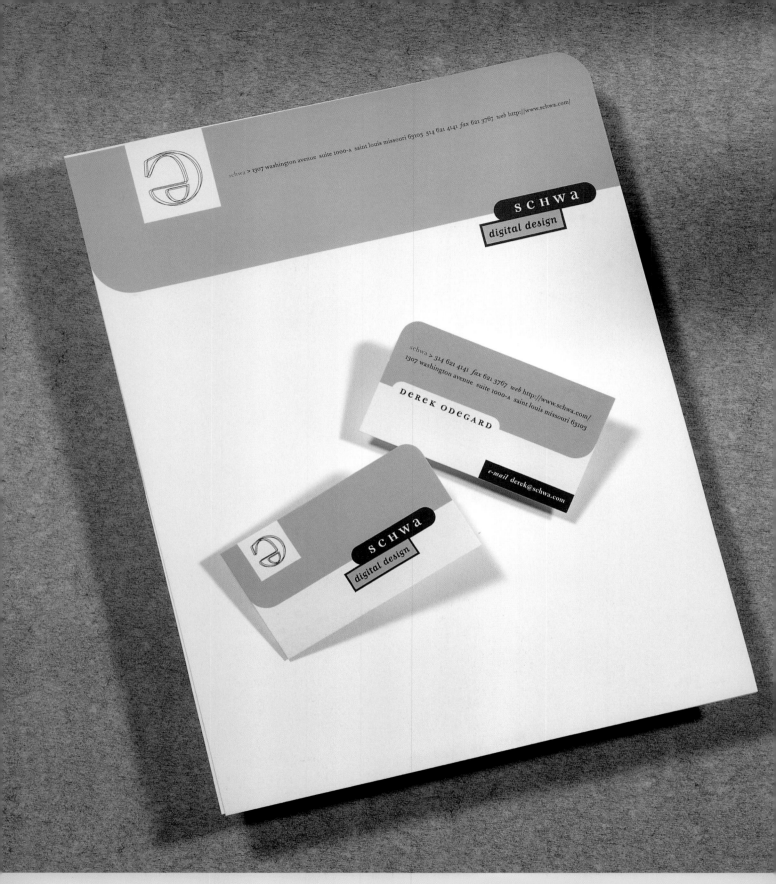

DESIGN FIRM | PHOENIX CREATIVE

ART DIRECTOR | ERIC THOELKE

DESIGNERS/ILLUSTRATORS | ERIC THOELKE, STEVE WIENKE

CLIENT | SCHWA DIGITAL DESIGN

TOOLS | ADOBE ILLUSTRATOR, QUARKXPRESS

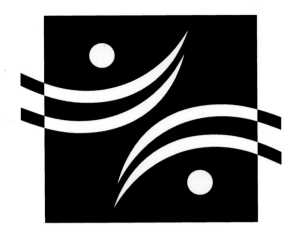

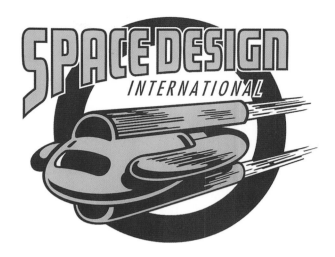

DESIGN FIRM | STEWART MONDERER DESIGN, INC.
ART DIRECTOR | STEWART MONDERER
DESIGNERS | AIME LECUSAY, STEWART MONDERER
ILLUSTRATOR | AIME LECUSAY
CLIENT | CORPORATE COMMUNICATIONS, INC.
TOOLS | ADOBE ILLUSTRATOR

DESIGN FIRM | SPACE DESIGN INTERNATIONAL
ALL DESIGN | TIM A. FRAME
CLIENT | SPACE DESIGN INTERNATIONAL
TOOLS | ADOBE ILLUSTRATOR

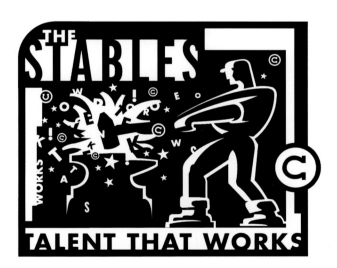

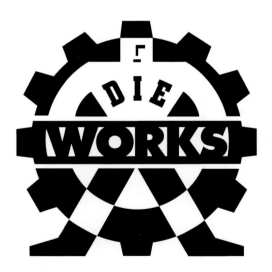

DESIGN FIRM | INSIGHT DESIGN COMMUNICATIONS
ALL DESIGN | SHERRIE HOLDEMAN, TRACY HOLDEMAN
CLIENT | THE STABLES
TOOLS | POWER MACINTOSH, MACROMEDIA FREEHAND

DESIGN FIRM | WEBSTER DESIGN ASSOCIATES
ART DIRECTOR | DAVE WEBSTER
DESIGNER/ILLUSTRATOR | ANDREY NAGORNY
CLIENT | DIE WORKS
TOOLS | MACROMEDIA FREEHAND

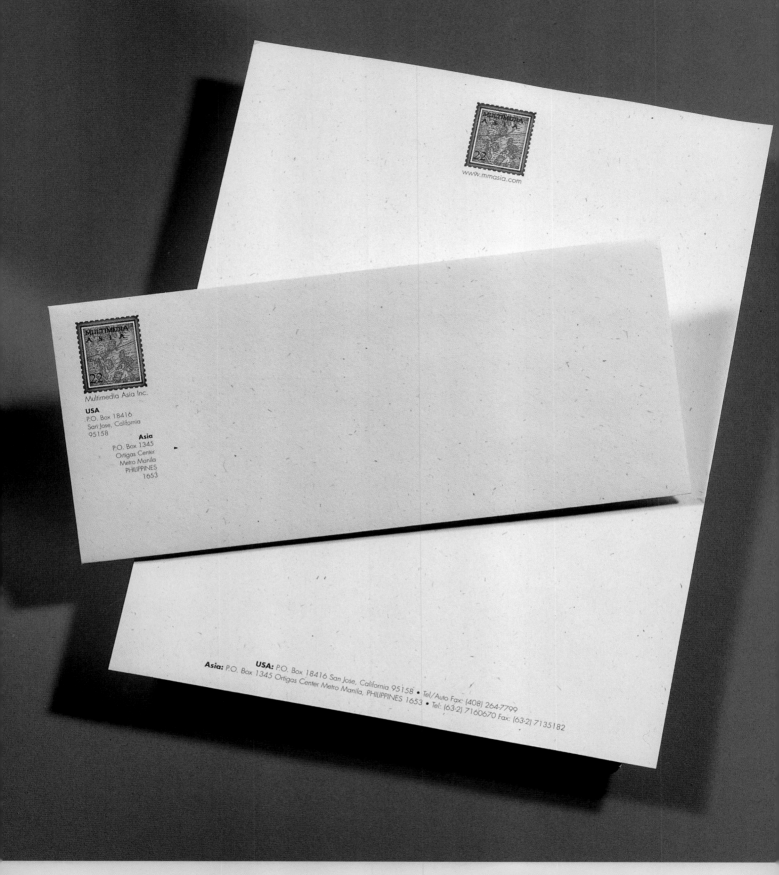

DESIGN FIRM | MULTIMEDIA ASIA, INC.

ART DIRECTOR | G. LEE

CLIENT | MULTIMEDIA ASIA,INC.

TOOLS | ADOBE PAGEMAKER

PAPER/PRINTING | 80 LB. MILKWEED GENESIS

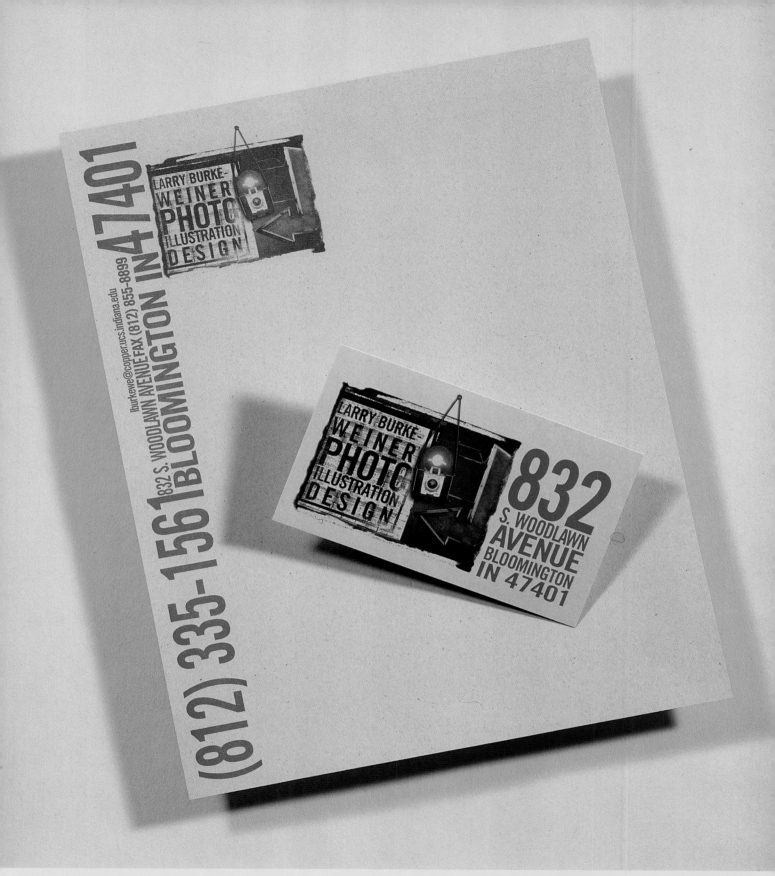

DESIGN FIRM | LARRY BURKE-WEINER DESIGN

ALL DESIGN | LARRY BURKE-WEINER

CLIENT | LARRY BURKE-WEINER

TOOLS | ADOBE PHOTOSHOP, PAINTER,

ADOBE ILLUSTRATOR, QUARKXPRESS

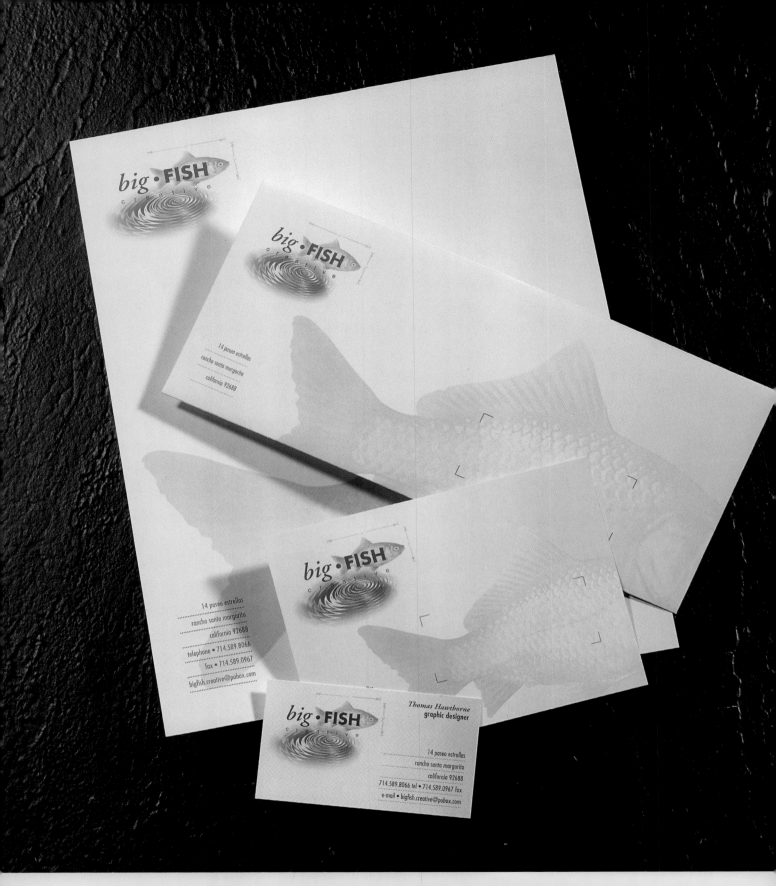

DESIGN FIRM | BIG FISH CREATIVE

ALL DESIGN | THOMAS HAWTHORNE

CLIENT | BIG FISH CREATIVE

TOOLS | QUARKXPRESS, ADOBE PHOTOSHOP, MACINTOSH

PAPER/PRINTING | STRATHMORE ELEMENTS

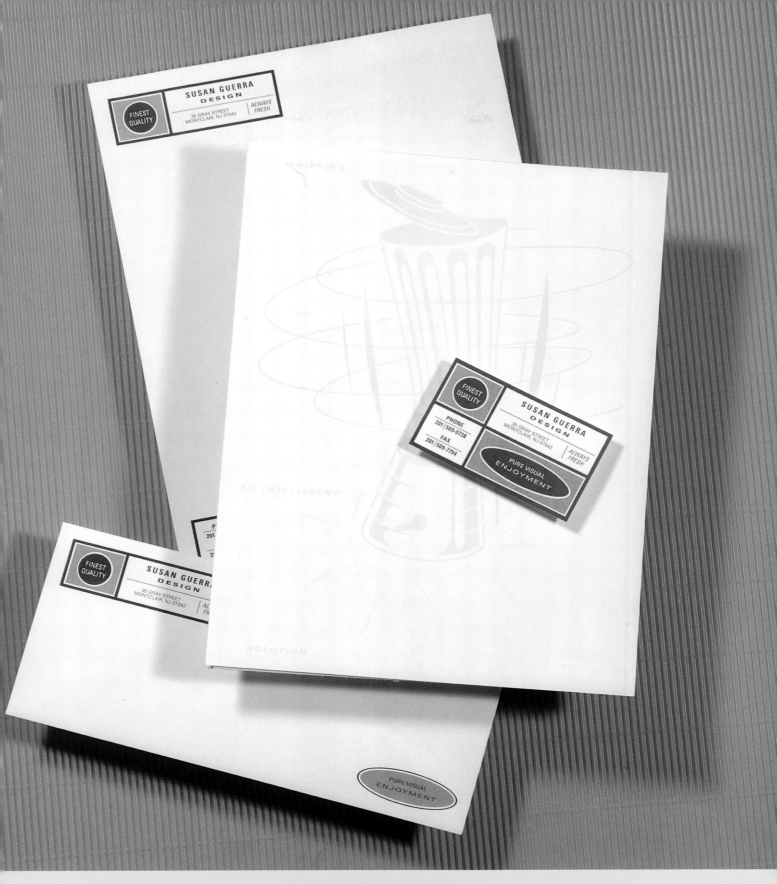

DESIGN FIRM | SUSAN GUERRA DESIGN

ART DIRECTOR/DESIGNER | SUSAN GUERRA

ILLUSTRATOR | METAL STUDIOS CLIP ART

CLIENT | SUSAN GUERRA DESIGN

TOOLS | QUARKXPRESS, ADOBE ILLUSTRATOR

PAPER/PRINTING | CLASSIC CREST/TWO COLOR

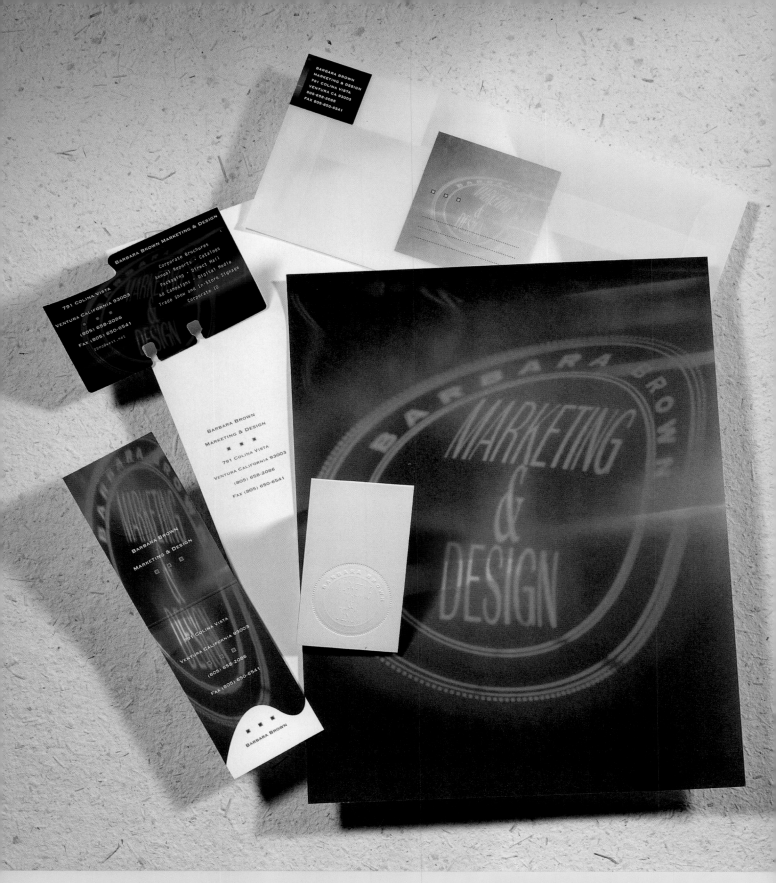

DESIGN FIRM | BARBARA BROWN MARKETING & DESIGN

ART DIRECTOR | BARBARA BROWN

DESIGNER | LANA CURTIN, PRODUCTION ARTIST

PHOTOGRAPHER | SCHAF PHOTO

CLIENT | BARBARA BROWN MARKETING & DESIGN

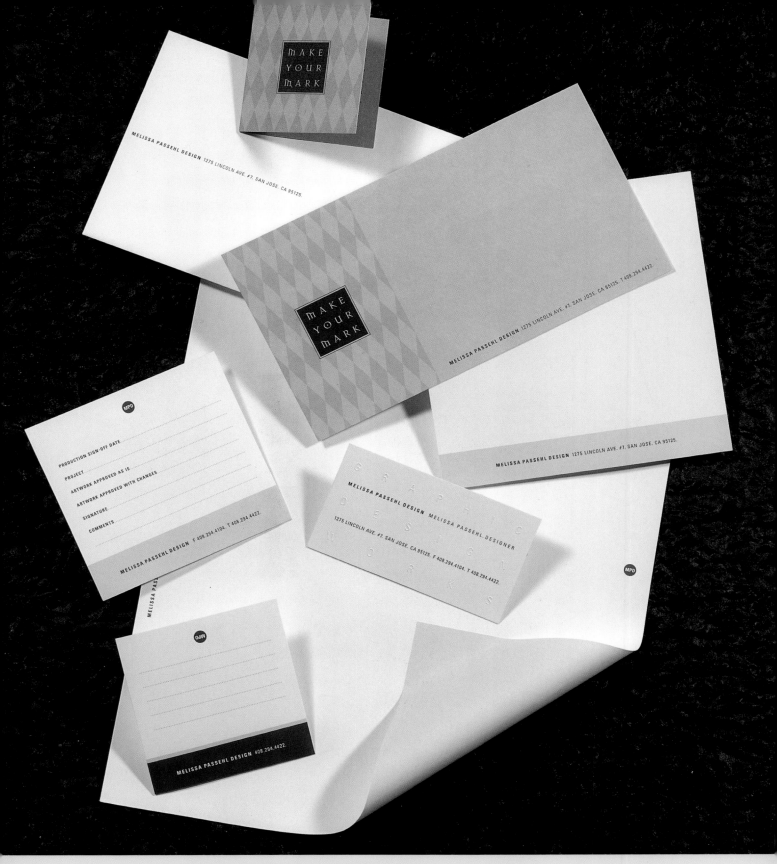

DESIGN FIRM | MELISSA PASSEHL DESIGN
ART DIRECTOR | MELISSA PASSEHL
DESIGNERS | MELISSA PASSEHL, CHARLOTTE LAMBRECHTS
CLIENT | MELISSA PASSEHL DESIGN

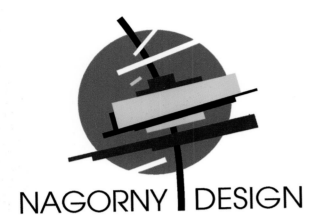

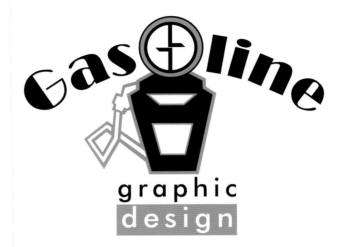

DESIGN FIRM | NAGORNY DESIGN
ALL DESIGN | ANDREY NAGORNY
CLIENT | NAGORNY DESIGN
TOOLS | MACROMEDIA FREEHAND

DESIGN FIRM | GASOLINE GRAPHIC DESIGN
ART DIRECTORS | ANGELINE BECKLEY, ZANE VREDENBURG
DESIGNERS | ZANE VREDENBURG, ANGELINE BECKLEY
CLIENT | GASOLINE GRAPHIC DESIGN
TOOLS | ADOBE ILLUSTRATOR

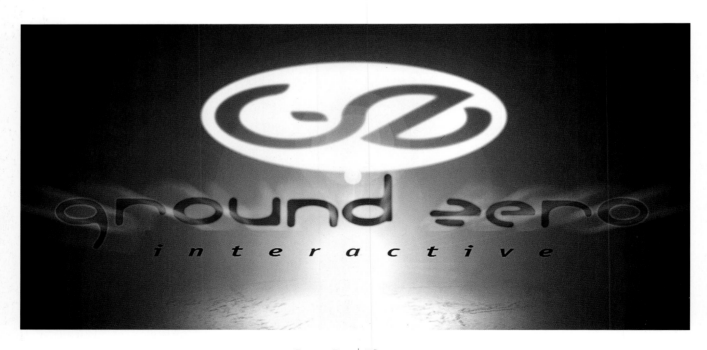

DESIGN FIRM | MÖBIUS
ALL DESIGN | CHIP TAYLOR
CLIENT | GROUND ZERO INTERACTIVE
TOOLS | MACINTOSH, ADOBE PHOTOSHOP, ADOBE ILLUSTRATOR

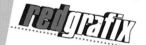

19750 West Observatory Rd.

New Berlin, WI 53146-3420

Voice (414) 542-5547

Fax (414) 542-5322

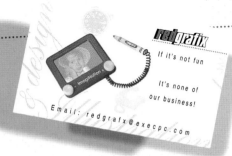

redgrafix

If it's not fun

It's none of

our business!

Email: redgrafx@execpc.com

redgrafix

19750 West Observatory Rd.

New Berlin, WI 53146-3420

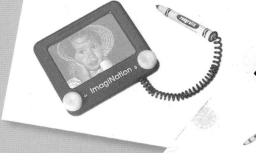

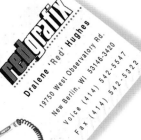

redgrafix

Dralene 'Red' Hughes

19750 West Observatory Rd.
New Berlin, WI 53146-3420
Voice (414) 542-5547
Fax (414) 542-5322

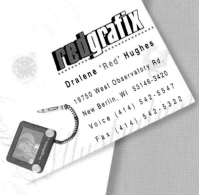

redgrafix

Dralene 'Red' Hughes

19750 West Observatory Rd.
New Berlin, WI 53146-3420
Voice (414) 542-5547
Fax (414) 542-5322

DESIGN FIRM | REDGRAFIX DESIGN & ILLUSTRATION
ALL DESIGN | DRALENE "RED" HUGHES
CLIENT | REDGRAFIX DESIGN & ILLUSTRATION
TOOLS | ADOBE PHOTOSHOP, ADOBE ILLUSTRATOR,
QUARKXPRESS
PAPER/PRINTING | STRATHMORE ELEMENTS
WHITE/FOUR COLOR, TI PRINTING

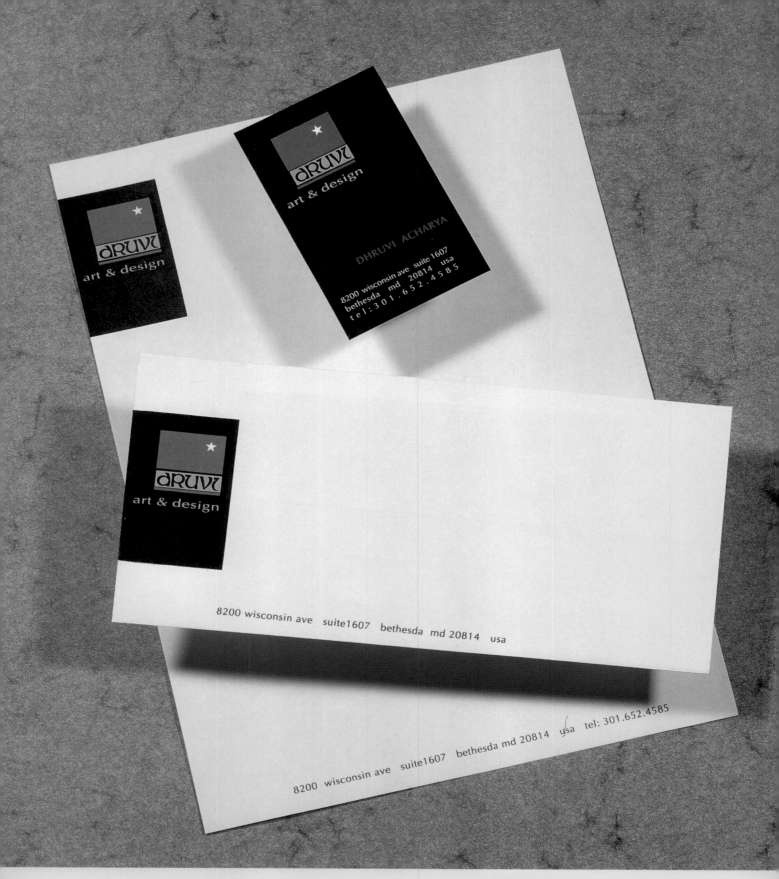

DESIGN FIRM | DRUVI ART AND DESIGN

ALL DESIGN | DRUVI ACHARYA

CLIENT | DRUVI ART AND DESIGN

PAPER/PRINTING | 80/100 LBS. CARD STOCK,
 BOND PAPER/SCREENPRINTING

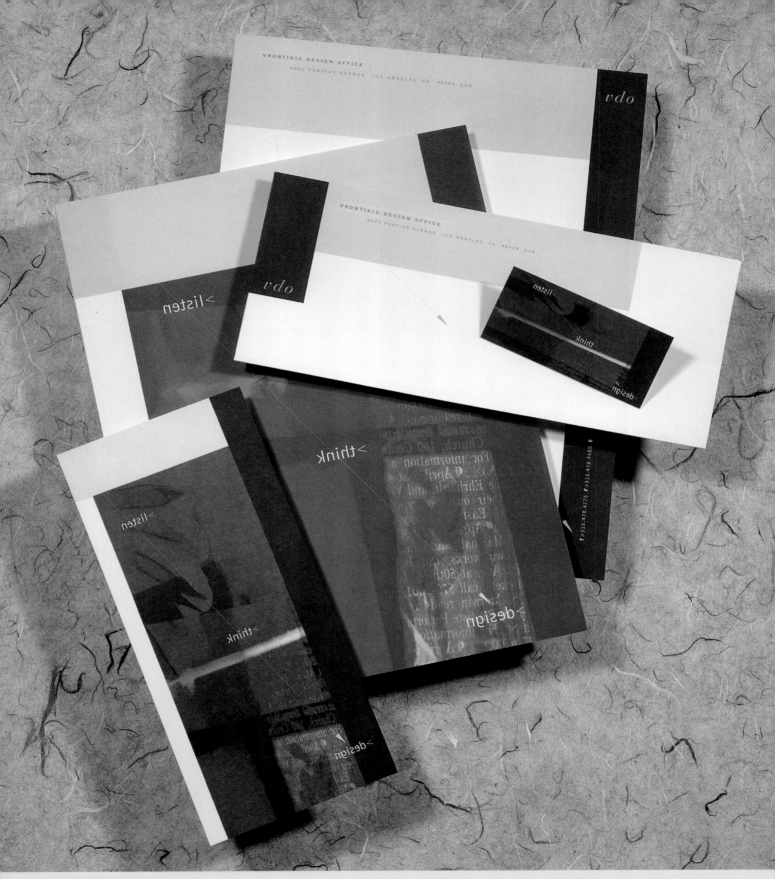

DESIGN FIRM | VRONTIKIS DESIGN OFFICE

ART DIRECTOR/DESIGNER | PETRULA VRONTIKIS

CLIENT | VRONTIKIS DESIGN OFFICE

TOOLS | QuarkXPress, Adobe Photoshop

PAPER/PRINTING | Neenah Classic Crest/Login Printing

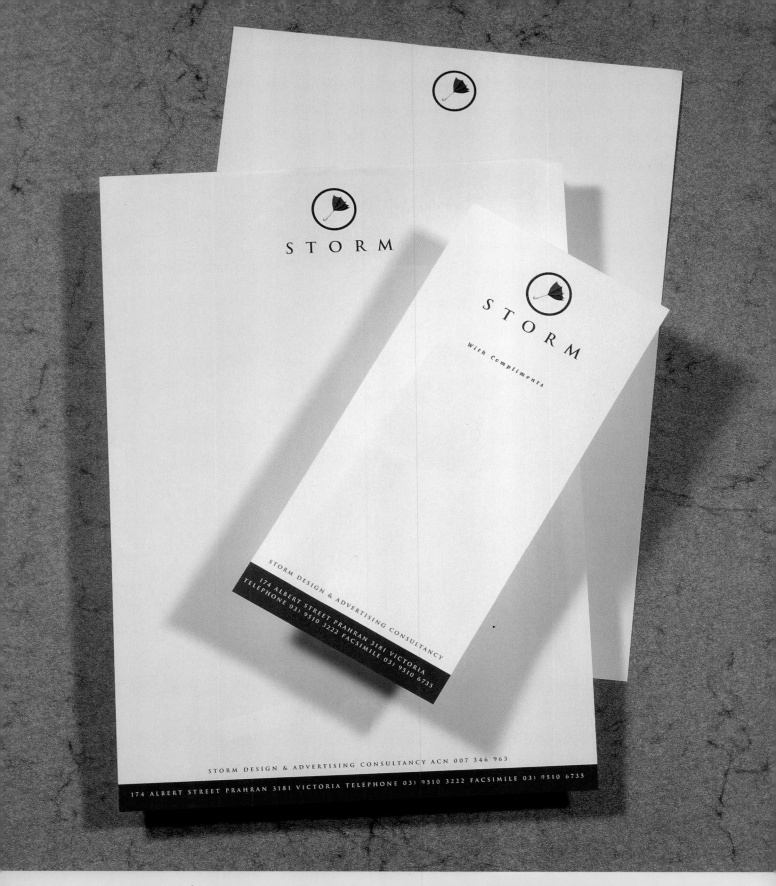

DESIGN FIRM | STORM DESIGN & ADVERTISING CONSULTANCY

ART DIRECTORS/DESIGNERS | DAVID ANSETT, DEAN BUTLER, JULIA JARVIS

PHOTOGRAPHER | MARCUS STRUZINA

CLIENT | STORM DESIGN & ADVERTISING CONSULTANCY

TOOLS | ADOBE PHOTOSHOP

PAPER/PRINTING | SAXTON SMOOTHE/FOUR COLOR PROCESS PLUS ONE

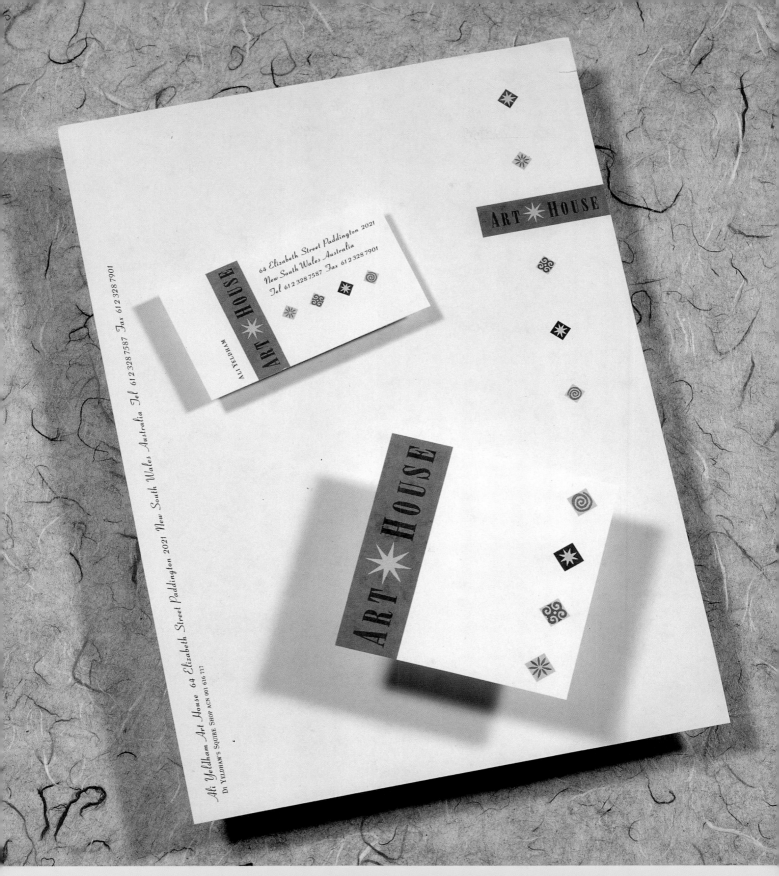

DESIGN FIRM | MOTHER GRAPHIC DESIGN

ALL DESIGN | KRISTIN THIEME

CLIENT | ART HOUSE

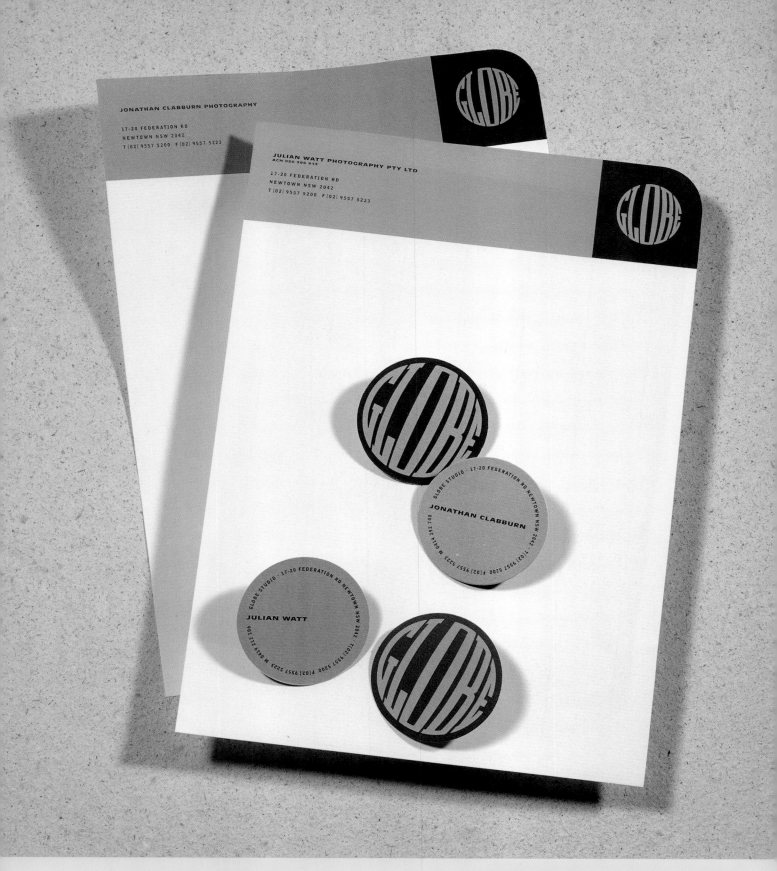

JONATHAN CLABBURN PHOTOGRAPHY

17-20 FEDERATION RD
NEWTOWN NSW 2042
T (02) 9557 5200 F (02) 9557 5223

JULIAN WATT PHOTOGRAPHY PTY LTD
ACN 050 596 813

17-20 FEDERATION RD
NEWTOWN NSW 2042
T (02) 9557 5200 F (02) 9557 5223

GLOBE STUDIO · 17-20 FEDERATION RD NEWTOWN NSW 2042

JONATHAN CLABBURN

GLOBE STUDIO · 17-20 FEDERATION RD NEWTOWN NSW 2042

JULIAN WATT

DESIGN FIRM | MOTHER GRAPHIC DESIGN
ART DIRECTOR/DESIGNER | KRISTIN THIEME
CLIENT | GLOBE STUDIO

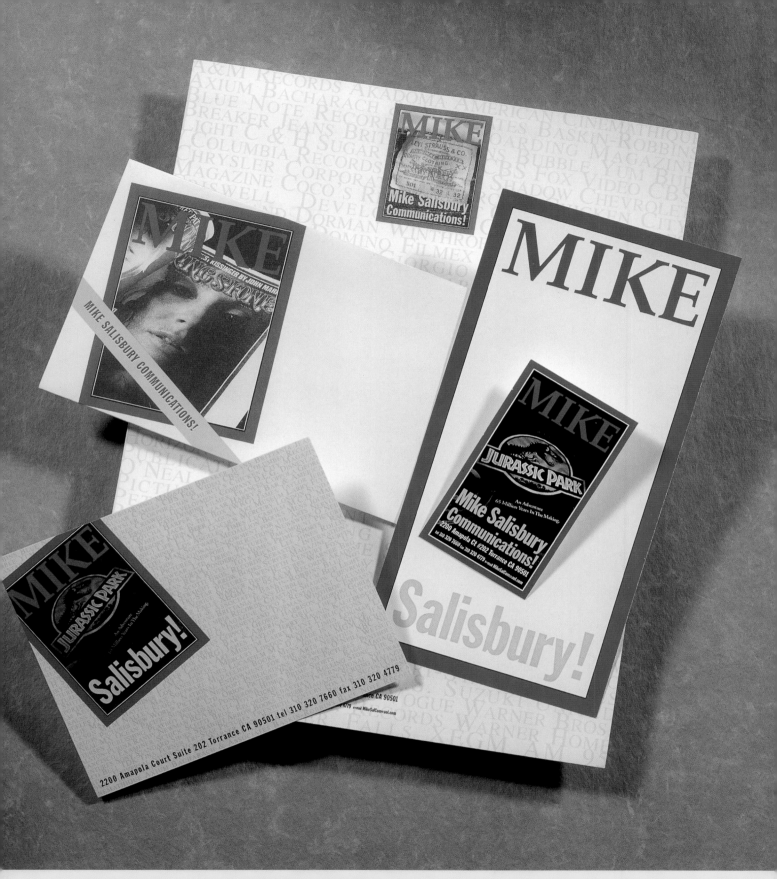

DESIGN FIRM | MIKE SALISBURY COMMUNICATIONS, INC.
ART DIRECTOR | MIKE SALISBURY
DESIGNER | MARY EVELYN MCGOUGH
CLIENT | MIKE SALISBURY COMMUNICATIONS

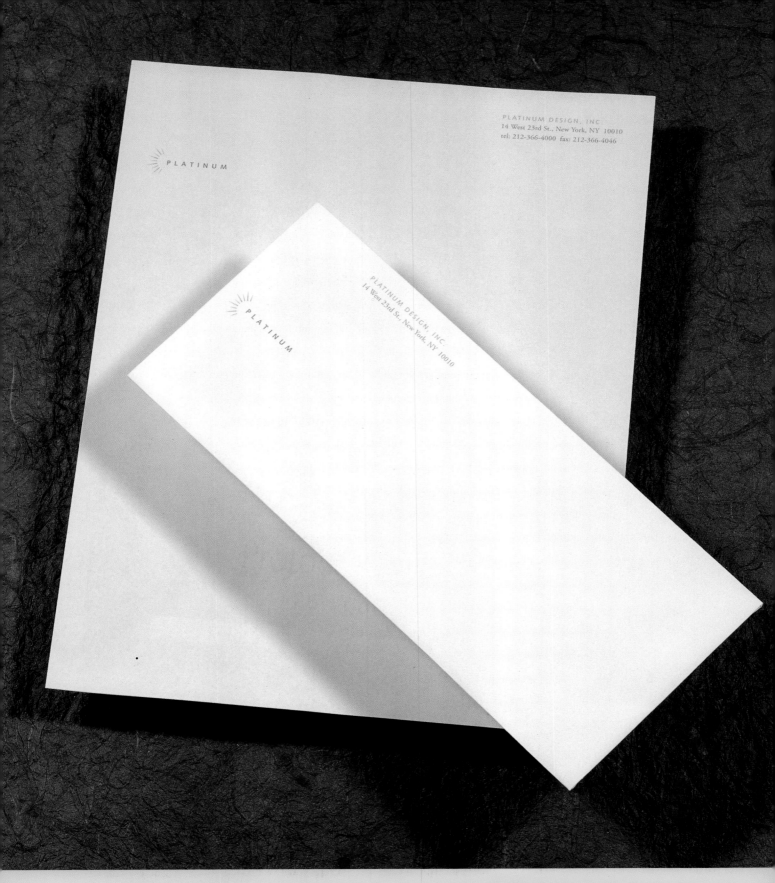

DESIGN FIRM | PLATINUM DESIGN, INC.

ART DIRECTOR/DESIGNER | VICTORIA STAMM

CLIENT | PLATINUM DESIGN, INC.

TOOLS | POWER MACINTOSH 8100

PAPER/PRINTING | CLR/STARWHITE VICKSBURG

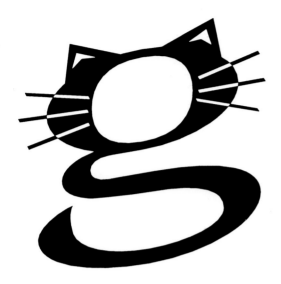

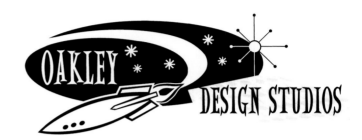

DESIGN FIRM | GRAY CAT DESIGN
DESIGNER | LISA SCALISE
CLIENT | GRAY CAT DESIGN
PAPER/PRINTING | MOHAWK SUPERFINE/LAKE PRINTERS

DESIGN FIRM | OAKLEY DESIGN STUDIOS
ALL DESIGN | TIM OAKLEY
CLIENT | OAKLEY DESIGN STUDIOS
TOOLS | ADOBE ILLUSTRATOR

JUICE

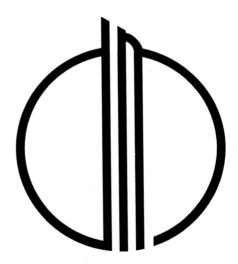

DESIGN FIRM | JUICE DESIGN
ART DIRECTOR | BRETT M. CRITCHLOW
DESIGNERS | BRETT M. CRITCHLOW, MATT SMIALEK, MIMI PAJO
CLIENT | JUICE DESIGN

DESIGN FIRM | MALIK DESIGN
ALL DESIGN | DONNA MALIK
CLIENT | MALIK DESIGN
TOOLS | MACROMEDIA FREEHAND
PAPER/PRINTING | STRATHMORE RENEWAL

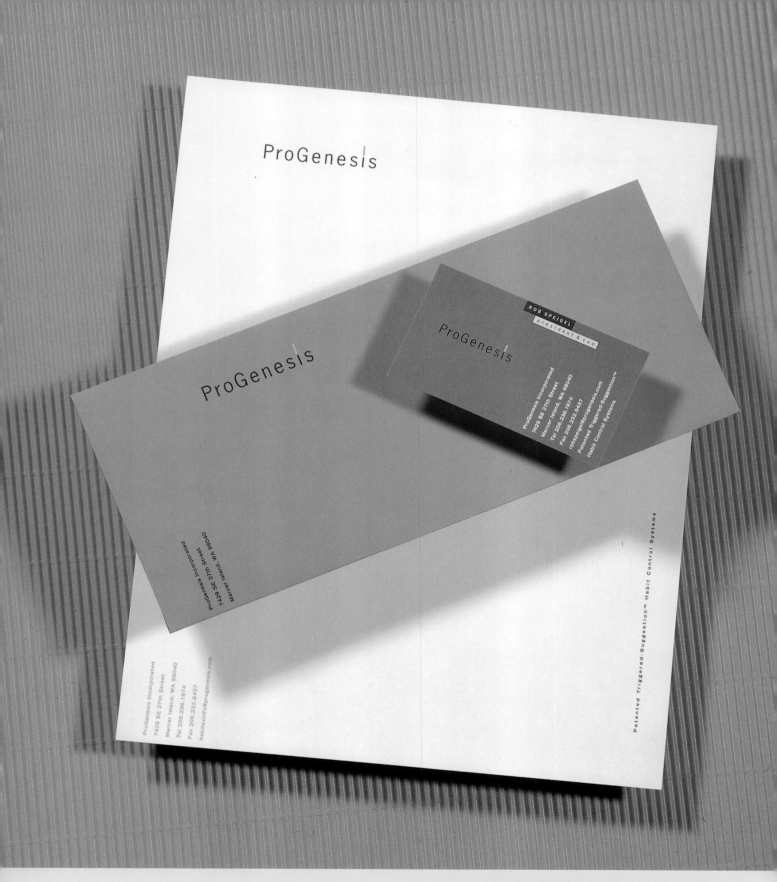

DESIGN FIRM | WIDMEYER DESIGN

ART DIRECTORS | KEN WIDMEYER, DALE HART

DESIGNER | DALE HART

CLIENT | PROGENESIS

TOOLS | POWER MACINTOSH, MACROMEDIA FREEHAND

PAPER/PRINTING | ENVIRONMENT/OFFSET

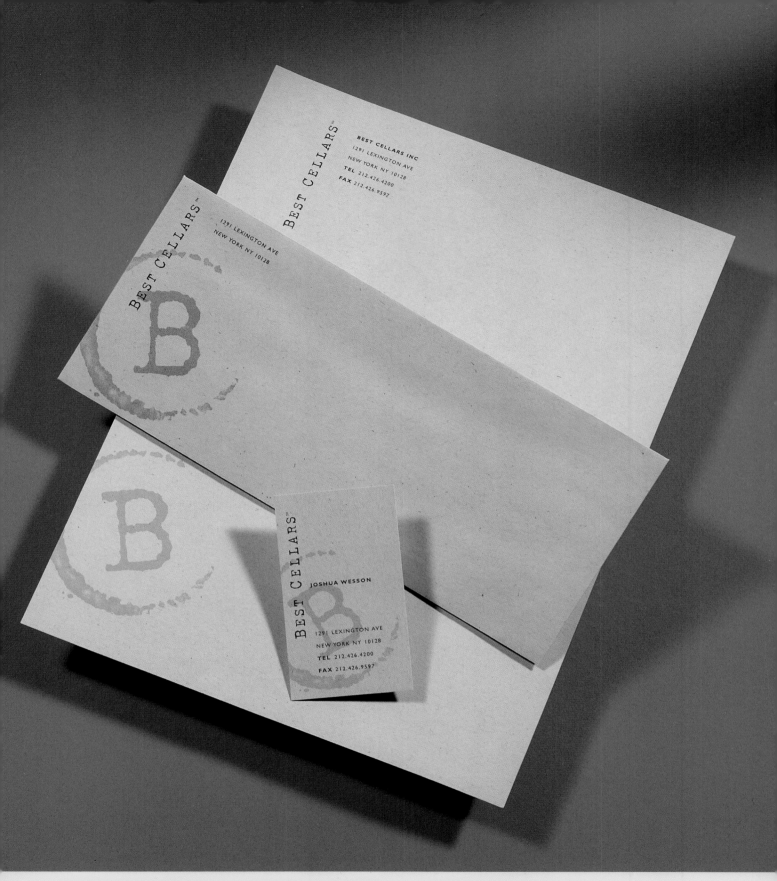

DESIGN FIRM | HORNALL ANDERSON DESIGN WORKS, INC.

ART DIRECTOR | JACK ANDERSON

DESIGNERS | JACK ANDERSON, LISA CERVENY,
JANA WILSON, DAVID BATES

CLIENT | BEST CELLARS

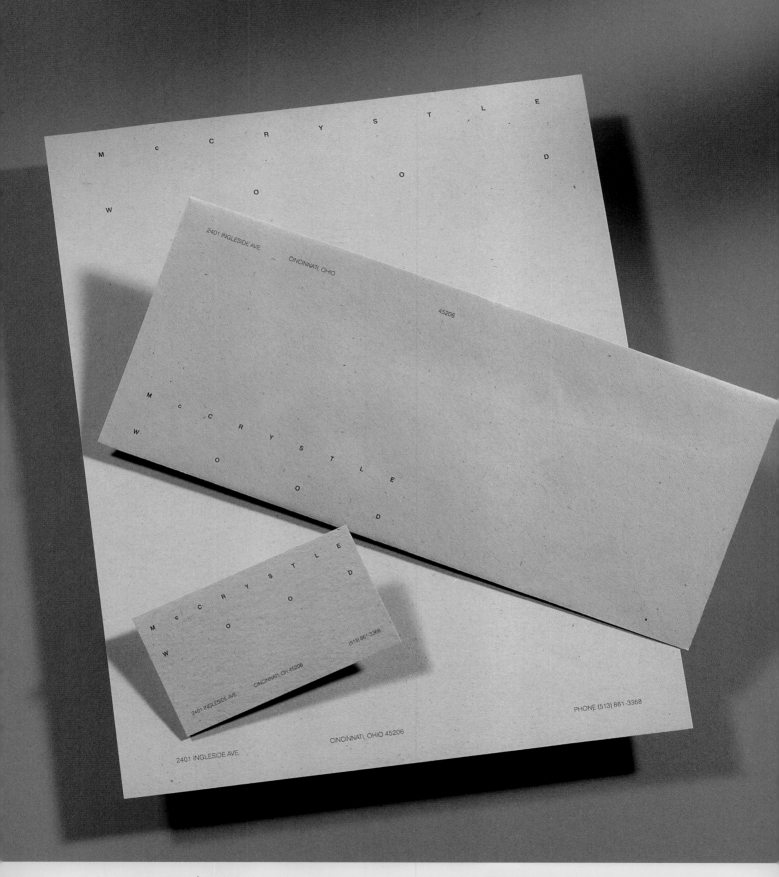

DESIGN FIRM | WOOD/BROD DESIGN

ART DIRECTOR/DESIGNER | STAN BROD

CLIENT | STAN BROD, MCCRYSTLE WOOD

TOOLS | ADOBE ILLUSTRATOR

PAPER/PRINTING | SPECKLETONE/BERMAN PRINTING COMPANY

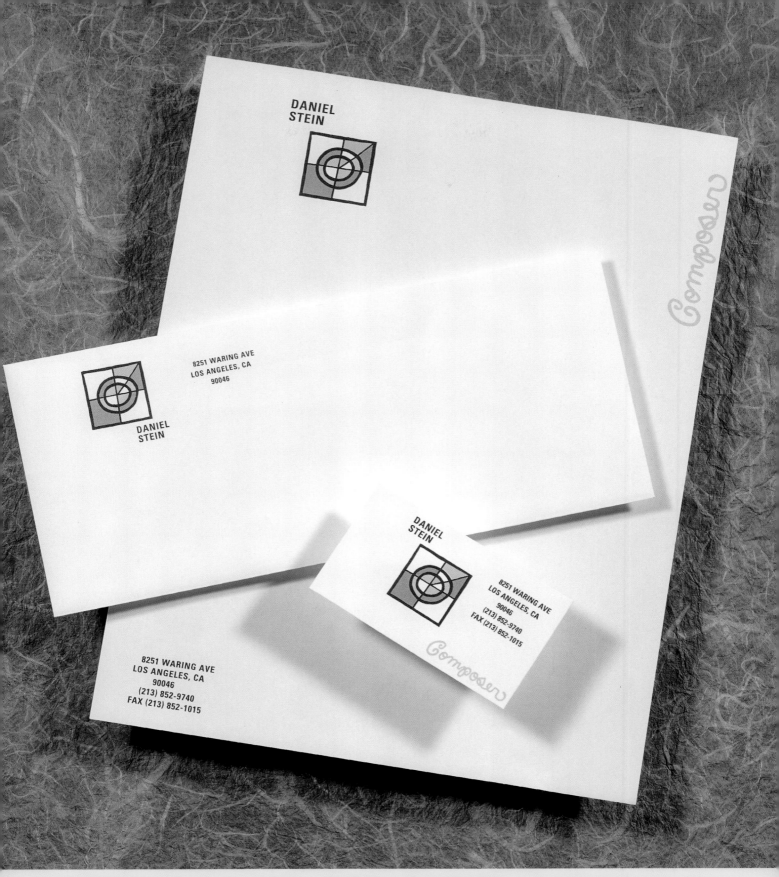

DESIGN FIRM | SUSAN GUERRA DESIGN

ALL DESIGN | SUSAN GUERRA DESIGN

CLIENT | DANIEL STEIN

TOOLS | ADOBE ILLUSTRATOR

PAPER/PRINTING | CLASSIC CREST/TWO COLOR

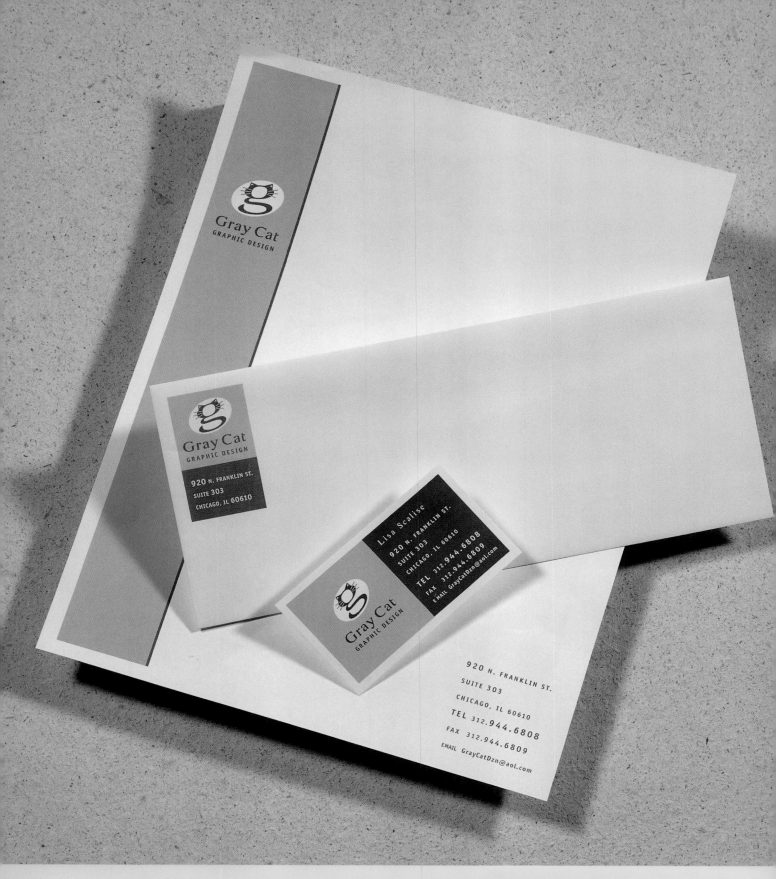

DESIGN FIRM | GRAY CAT DESIGN

DESIGNER | LISA SCALISE

CLIENT | GRAY CAT DESIGN

PAPER/PRINTING | MOHAWK SUPERFINE/LAKE PRINTERS

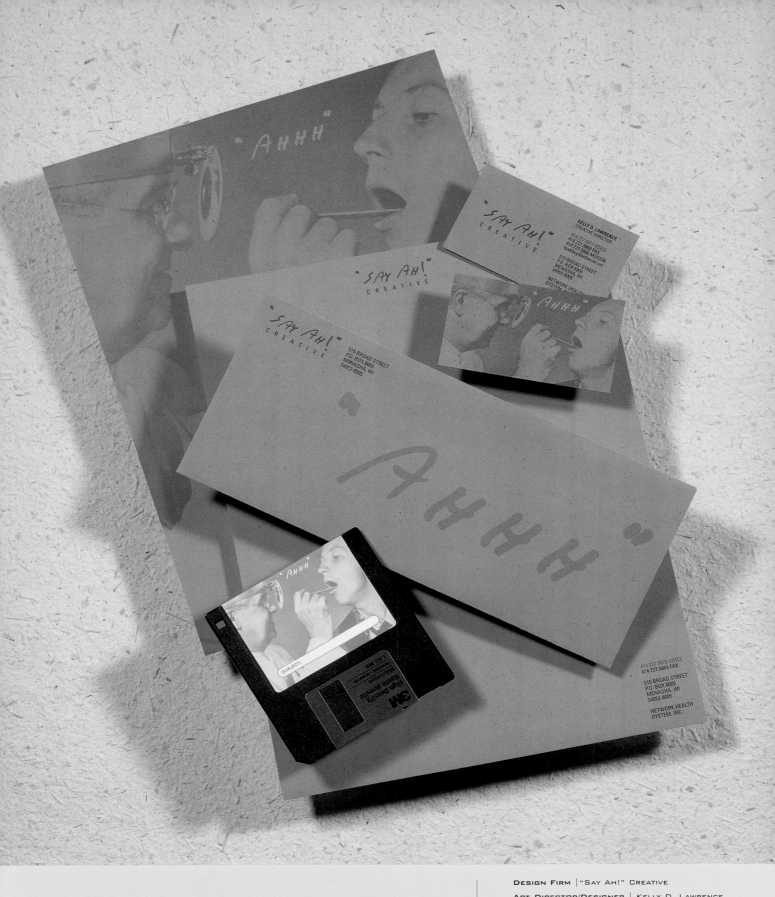

DESIGN FIRM | "SAY AH!" CREATIVE

ART DIRECTOR/DESIGNER | KELLY D. LAWRENCE

PHOTOGRAPHY | SUPERSTOCK

PRODUCTION | JON EMPEY, VICKIE MARTIN

CLIENT | "SAY AH!" CREATIVE

TOOLS | QUARKXPRESS, ADOBE PHOTOSHOP,

ADOBE ILLUSTRATOR

PAPER/PRINTING | SIMPSON QUEST-BRONZE/OFFSET

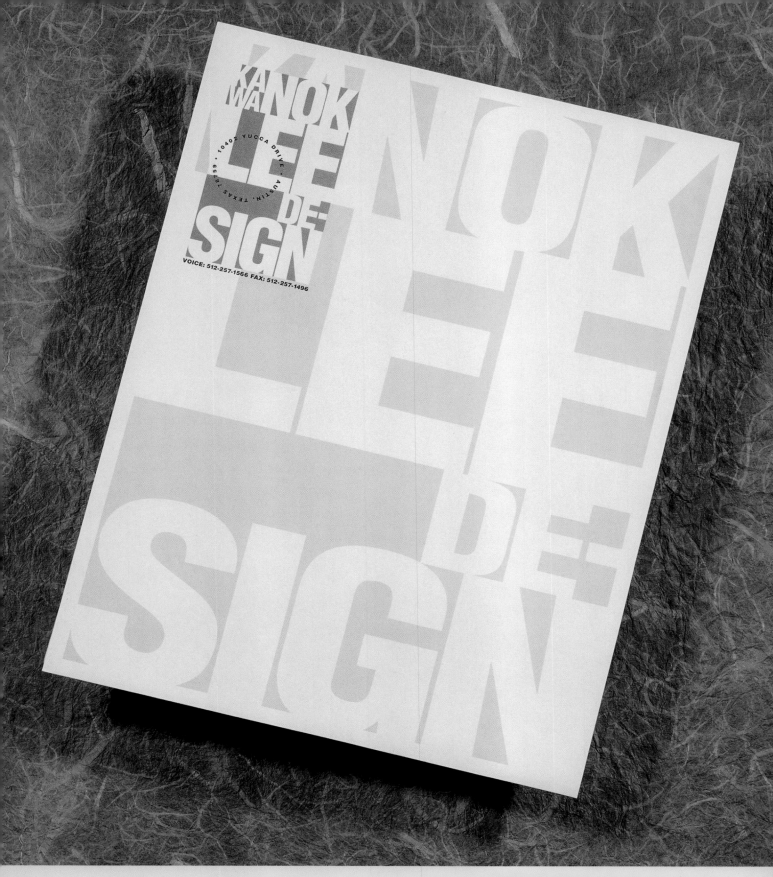

DESIGN FIRM | KANOKWALEE DESIGN

ART DIRECTOR/DESIGNER | KANOKWALEE LEE

CLIENT | KANOKWALEE DESIGN

TOOLS | ADOBE ILLUSTRATOR, QUARKXPRESS

PAPER/PRINTING | STRATHMORE KRAFT/OFFSET

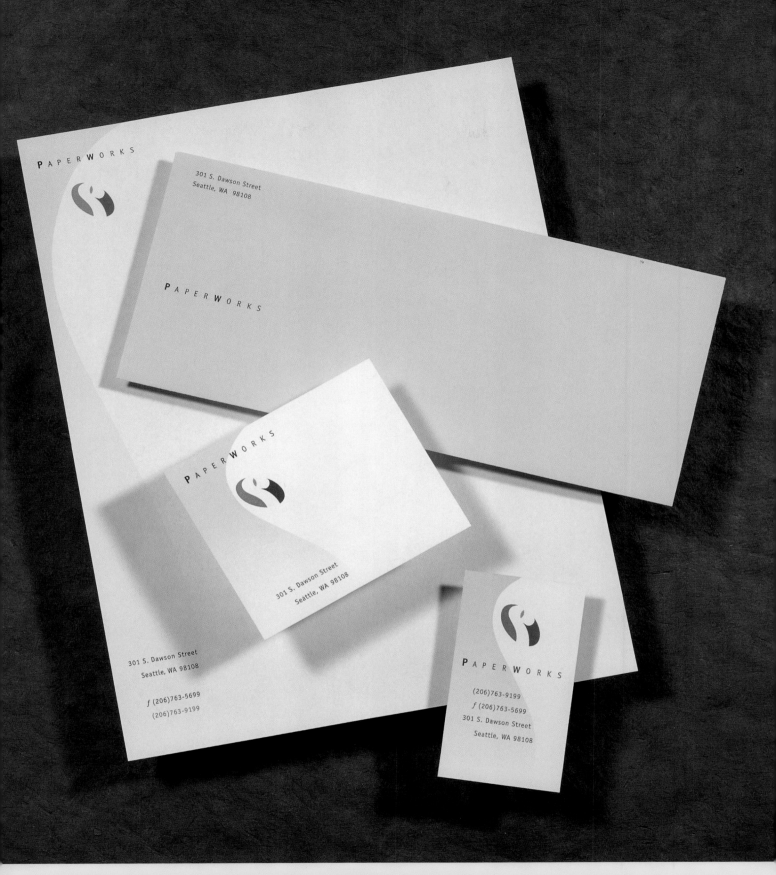

DESIGN FIRM | BELYEA DESIGN ALLIANCE
ART DIRECTOR | PATRICIA BELYEA
DESIGNER | CHRISTIAN SALAS
CLIENT | PAPERWORKS

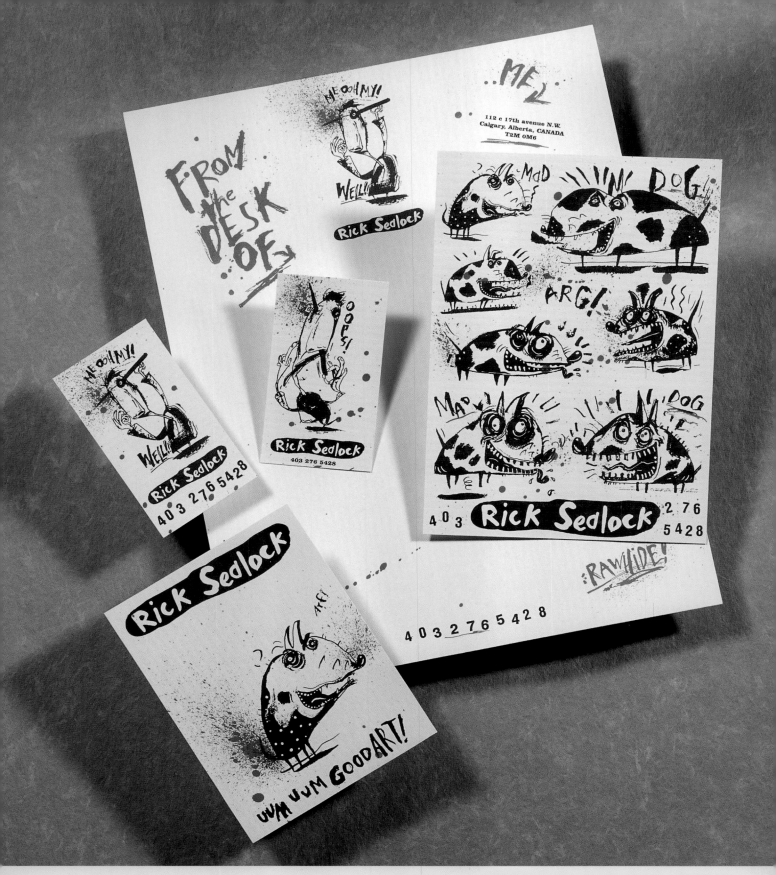

DESIGN FIRM | RICK SEALOCK ILLUSTRATION

ALL DESIGN | RICK SEALOCK

CLIENT | RICK SEALOCK

TOOLS | FOUND TYPE/PHOTOCOPIER

PAPER/PRINTING | CLASSIC COLUMN/OFFSET

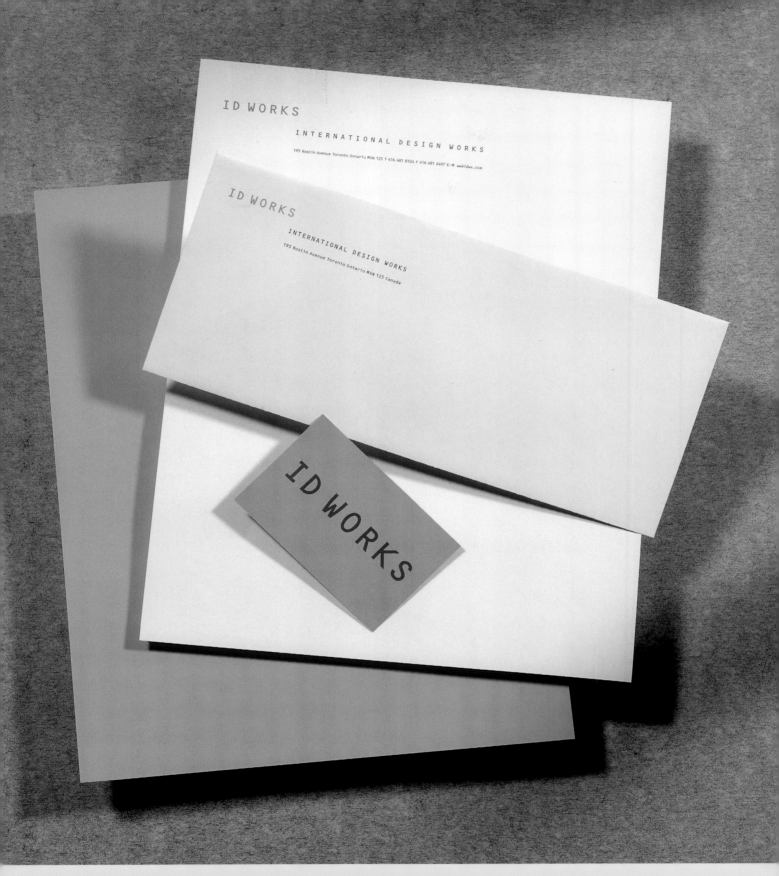

DESIGN FIRM | TEIKNA

ART DIRECTOR/DESIGNER | CLAUDIA NERI

CLIENT | ID WORKS

TOOLS | QUARKXPRESS

PAPER/PRINTING | MOHAWK OPTIONS/TWO COLOR

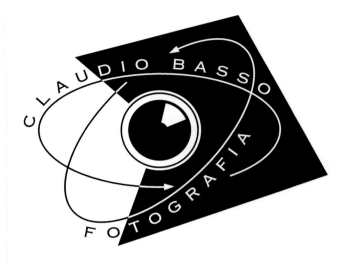

DESIGN FIRM | SIBLEY/PETEET DESIGN
DESIGNER | TOM KIRSCH
CLIENT | MIKE KING

DESIGN FIRM | VOSS DESIGN
ART DIRECTOR/DESIGNER | AXEL VOSS
CLIENT | CLAUDIO BASSO

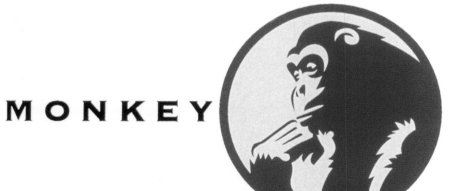

DESIGN FIRM | TRACY SABIN GRAPHIC DESIGN
ART DIRECTOR | RUSSELL SABIN
ILLUSTRATOR | TRACY SABIN
CLIENT | MONKEY STUDIOS
TOOLS | ADOBE ILLUSTRATOR

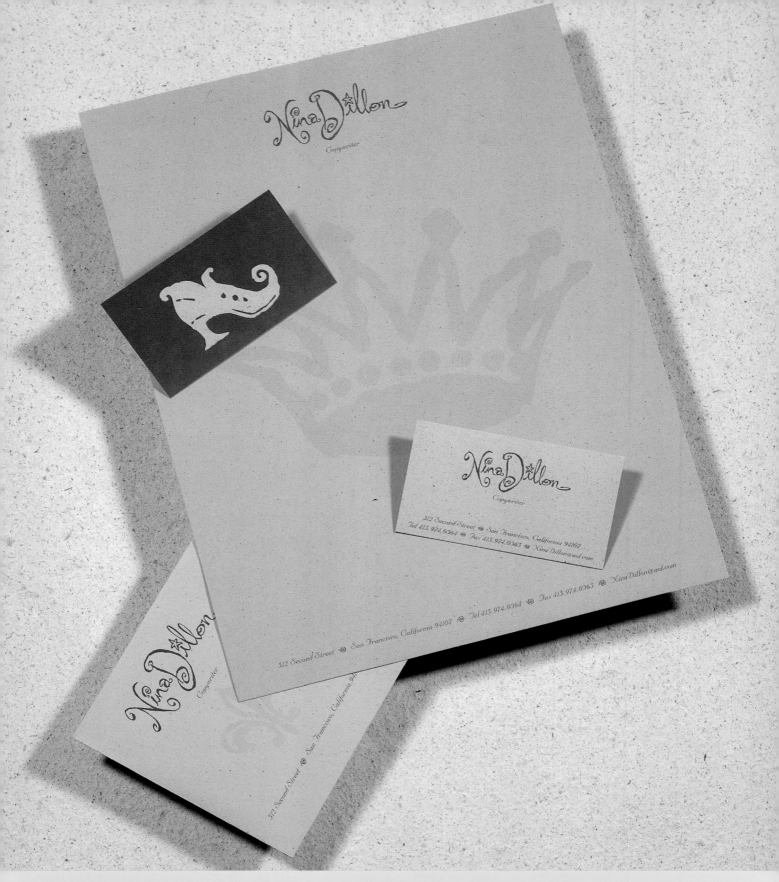

DESIGN FIRM | TIM NOONAN

DESIGNER | TIM NOONAN

CLIENT | NINA DILLON

TOOLS | QUARKXPRESS, HAND LETTERING

PAPER/PRINTING | SIMPSON QUEST/ONE PMS

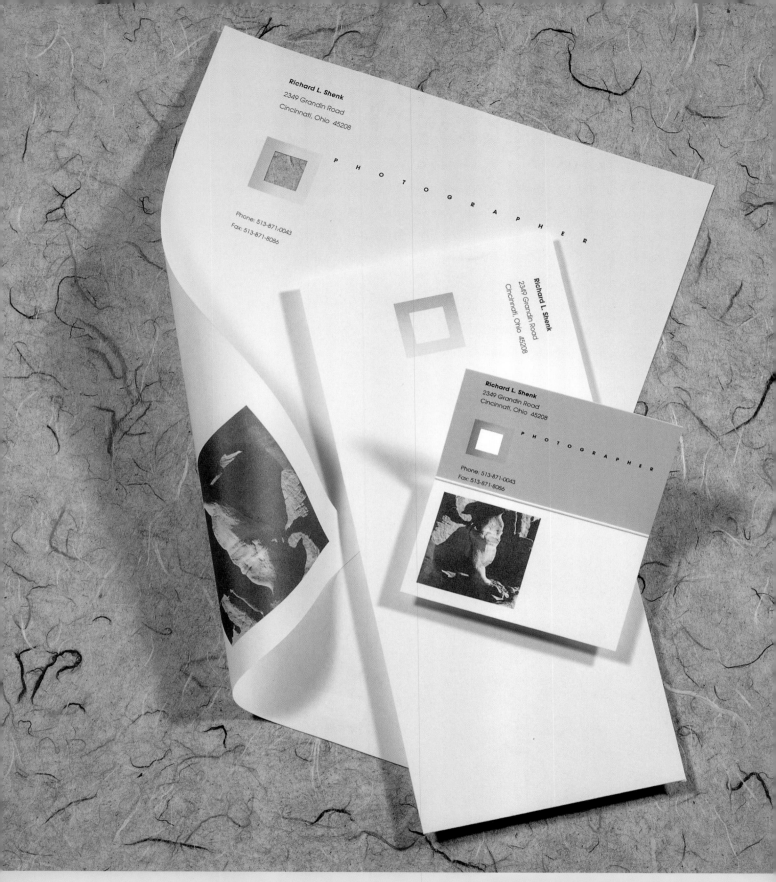

DESIGN FIRM | WOOD/BROD DESIGN
ALL DESIGN | STAN BROD
CLIENT | RICHARD L. SHENK
TOOLS | ADOBE ILLUSTRATOR

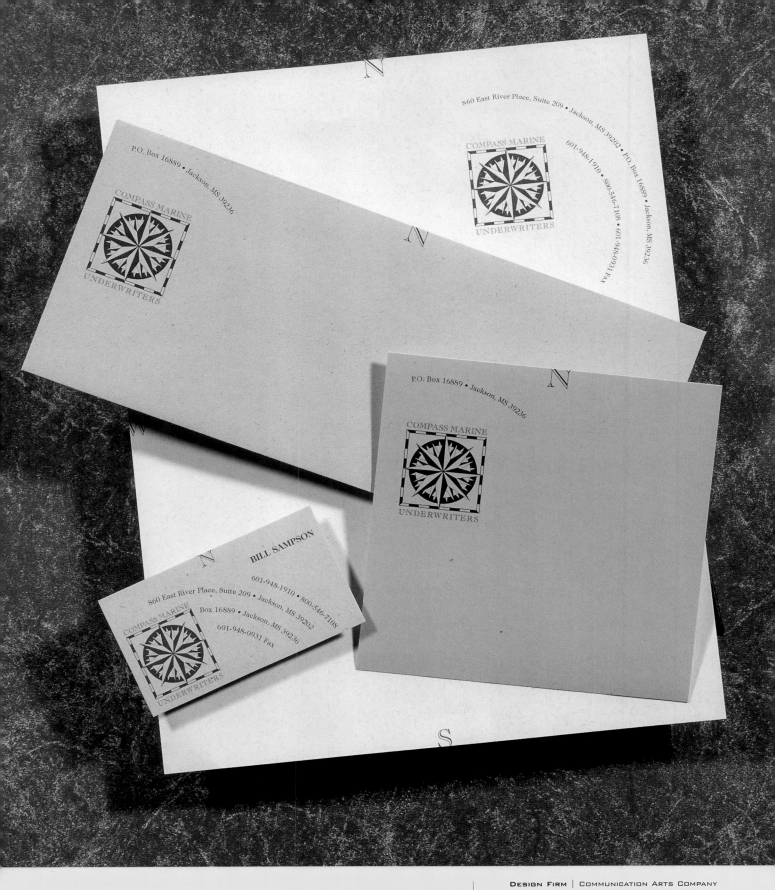

DESIGN FIRM | COMMUNICATION ARTS COMPANY

ART DIRECTOR | HAP OWEN

DESIGNER | ANNE-MARIE OTVOS

CLIENT | COMPASS MARINE UNDERWRITERS

TOOLS | MACINTOSH

PAPER/PRINTING | PROTERRA PARCHMENT &
STUCO, KRAFT/OFFSET LITHOGRAPHY

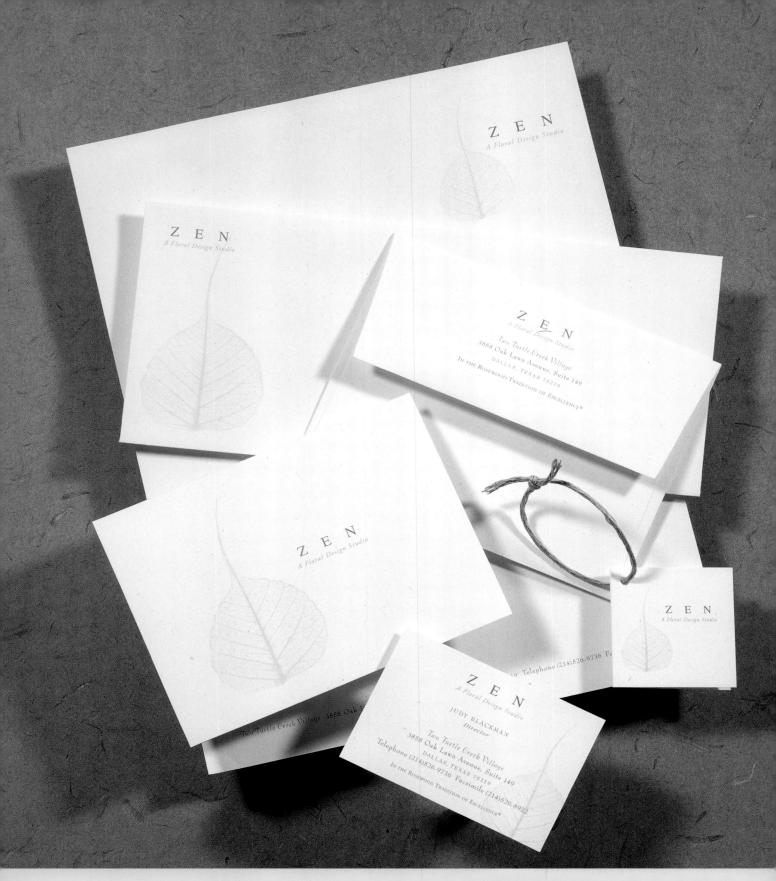

DESIGN FIRM | DAVID CARTER DESIGN

ART DIRECTORS | SHARON LEJEUNE, LORI B. WILSON

CLIENT | ZEN FLORAL DESIGN STUDIO

PAPER/PRINTING | SIMPSON EVERGREEN BIRCH/JARVIS PRESS

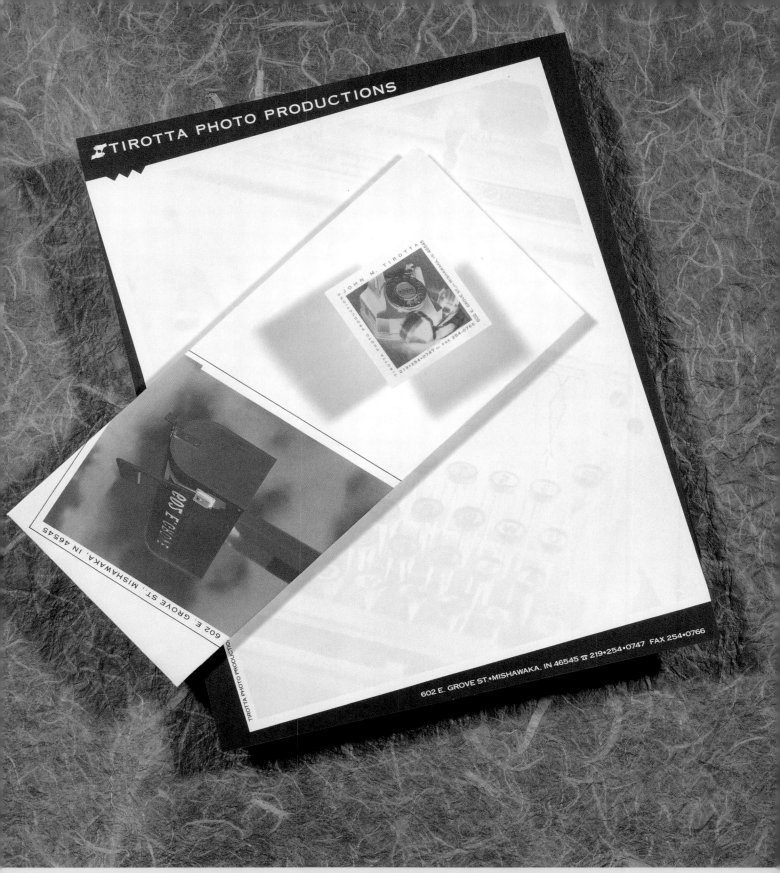

DESIGN FIRM | HIEROGLYPHICS ART & DESIGN
DESIGNER | CHRISTINE OSBORN TIROTTA
PHOTOGRAPHER | JOHN TIROTTA
CLIENT | TIROTTA PHOTO PRODUCTIONS
PAPER/PRINTING | STARWHITE VICKSBURG, UV ULTRA II

Pesona Pictures Sdn Bhd
159A Jalan Aminuddin Baki
Taman Tun Dr Ismail
60000 Kuala Lumpur *Malaysia*
Tel 603 719 1602 ✦ 718 2316
Fax 603 719 1586

Studio
24 Jalan Kemajuan 12/18
46200 Petaling Jaya
Selangor Darul Ehsan *Malaysia*
Tel 603 754 2334 ✦ 754 2276
Fax 603 754 2335

Pesona Pictures Sdn Bhd
159A Jalan Aminuddin Baki
Taman Tun Dr Ismail
60000 Kuala Lumpur *Malaysia*
Tel 603 719 1602 ✦ 718 2316
Fax 603 719 1586

Studio
24 Jalan Kemajuan 12/18
46200 Petaling Jaya
Selangor Darul Ehsan *Malaysia*
Tel 603 754 2334 ✦ 754 2276
Fax 603 754 2335

DESIGN FIRM | WERK-HAUS

ART DIRECTOR | EZRAH RAHIM

DESIGNERS | ELRAH RAHIM, WAI MING, WEE

CLIENT | PESONA PICTURES

PAPER/PRINTING | CONCEPT WAVE SAND/ONE
 COLOR, COPPER HOT STAMPING, EMBOSSING

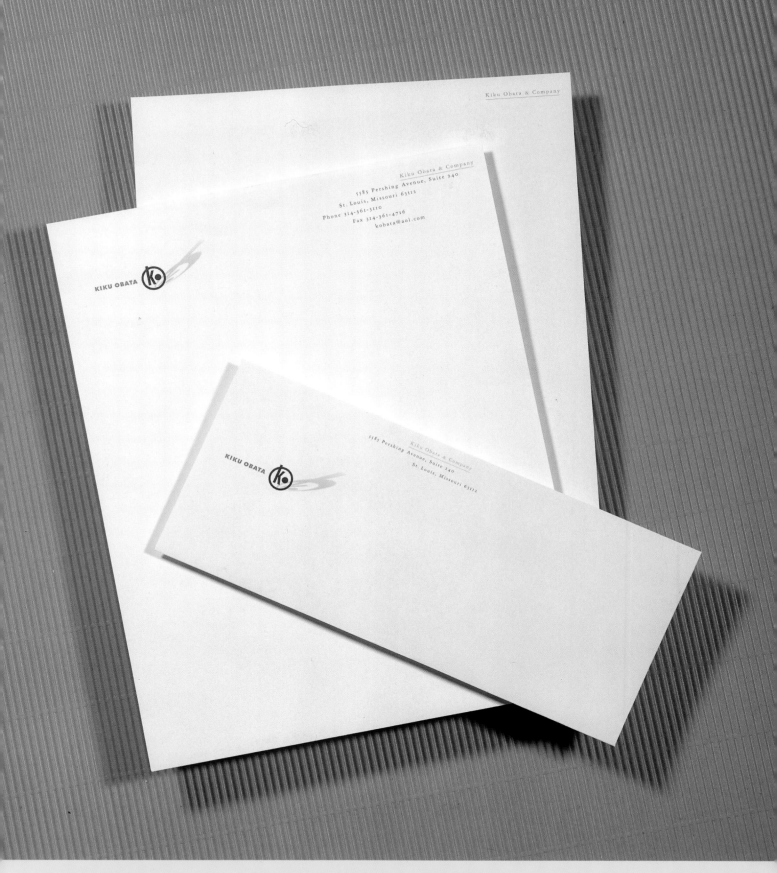

DESIGN FIRM | KIKU OBATA & COMPANY
ART DIRECTOR/DESIGNER | RICH NELSON
CLIENT | KIKU OBATA & COMPANY
PAPER/PRINTING | REPROX

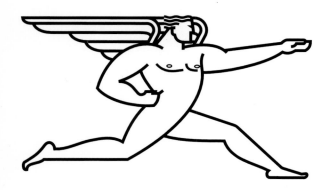

TOWER OF BABEL

DESIGN FIRM | SIBLEY/PETEET DESIGN
DESIGNER | TOM HOUGH
CLIENT | MERCURY MESSENGER

DESIGN FIRM | TOWER OF BABEL
DESIGNER | ERIC STEVENS
CLIENT | TOWER OF BABEL

DESIGN FIRM | KIRBY STEPHENS DESIGN, INC.
ART DIRECTOR/DESIGNER | KIRBY STEPHENS
ILLUSTRATORS | DANIEL DUTTON, WILLIAM V. COX
CLIENT | KENTUCKY TOURISM COUNCIL
TOOLS | PENCIL, MACINTOSH PPC, SCANNER

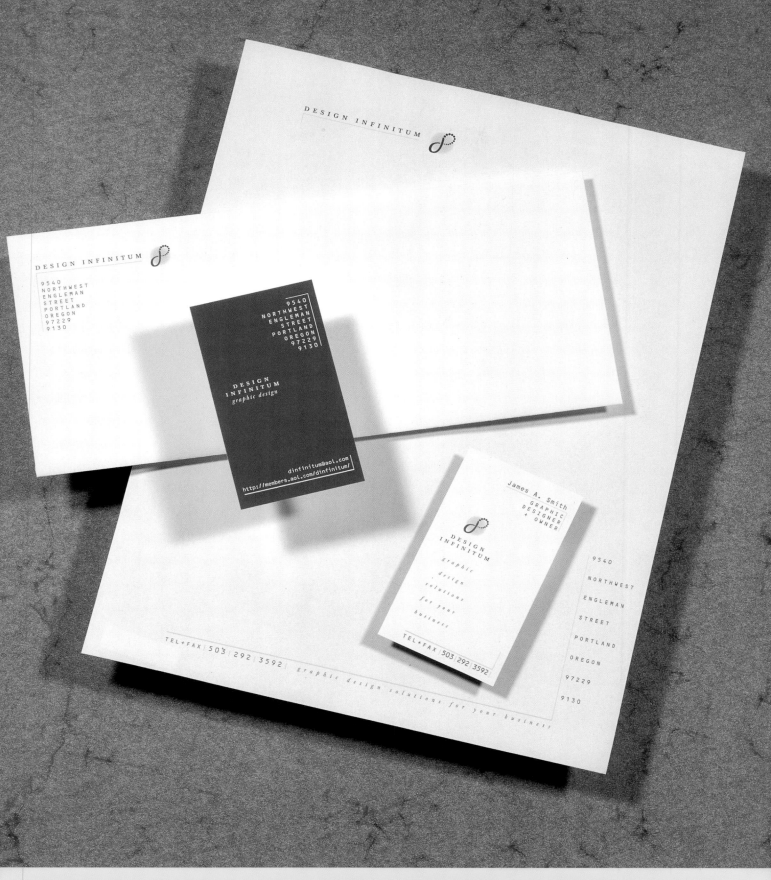

DESIGN FIRM | DESIGN INFINITUM

ALL DESIGN | JAMES A. SMITH

CLIENT | DESIGN INFINITUM

TOOLS | QUARKXPRESS, ADOBE ILLUSTRATOR

PAPER/PRINTING | BECKETT EXPRESSION/

CHROMAGRAPHICS

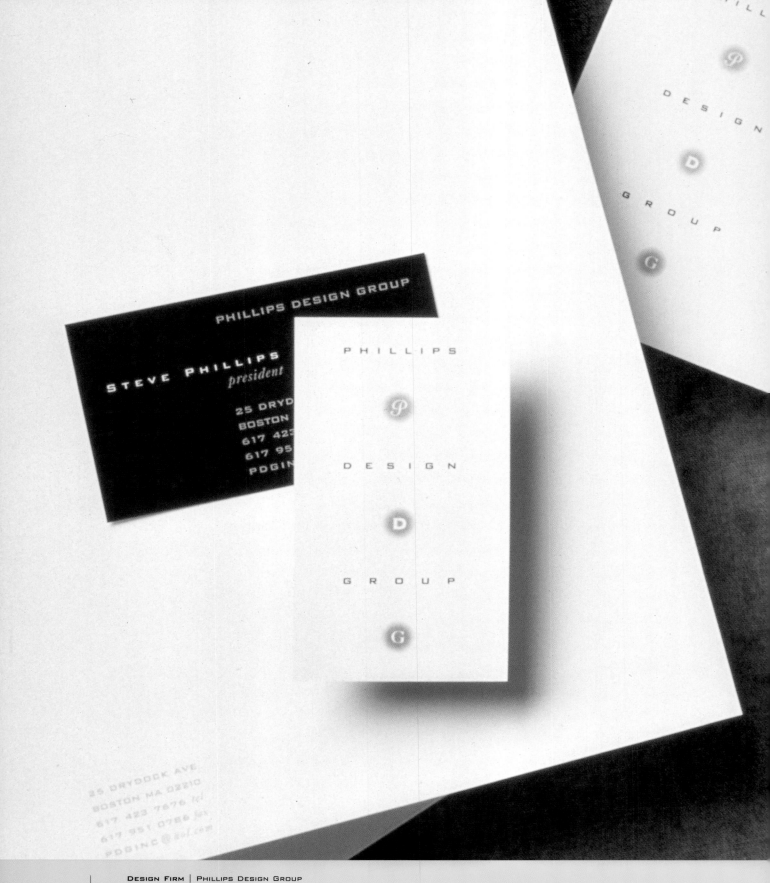

DESIGN FIRM | PHILLIPS DESIGN GROUP

ART DIRECTOR | STEVE PHILLIPS

DESIGNERS | BETH PARKER, ALISON GOUDREAULT

CLIENT | PHILLIPS DESIGN GROUP

TOOLS | ADOBE ILLUSTRATOR

PAPER/PRINTING | STRATHMORE/MARAN PRINTING

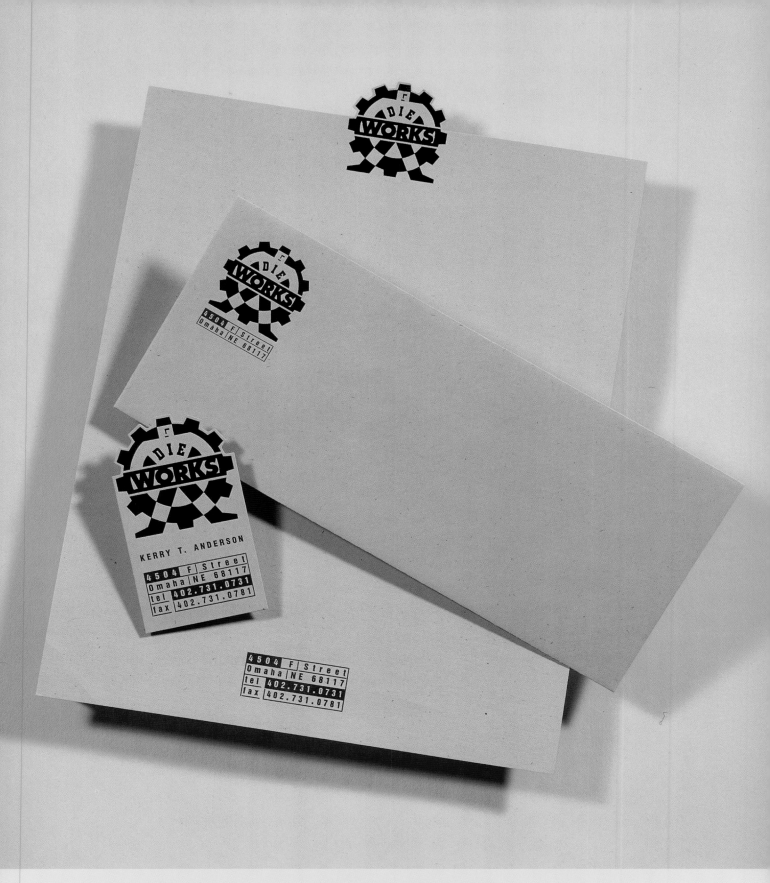

DESIGN FIRM | WEBSTER DESIGN ASSOCIATES

ART DIRECTOR | DAVE WEBSTER

DESIGNER/ILLUSTRATOR | ANDREY NAGORNY

CLIENT | DIE WORKS

TOOLS | MACROMEDIA FREEHAND

PAPER/PRINTING | CROSS POINTE GENESIS FOSSIL,

FOIL STAMPED

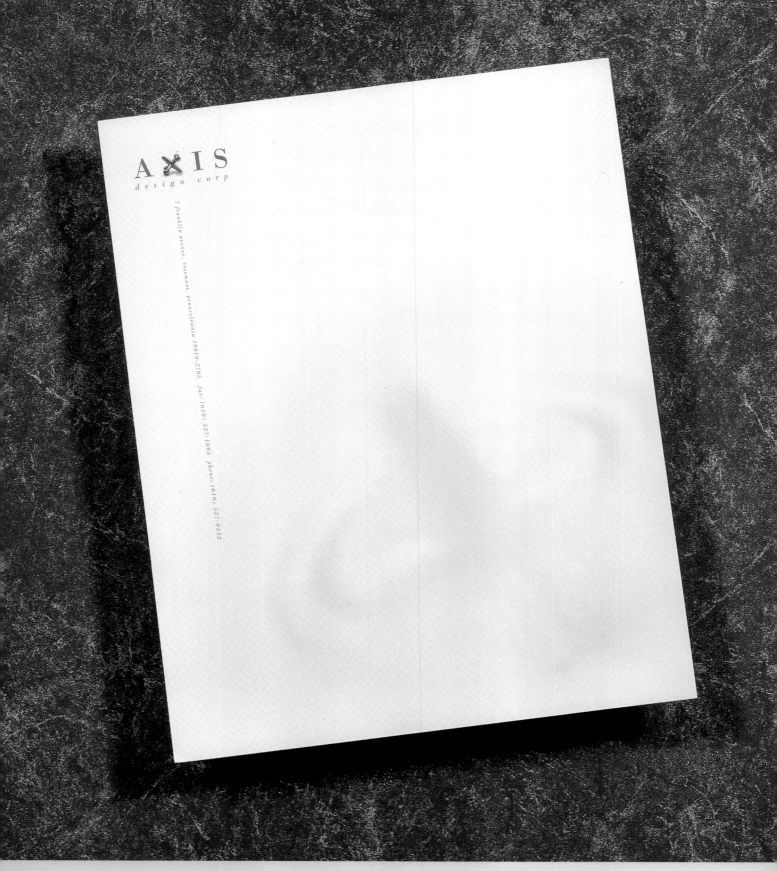

AXIS
design corp

7 franklin avenue, rosemont, pennsylvania 19010-2705 fax: (610) 527-1095 phone: (610) 527-0332

DESIGN FIRM │ AXIS DESIGN
ART DIRECTOR/DESIGNER │ WILLIAM MILNAZIK
CLIENT │ AXIS DESIGN
PAPER/PRINTING │ STRATHMORE ELEMENTS

DESIGN FIRM | DOGSTAR
DESIGNER/ILLUSTRATOR | RODNEY DAVIDSON
CLIENT | DOGSTAR
TOOLS | ADOBE ILLUSTRATOR, STREAMLINE, MACROMEDIA FREEHAND

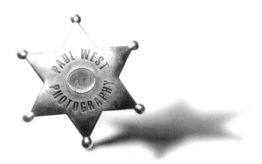

DESIGN FIRM | STORM DESIGN & ADVERTISING CONSULTANCY
ART DIRECTORS/DESIGNERS | DAVID ANSETT, DEAN BUTLER
ILLUSTRATORS | DEAN BUTLER, DAVID ANSETT
CLIENT | PAUL WEST PHOTOGRAPHY
TOOLS | ADOBE PHOTOSHOP

DESIGN FIRM | "SAY AH!" CREATIVE
ART DIRECTOR/DESIGNER | KELLY D. LAWRENCE
PHOTOGRAPHY | SUPERSTOCK
PRODUCTION | JON EMPEY, VICKIE MARTIN
CLIENT | "SAY AH!" CREATIVE
TOOLS | QUARKXPRESS, ADOBE PHOTOSHOP, ADOBE ILLUSTRATOR

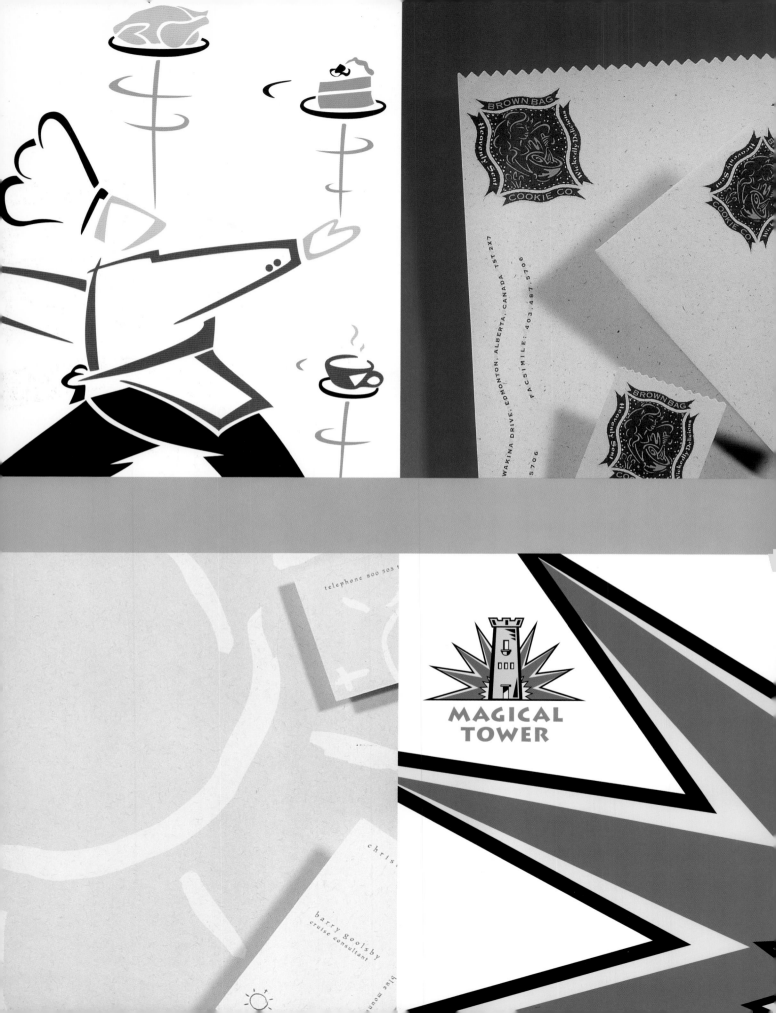

BROWN BAG COOKIE CO.
Heavenly Sent · Wickedly Delicious

WAKINA DRIVE, EDMONTON, ALBERTA, CANADA, T5T 2X7

FACSIMILE: 403.487.5706

5706

telephone 800 505

christ

barry goolsby
cruise consultant

MAGICAL TOWER

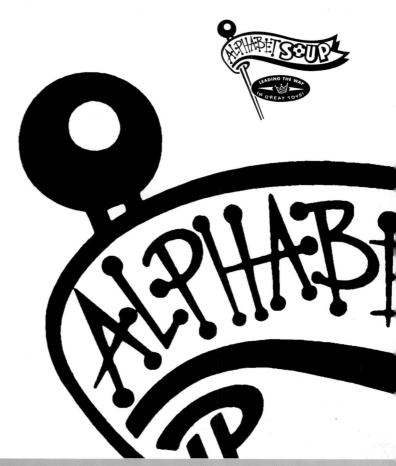

RESTAURANT, RETAIL, AND HOSPITALITY

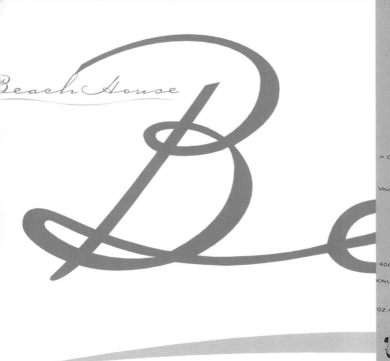

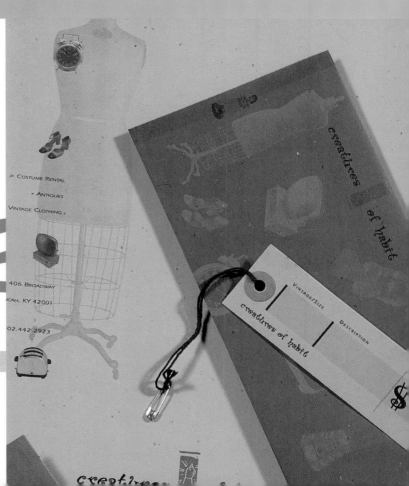

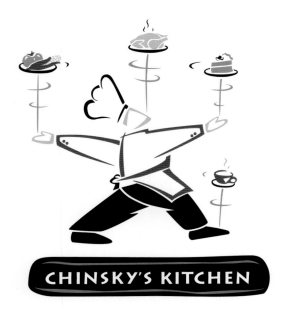

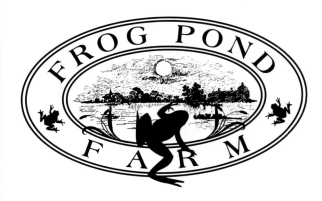

DESIGN FIRM | KIKU OBATA & COMPANY
ART DIRECTOR/DESIGNER JOE FLORESCA
CLIENT | CHINSKY'S KITCHEN

DESIGN FIRM | TURNER DESIGN
ALL DESIGN | BERT TURNER
CLIENT | FROG POND FARM

CASA de FRUTA

SINCE 1908

DESIGN FIRM | THARP DID IT
ART DIRECTOR | RICK THARP
DESIGNERS | RICK THARP, KIM TOMLINSON
CLIENT | CASA DE FRUTA
TOOLS | INK

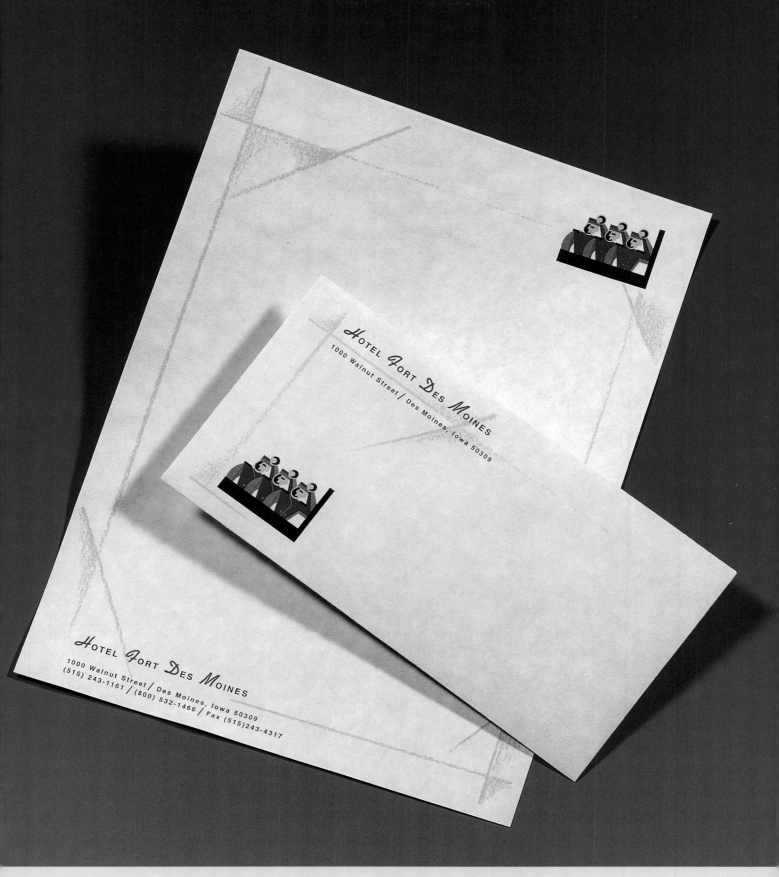

HOTEL FORT DES MOINES

1000 Walnut Street / Des Moines, Iowa 50309

HOTEL FORT DES MOINES
1000 Walnut Street / Des Moines, Iowa 50309
(515) 243-1161 / (800) 532-1466 / Fax (515)243-4317

DESIGN FIRM | SAYLES GRAPHIC DESIGN
ALL DESIGN | JOHN SAYLES
CLIENT | HOTEL FORT DES MOINES
PAPER/PRINTING | HOPPER SKYTONE NATURAL/OFFSET

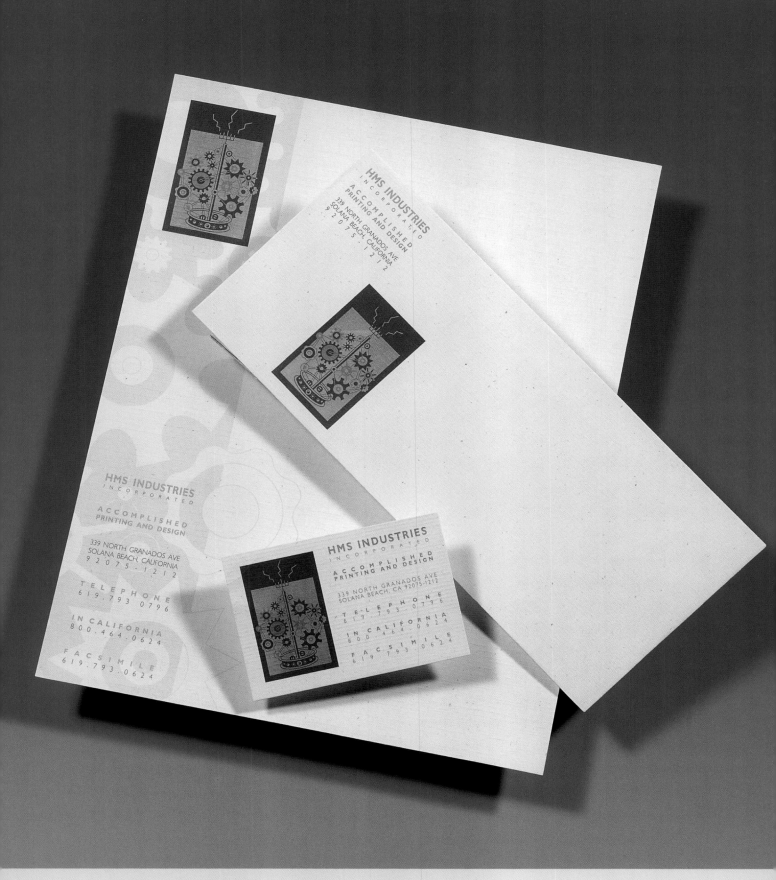

DESIGN FIRM | ICEHOUSE DESIGN

ART DIRECTOR/DESIGNER | PATTIE BELLE HASTINGS

ILLUSTRATOR | VAL TILLERY

CLIENT | HMS INDUSTRIES

TOOLS | POWER MACINTOSH

PAPER/PRINTING | CLASSIC CREST

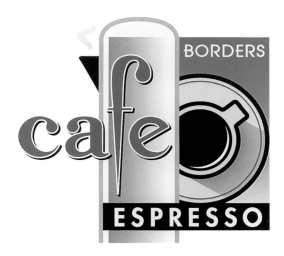

L E N O X
R O O M

T I P W E L L A N D P R O S P E R

DESIGN FIRM | FRCH DESIGN WORLDWIDE
ART DIRECTOR | JOAN DONNELLY
DESIGNER/ILLUSTRATOR | TIM A. FRAME
CLIENT | BORDERS BOOKS AND MUSIC
TOOLS | ADOBE ILLUSTRATOR

DESIGN FIRM | AERIAL
ART DIRECTOR/DESIGNER | TRACY MOON
PHOTOGRAPHY | R. J. MUNA
CLIENT | LENOX ROOM RESTAURANT
TOOLS | ADOBE PHOTOSHOP, QUARKXPRESS

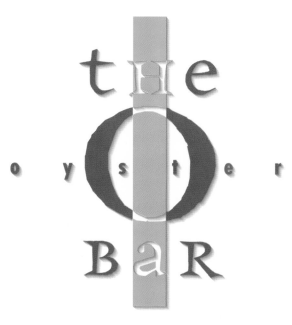

DESIGN FIRM | FLAHERTY ART & DESIGN
ALL DESIGN | MARIE FLAHERTY
CLIENT | THE O BAR OF EATING UP THE COAST
TOOLS | ADOBE ILLUSTRATOR

DESIGN FIRM | JEFF FISHER LOGOMOTIVES
ALL DESIGN | JEFF FISHER
CLIENT | TRIAD (AD AGENCY FOR GINA'S ITALY)
TOOLS | MACROMEDIA FREEHAND

DESIGN FIRM | VRONTIKIS DESIGN OFFICE
ART DIRECTOR | PETRULA VRONTIKIS
DESIGNER | LISA CRITCHFIELD
CLIENT | HASEGAWA ENTERPRISES
TOOLS | QUARKXPRESS, ADOBE PHOTOSHOP

DESIGN FIRM | SAYLES GRAPHIC DESIGN
ALL DESIGN | JOHN SAYLES
CLIENT | ALPHABET SOUP

DESIGN FIRM | CORNOYER-HEDRICK, INC.
ART DIRECTOR | JIM BOLEK
DESIGNER/ILLUSTRATOR | LANIE GOTCHER
CLIENT | MOTOROLA
TOOLS | ADOBE ILLUSTRATOR

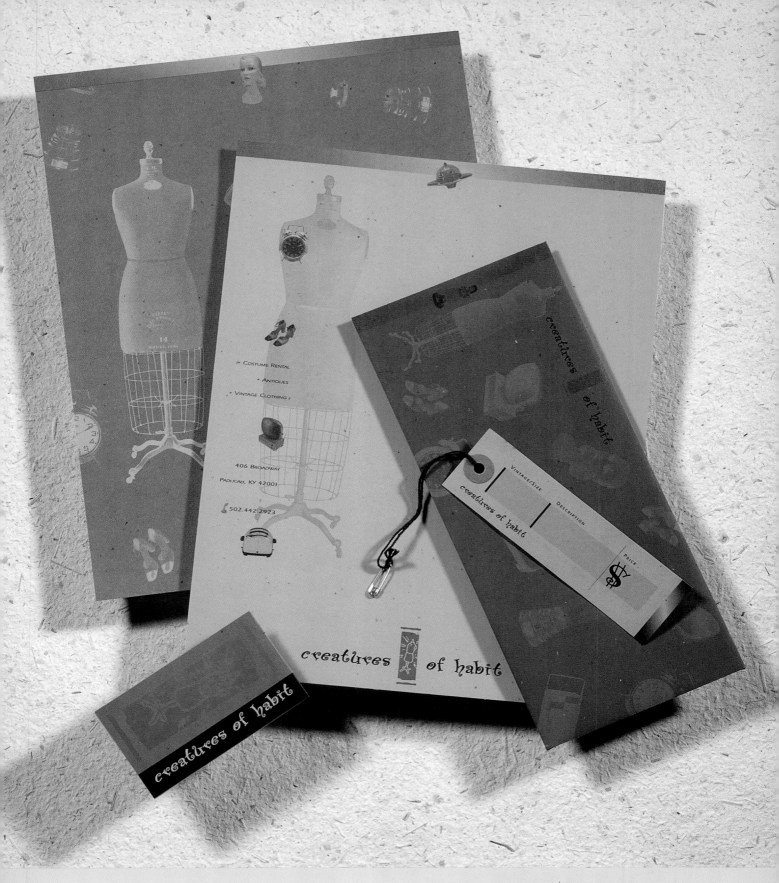

DESIGN FIRM | FIRE HOUSE, INC.

ART DIRECTOR/DESIGNER | GREGORY R. FARMER

CLIENT | CREATURES OF HABIT

TOOLS | QUARKXPRESS, ADOBE PHOTOSHOP

PAPER/PRINTING | FOX RIVER CONFETTI, MOORE-LANGEN

PRINTING COMPANY, KENNY GRAPHICS

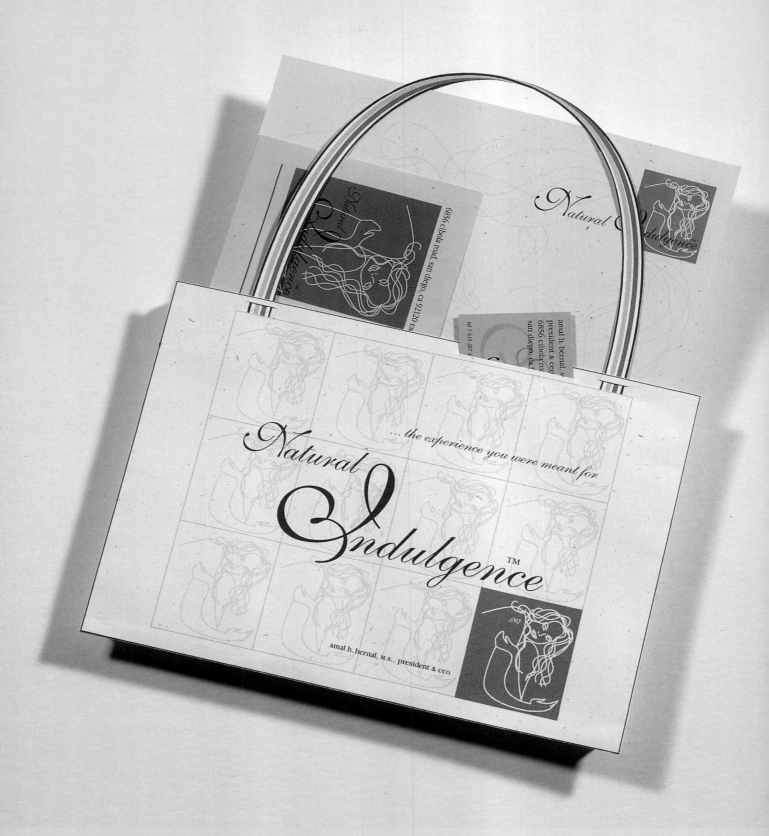

DESIGN FIRM | THE PROVEN EDGE

ALL DESIGN | RITA GOLD

CLIENT | NATURAL INDULGENCE

TOOLS | ADOBE ILLUSTRATOR

PAPER/PRINTING | CROSS POINTE/FRASER AND HOPPER, PRIORITY
PRINTERS AND EPSON STYLUS PRO WITH BINARY POWER RIP

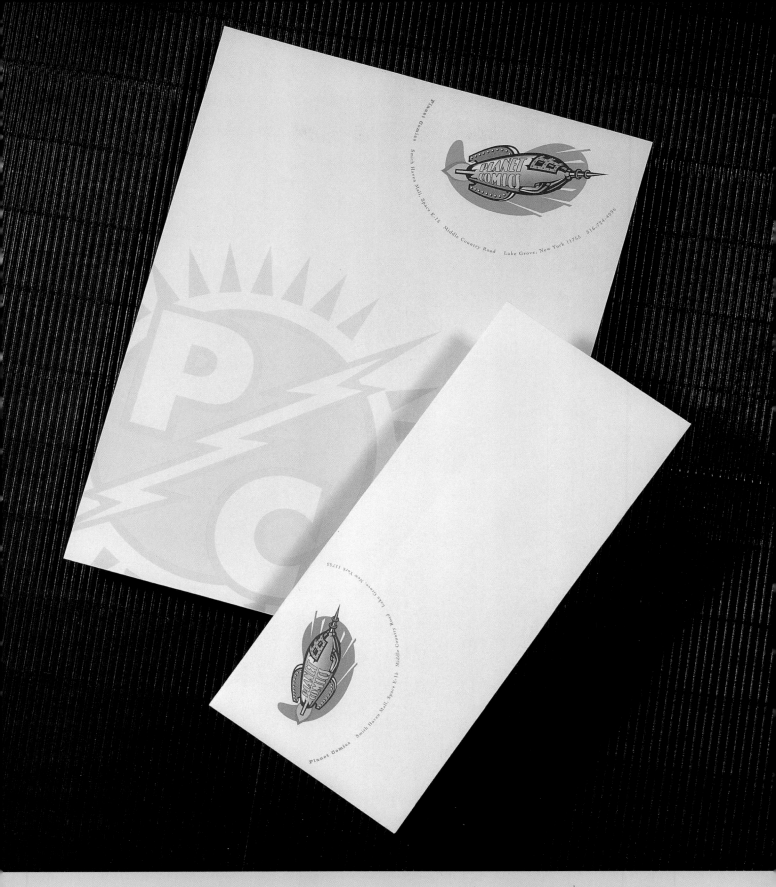

DESIGN FIRM | KIKU OBATA & COMPANY
ART DIRECTOR/DESIGNER | RICH NELSON
CLIENT | PLANET COMICS

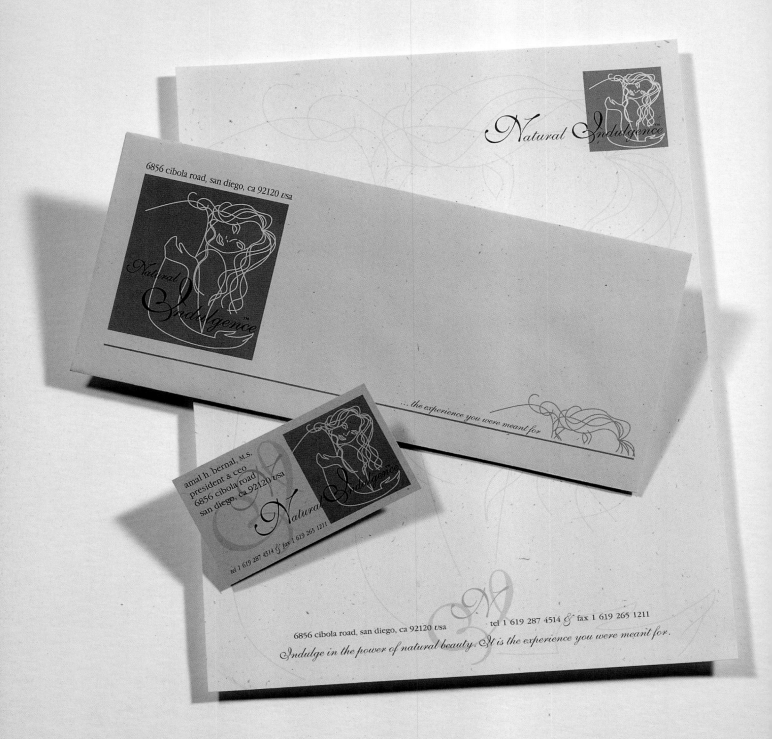

DESIGN FIRM | THE PROVEN EDGE

ALL DESIGN | RITA GOLD

CLIENT | NATURAL INDULGENCE

TOOLS | ADOBE ILLUSTRATOR

PAPER/PRINTING | CROSS POINTE/FRASER AND HOPPER, PRIORITY
PRINTERS AND EPSON STYLUS PRO WITH BINARY POWER RIP

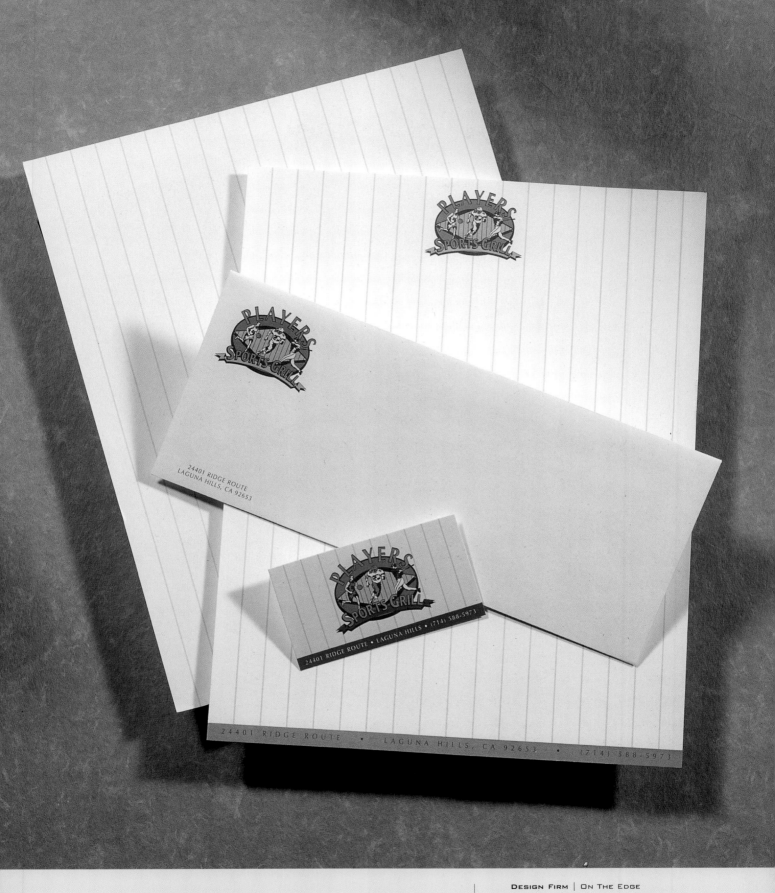

DESIGN FIRM | ON THE EDGE
ART DIRECTOR | JEFF GASPER
DESIGNER | GINA MIMS
ILLUSTRATOR | RUSS MIMS
CLIENT | PLAYERS SPORTS GRILL
TOOLS | QUARKXPRESS, ADOBE ILLUSTRATOR,
ADOBE PHOTOSHOP
PAPER/PRINTING | EVERGREEN WHITE

MISAKI ICHIBA

DESIGN FIRM | KIKU OBATA & COMPANY
ART DIRECTOR | JOE FLORESCA
DESIGNERS | JOE FLORESCA, JEFF RIFKIN, ELEANOR SAFE
CLIENT | R.I.C. DESIGN

dog lips

DESIGN FIRM | JUICE DESIGN
ART DIRECTOR/DESIGNER | BRETT M. CRITCHCHLOW
CLIENT | DOGLIPS

DESIGN FIRM | KIKU OBATA & COMPANY
ART DIRECTOR/DESIGNER | RICH NELSON
CLIENT | R.I.C. DESIGN

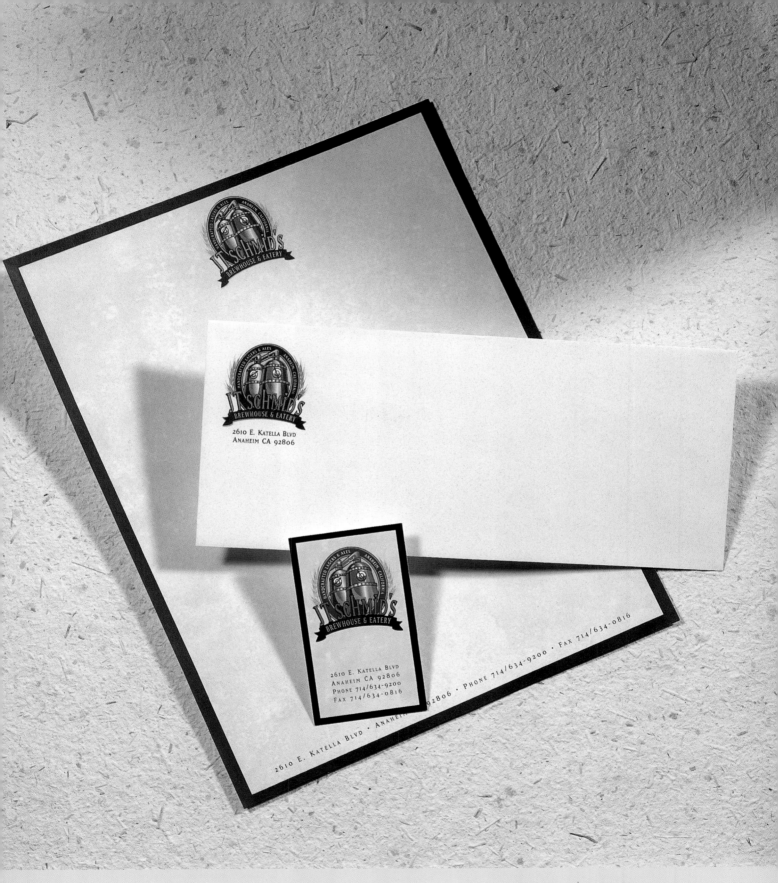

DESIGN FIRM | ON THE EDGE

ART DIRECTOR | JEFF GASPER

DESIGNER | GINA MIMS

ILLUSTRATOR | ERIC PETERSON

CLIENT | JT SCHMID'S BREWHOUSE & EATERY

TOOLS | ADOBE ILLUSTRATOR, QUARKXPRESS

PAPER/PRINTING | CLASSIC CREST IVORY CARD,
LUNA WHITE COVER/FIVE COLOR

La Bodega

Company Store & Deli

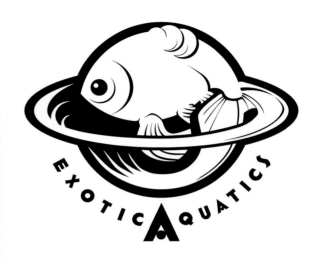

DESIGN FIRM | FLAHERTY ART & DESIGN
ALL DESIGN | MARIE FLAHERTY
CLIENT | LA BODEGA OF EATING UP THE COAST
TOOLS | ADOBE ILLUSTRATOR

DESIGN FIRM | S&N DESIGN
ALL DESIGN | CRAIG GOODMAN
CLIENT | EXOTIC AQUATICS
TOOLS | ADOBE ILLUSTRATOR

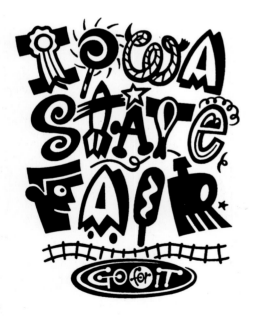

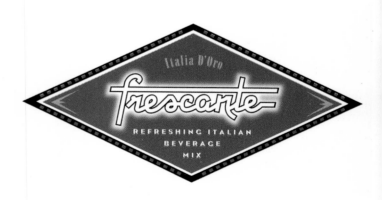

DESIGN FIRM | SAYLES GRAPHIC DESIGN
ART DIRECTOR/ILLUSTRATOR | JOHN SAYLES
DESIGNER | JOHN SAYLES, JENNIFER ELLIOTT
CLIENT | IOWA STATE FAIR

DESIGN FIRM | MIRES DESIGN
ART DIRECTORS | SCOTT MIRES, MIKE BROWER
DESIGNERS | MIKE BROWER, SCOTT MIRES
ILLUSTRATOR | TRACY SABIN
COPYWRITER | JOHN KURAOKA
CLIENT | FOOD GROUP/BOYDS COFFEE

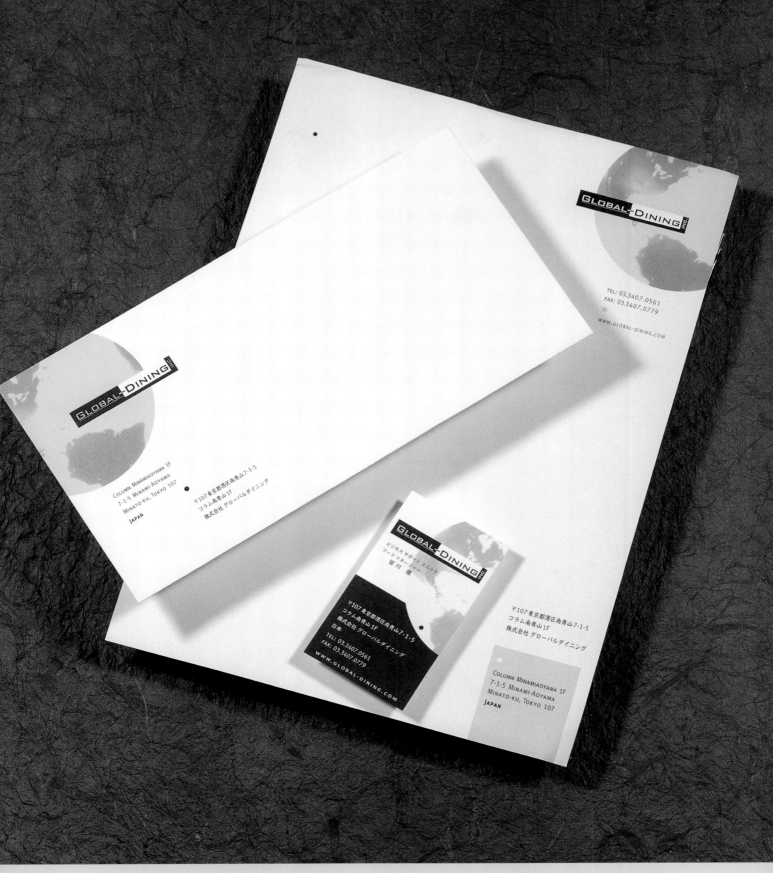

DESIGN FIRM | VRONTIKIS DESIGN OFFICE

ART DIRECTOR/DESIGNER | PETRULA VRONTIKIS

CLIENT | GLOBAL-DINING, INC.

TOOLS | QUARKXPRESS, ADOBE PHOTOSHOP

PAPER/PRINTING | NEENAH CLASSIC

CREST/DONAHUE PRINTING

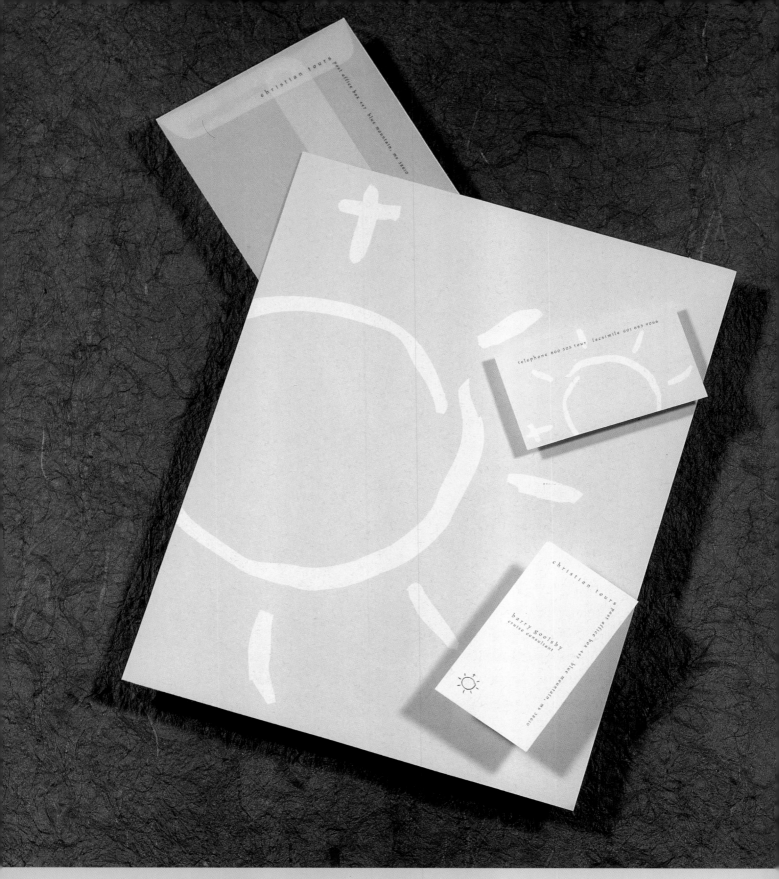

DESIGN FIRM | DAVID CARTER DESIGN

ART DIRECTOR | LORI B. WILSON, GARY LoBUE, JR.

DESIGNER/ILLUSTRATOR | TRACY HUCK

CLIENT | CHRISTIAN TOURS

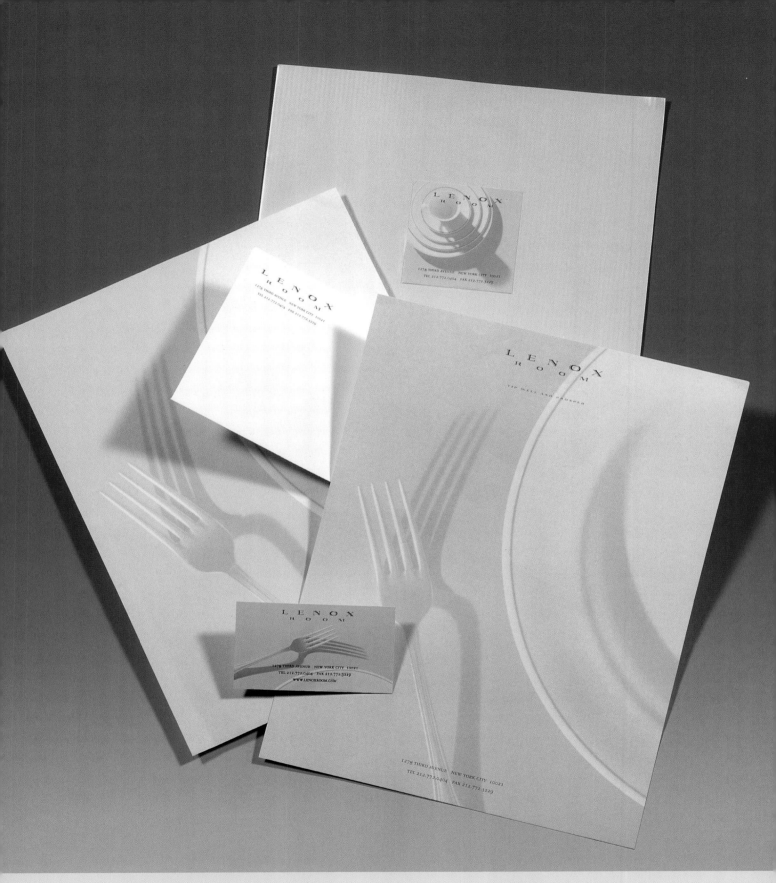

DESIGN FIRM | AERIAL

ART DIRECTOR/DESIGNER | TRACY MOON

PHOTOGRAPHY | R. J. MUNA

CLIENT | LENOX ROOM RESTAURANT

TOOLS | ADOBE PHOTOSHOP, QUARKXPRESS

PAPER/PRINTING | 24 LB. EVERGREEN IVORY

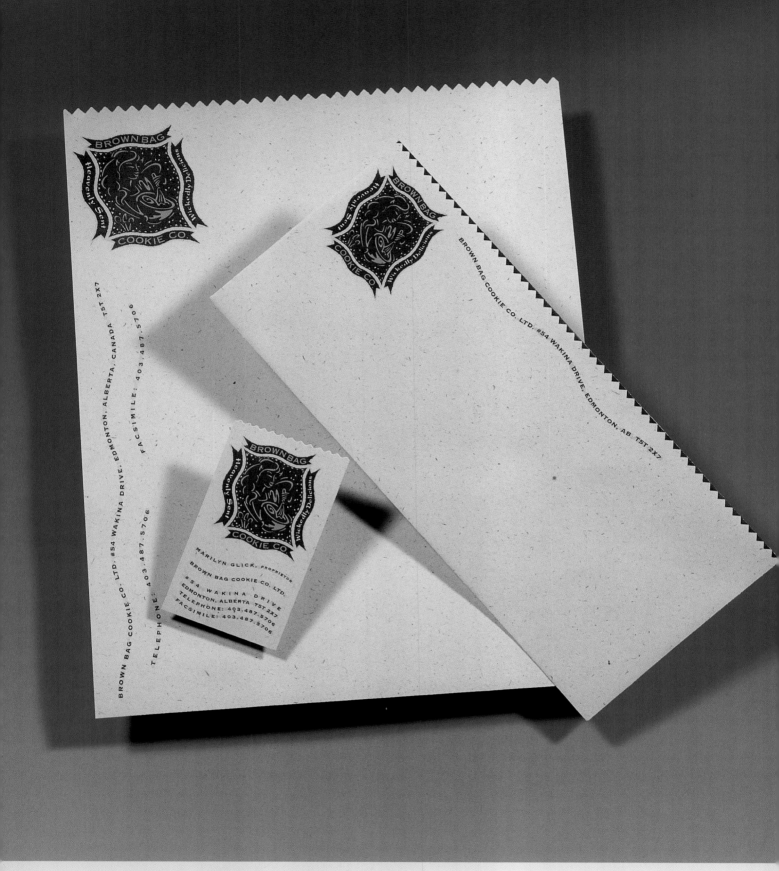

DESIGN FIRM | DUCK SOUP GRAPHICS

ALL DESIGN | WILLIAM DOUCETTE

CLIENT | BROWN BAG COOKIE COMPANY

TOOLS | ADOBE ILLUSTRATOR, QUARKXPRESS

PAPER/PRINTING | FRENCH SPECKLETONE/2 MATCH COLORS

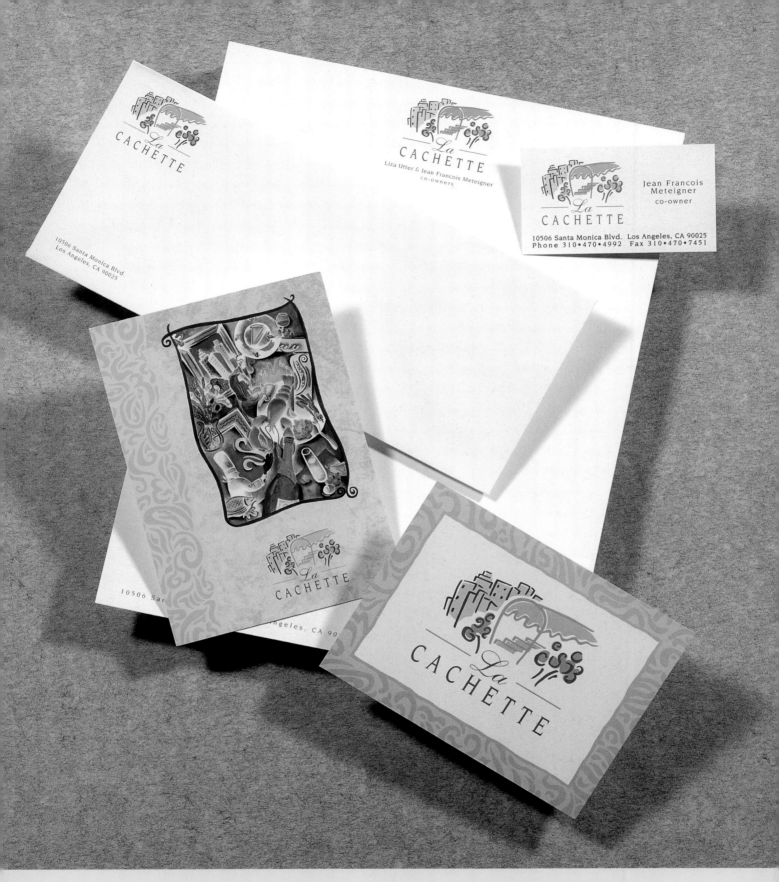

DESIGN FIRM | ON THE EDGE

ART DIRECTOR | JEFF GASPER

DESIGNER | GINA MIMS

ILLUSTRATOR | JEFF GASPER

CLIENT | LA CACHETTE

TOOLS | QUARKXPRESS, ADOBE ILLUSTRATOR,

ADOBE PHOTOSHOP

GLOBAL-DINING INC.

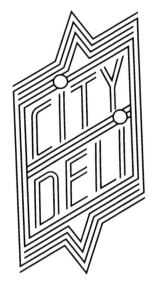

DESIGN FIRM | VRONTIKIS DESIGN OFFICE
ART DIRECTOR/DESIGNER | PETRULA VRONTIKIS
CLIENT | GLOBAL-DINING, INC.
TOOLS | QUARKXPRESS, ADOBE PHOTOSHOP
PAPER/PRINTING | NEENAH CLASSIC CREST/DONAHUE PRINTING

DESIGN FIRM | SOMMESE DESIGN
ART DIRECTOR/ILLUSTRATOR | LANNY SOMMESE
DESIGNER | LANNY SOMMESE, DEVIN PEDSWATER
CLIENT | PENNSYLVANIA STATE UNIVERSITY
TOOLS | ADOBE ILLUSTRATOR

Beach House

DESIGN FIRM | AERIAL
ART DIRECTOR/DESIGNER | TRACY MOON
CLIENT | BEACH HOUSE HOTEL
TOOLS | ADOBE ILLUSTRATOR
PAPER/PRINTING | LEEWOOD PRESS/SF

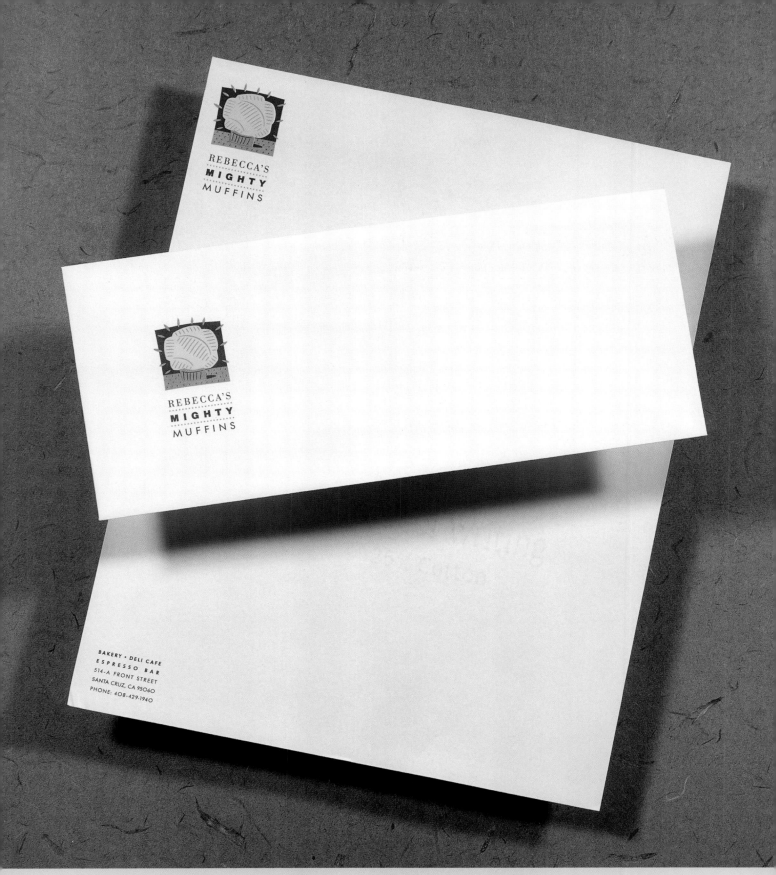

DESIGN FIRM | FAIA DESIGN

ALL DESIGN | DON FAIA

CLIENT | REBECCA'S MIGHTY MUFFINS

TOOLS | ADOBE ILLUSTRATOR

PAPER/PRINTING | PROTOCOL WRITING/OFFSET

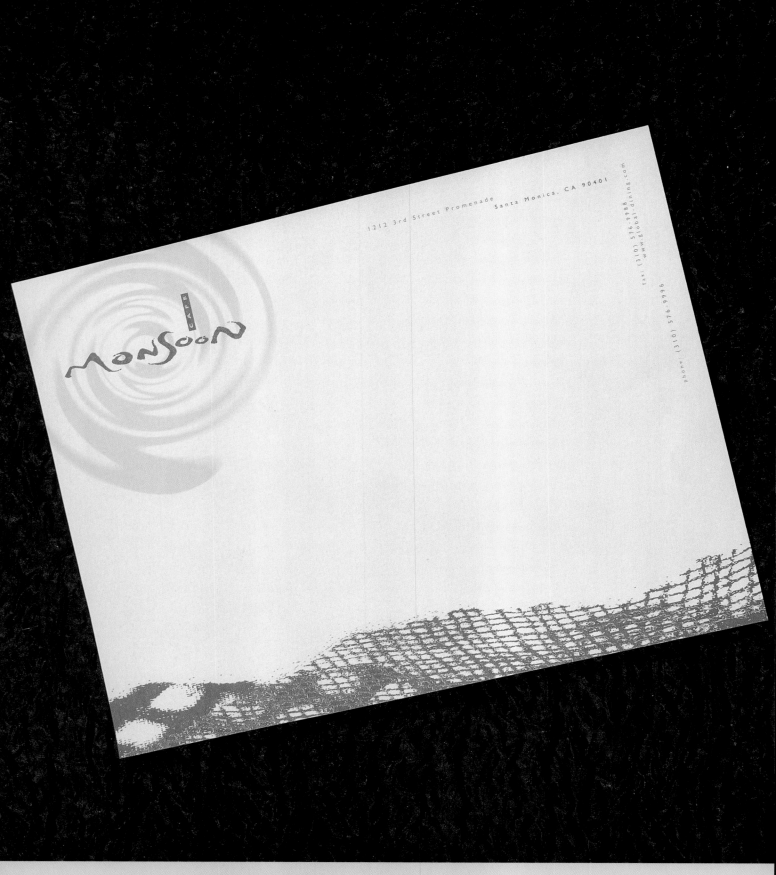

1212 3rd Street Promenade Santa Monica, CA 90401

www.plum.998.com
fax: (310) 576.998
phone: (310) 576-9996

DESIGN FIRM | VRONTIKIS DESIGN OFFICE

ART DIRECTOR | PETRULA VRONTIKIS

DESIGNER | LISA CRITCHFIELD

CLIENT | HASEGAWA ENTERPRISES

TOOLS | QUARKXPRESS, ADOBE PHOTOSHOP

PAPER/PRINTING | CROSSPOINTE SYNERGY/LOGIN PRINTING

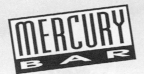

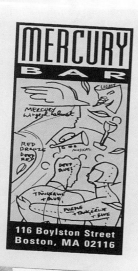

MERCURY BAR

BETHANY VAN DELFT
Manager
116 Boylston St. • Boston • (617) 482-7799

116 Boylston Street
BOSTON, MA 02116

116 Boylston Street • Boston, MA, 02116 • (617) 482-7799 • FAX (617) 350-6603

DESIGN FIRM | ON THE EDGE

ART DIRECTOR | JEFF GASPER

DESIGNER | GINA MIMS

ILLUSTRATOR | ANN FIELD

CLIENT | MERCURY BAR

TOOLS | ADOBE PHOTOSHOP, QUARKXPRESS, ADOBE ILLUSTRATOR

PAPER/PRINTING | CLASSIC CREST WHITE, LUNA WHITE COVER/FOUR COLOR

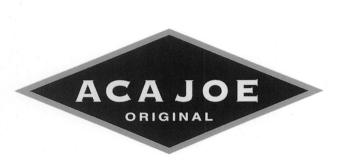

MANGGA DUA

DESIGN FIRM | THAT'S CADIZ! ORIGINALS
ART DIRECTOR/DESIGNER | MINELEO CADIZ
CLIENT | PT MANGGA DUA TOWER
TOOLS | MACROMEDIA FREEHAND

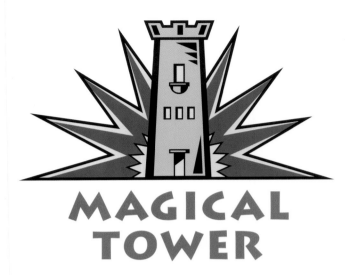

MAGICAL TOWER

DESIGN FIRM | KIKU OBATA & COMPANY
ART DIRECTOR | JOE FLORESCA
DESIGNERS | JOE FLORESCA, JEFF RIFKIN
CLIENT | R.I.C. DESIGN

ACA JOE
ORIGINAL

DESIGN FIRM | FRCH DESIGN WORLD WIDE
ART DIRECTOR | JOAN DONNELLY
DESIGNER | TIM A. FRAME
CLIENT | ACA JOE
TOOLS | ADOBE ILLUSTRATOR

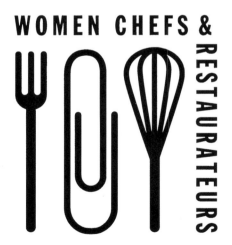

DESIGN FIRM | TONI SCHOWALTER DESIGN
ALL DESIGN | TONI SCHOWALTER
CLIENT | WOMEN CHEFS & RESTAURATEURS
TOOLS | QUARKXPRESS, ADOBE ILLUSTRATOR

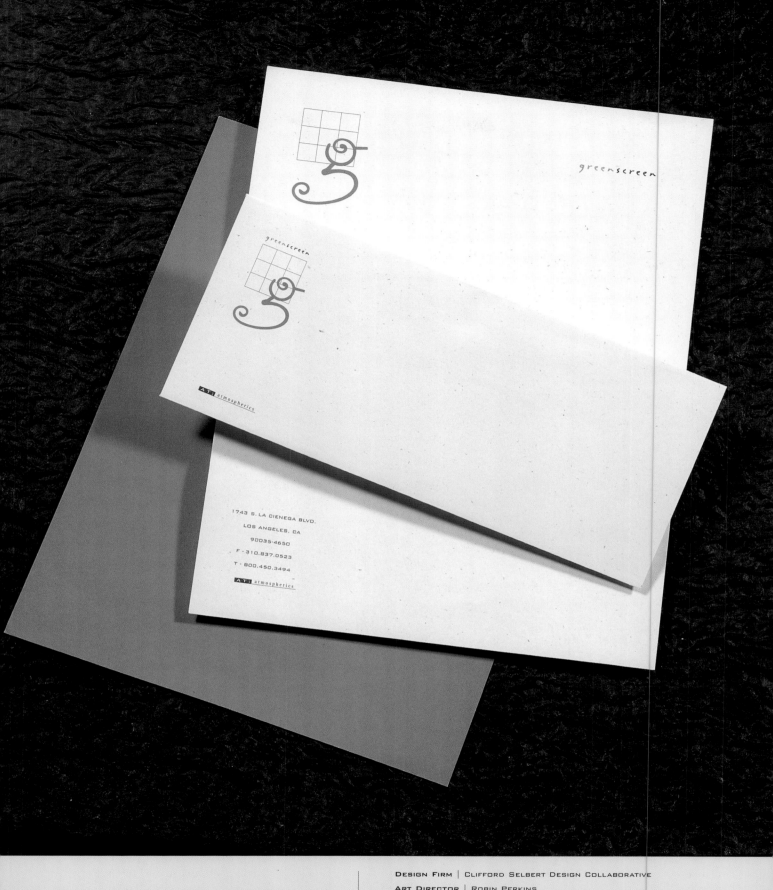

DESIGN FIRM | CLIFFORD SELBERT DESIGN COLLABORATIVE

ART DIRECTOR | ROBIN PERKINS

DESIGNER | ROBIN PERKINS, HEATHER WATSON

CLIENT | ATMOSPHERICS

TOOLS | ADOBE ILLUSTRATOR

PAPER/PRINTING | GENESIS CROSS POINT 80 LB. TEXT/CHALLENGE GRAPHICS

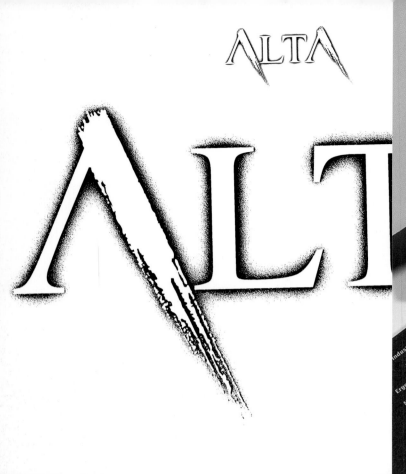

ALTA

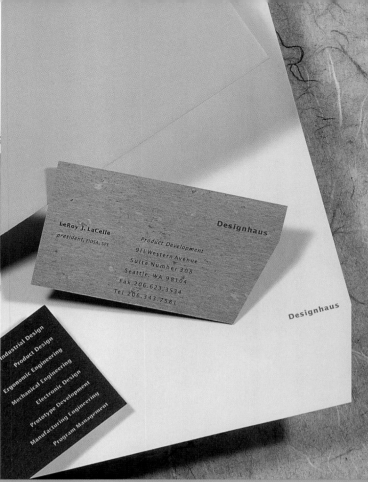

Designhaus

LeRoy J. LaCelle
president, FIDSA, SPE

Product Development
911 Western Avenue
Suite Number 308
Seattle, WA 98104
Fax 206.623.3534
Tel 206.343.7581

Designhaus

Industrial Design
Product Design
Ergonomic Engineering
Mechanical Engineering
Electronic Design
Prototype Development
Manufacturing Engineering
Program Management

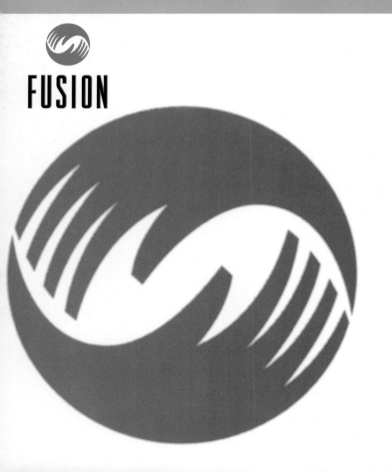

FUSION

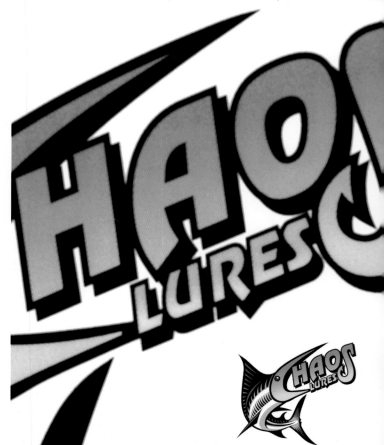

HAOS
LURES

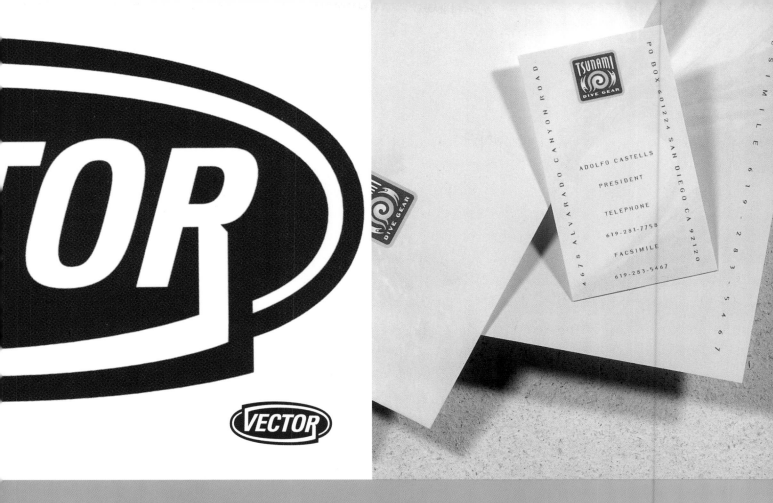

Industry and Manufacture

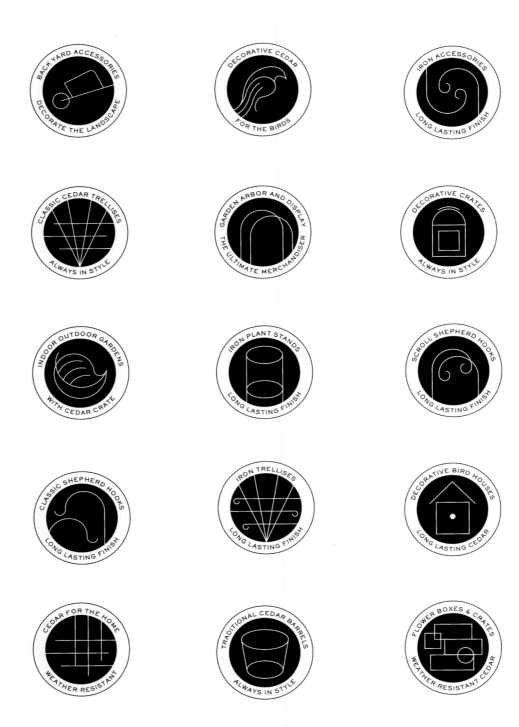

DESIGN FIRM | INSIGHT DESIGN COMMUNICATIONS

ALL DESIGN | SHERRIE AND TRACY HOLDEMAN

CLIENT | THE HAYES COMPANY

TOOLS | POWER MACINTOSH, MACROMEDIA FREEHAND

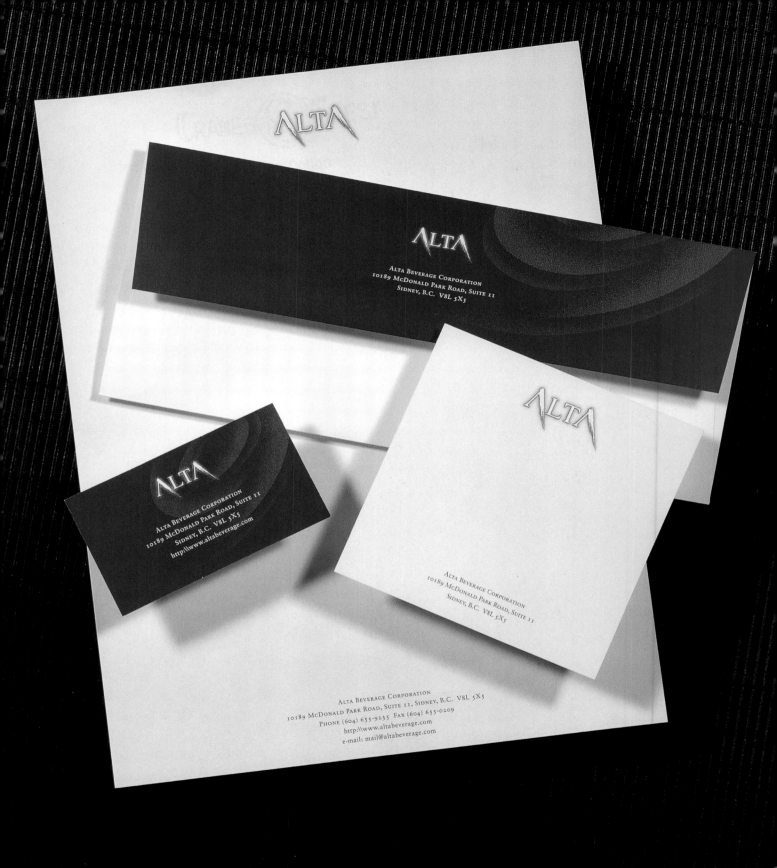

DESIGN FIRM │ HORNALL ANDERSON DESIGN WORKS, INC.

ART DIRECTOR │ JACK ANDERSON

DESIGNERS │ JACK ANDERSON, LARRY ANDERSON,

JULIE KEENAN

CLIENT │ ALTA BEVERAGE COMPANY

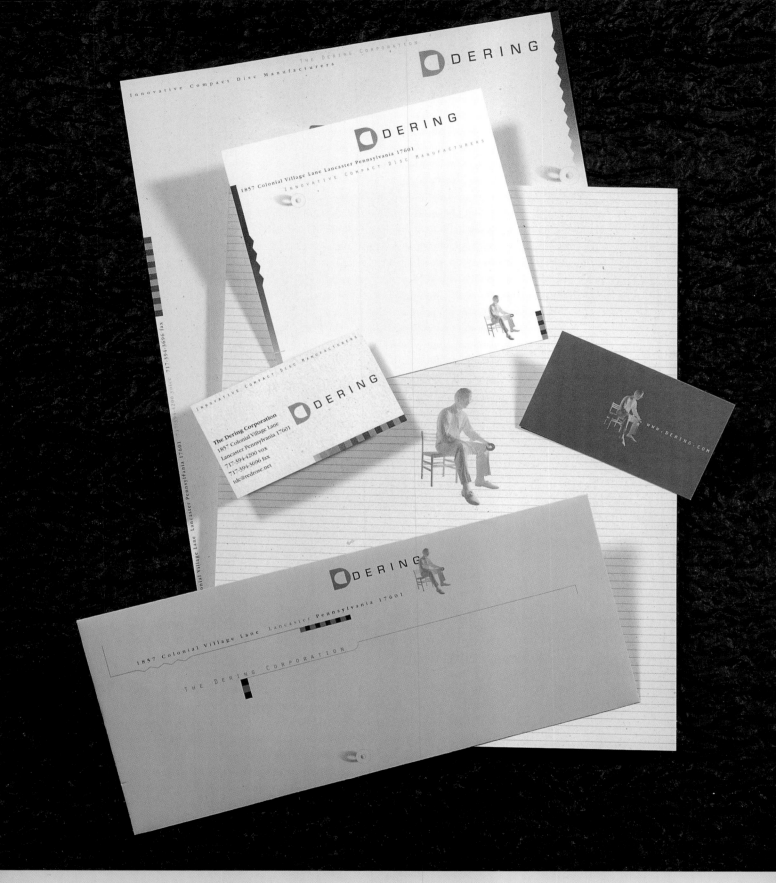

DESIGN FIRM | MUSSER DESIGN
ART DIRECTOR/DESIGNER | JERRY KING MUSSER
CLIENT | THE DERING CORPORATION
TOOLS | MACINTOSH, ADOBE ILLUSTRATOR

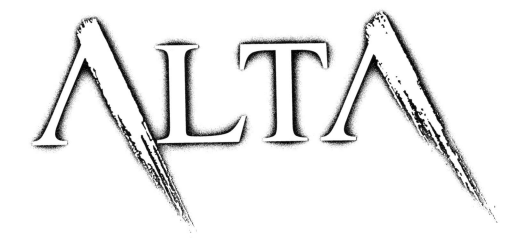

DESIGN FIRM | HORNALL ANDERSON DESIGN WORKS, INC.

ART DIRECTOR | JACK ANDERSON

DESIGNERS | JACK ANDERSON, LARRY ANDERSON, JULIE KEENAN

CLIENT | ALTA BEVERAGE COMPANY

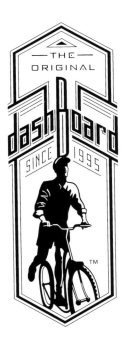

DESIGN FIRM | THARP DID IT

ART DIRECTOR | RICK THARP

DESIGNERS | RICK THARP, NICOLE COLEMAN

CLIENT | TIME WARNER

TOOLS | MACINTOSH

DESIGN FIRM | THARP DID IT

ART DIRECTORS | RICK THARP, CHARLES DRUMMOND

DESIGNER | RICK THARP

ILLUSTRATOR | NICOLE COLEMAN

CLIENT | THE DASHBOARD COMPANY

TOOLS | INK, MACINTOSH

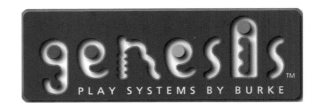

DESIGN FIRM | TRACY SABIN GRAPHIC DESIGN
ART DIRECTOR | RITA HOFFMAN
ILLUSTRATOR | TRACY SABIN
CLIENT | TAYLOR GUITARS
TOOLS | STRATA STUDIO PRO
PAPER/PRINTING | NEWSLETTER MEAD

DESIGN FIRM | HANSON/DODGE DESIGN
ART DIRECTOR | KEN HANSON
DESIGNER/ILLUSTRATOR | JACK HARGREAVES
CLIENT | BCI BURKE COMPANY
TOOLS | ADOBE ILLUSTRATOR, ADOBE PHOTOSHOP
PAPER/PRINTING | 60 LB. COATED TEXT/FOUR PROCESS COLORS

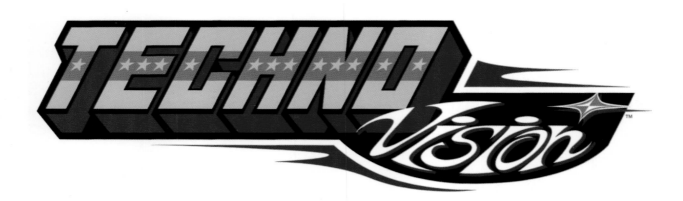

DESIGN FIRM | HANSON/DODGE DESIGN
ART DIRECTOR | LAURA SAMUELS
DESIGNER/ILLUSTRATOR | JACK HARGREAVES
CLIENT | TREK BICYCLE CORPORATION
TOOLS | ADOBE ILLUSTRATOR
PAPER/PRINTING | FOUR PROCESS COLORS PLUS GLOSS VARNISH, TEN POINT CIS

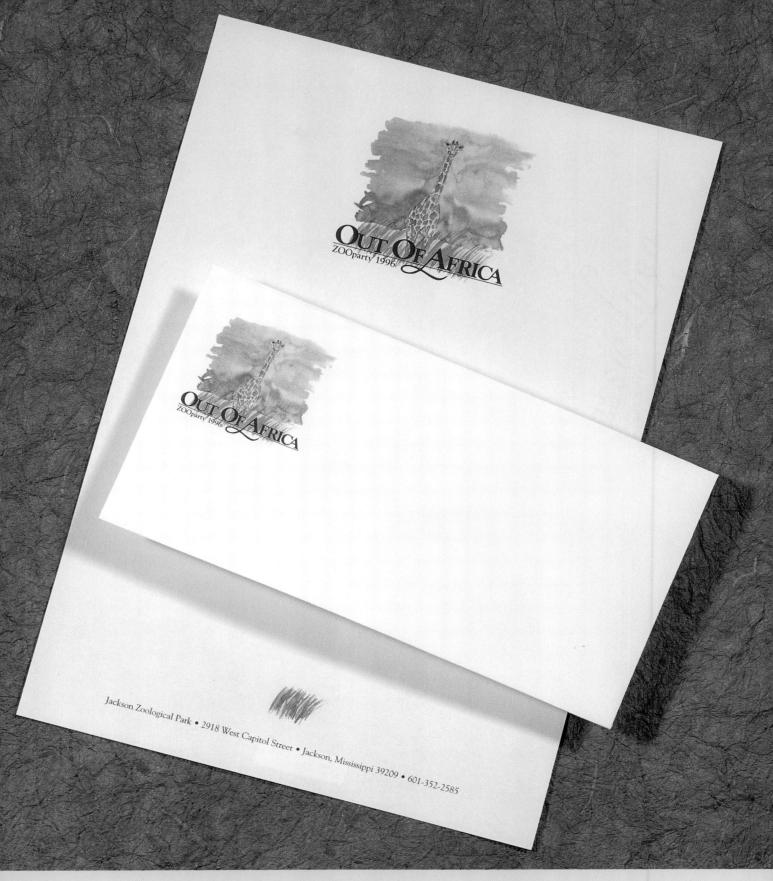

Jackson Zoological Park • 2918 West Capitol Street • Jackson, Mississippi 39209 • 601-352-2585

DESIGN FIRM | COMMUNICATION ARTS COMPANY

ART DIRECTOR | HAP OWEN

DESIGNER/ILLUSTRATOR | ANNE-MARIE OTVOS

CLIENT | JACKSON ZOOLOGICAL PARK

TOOLS | WATERCOLOR

PAPER/PRINTING | CLASSIC LINEN/OFFSET LITHOGRAPHY

Virtual Garden
221 Main Street
Suite 480
San Francisco, CA 94105
P 415.908.2000
F 415.908.2010

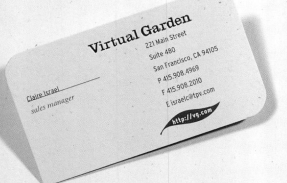

Virtual Garden
221 Main Street
Suite 480
San Francisco, CA 94105
P 415.908.4969
F 415.908.2010
E israelc@tpv.com

Claire Israel
sales manager

http://vg.com

http://vg.com

A Time Warner Company

DESIGN FIRM │ THARP DID IT

ART DIRECTOR │ RICK THARP

DESIGNERS │ RICK THARP, NICOLE COLEMAN

ILLUSTRATOR │ RIK OLSON

CLIENT │ TIME WARNER

TOOLS │ INK, MACINTOSH

PAPER/PRINTING │ SIMPSON EVERGREEN/SIMON PRINTING

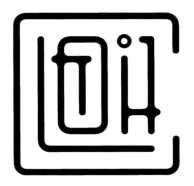

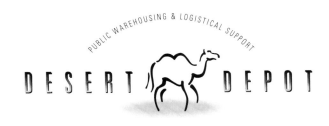

DESIGN FIRM | INSIGHT DESIGN COMMUNICATIONS
ALL DESIGN | SHERRIE AND TRACY HOLDEMAN
CLIENT | CLOTIA WOOD + METAL WORKS
TOOLS | POWER MACINTOSH, MACROMEDIA FREEHAND,
ADOBE PHOTOSHOP

DESIGN FIRM | LORENZ ADVERTISING & DESIGN
ART DIRECTORS | BRIAN LORENZ, ARNE RATERMANIS
DESIGNERS | ARNE RATERMANIS, BRIAN LORENZ
ILLUSTRATOR | ARNE RATERMANIS
CLIENT | DESERT DEPOT
TOOLS | MACINTOSH, ADOBE ILLUSTRATOR
PAPER/PRINTING | CLASSIC CREST/THREE COLOR OFFSET

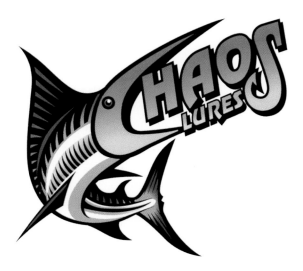

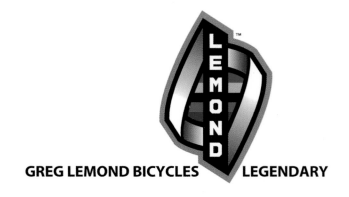

DESIGN FIRM | MIRES DESIGN
ART DIRECTOR/DESIGNER | JOSÉ A. SERRANO
ILLUSTRATOR | TRACY SABIN
CLIENT | CHAOS LURES

DESIGN FIRM | HANSON/DODGE DESIGN
ART DIRECTOR | JOE SUTTER
DESIGNER | SHAWN DOYLE
ILLUSTRATOR | JACK HARGREAVES
CLIENT | TREK BICYCLE CORPORATION
TOOLS | ADOBE ILLUSTRATOR

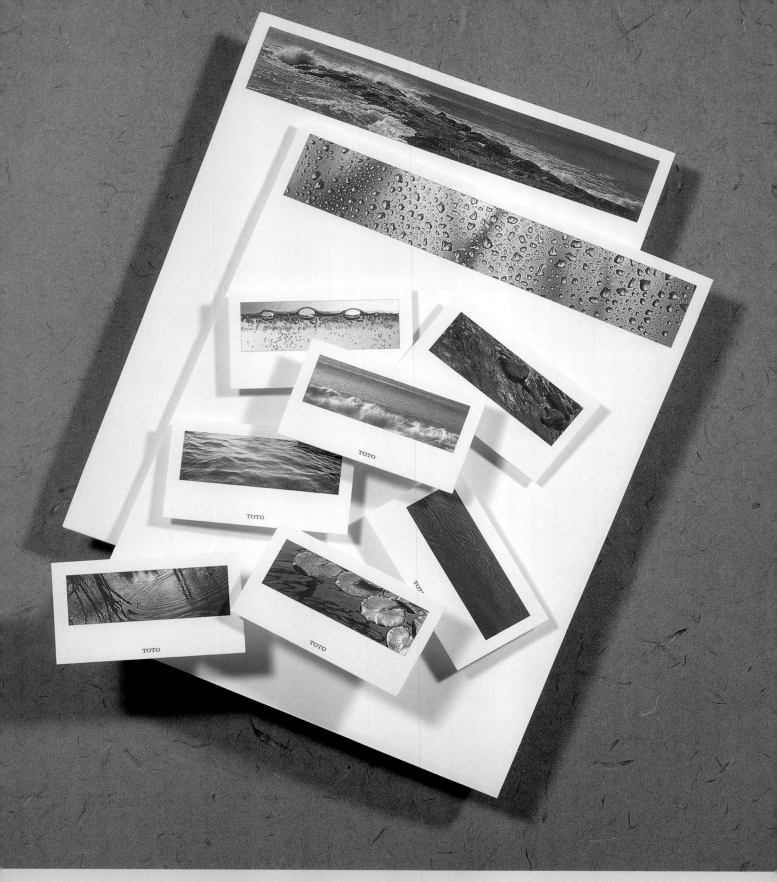

DESIGN FIRM | SAGMEISTER, INC.

ART DIRECTOR | STEFAN SAGMEISTER

DESIGNERS | STEFAN SAGMEISTER, PATRICK DAILY

ILLUSTRATOR | PATRICK DAILY

CLIENT | SCHERTLER AUDIO TRANSDUCERS

TOOLS | MACINTOSH

PAPER/PRINTING | STRATHMORE WRITING 25% COTTON

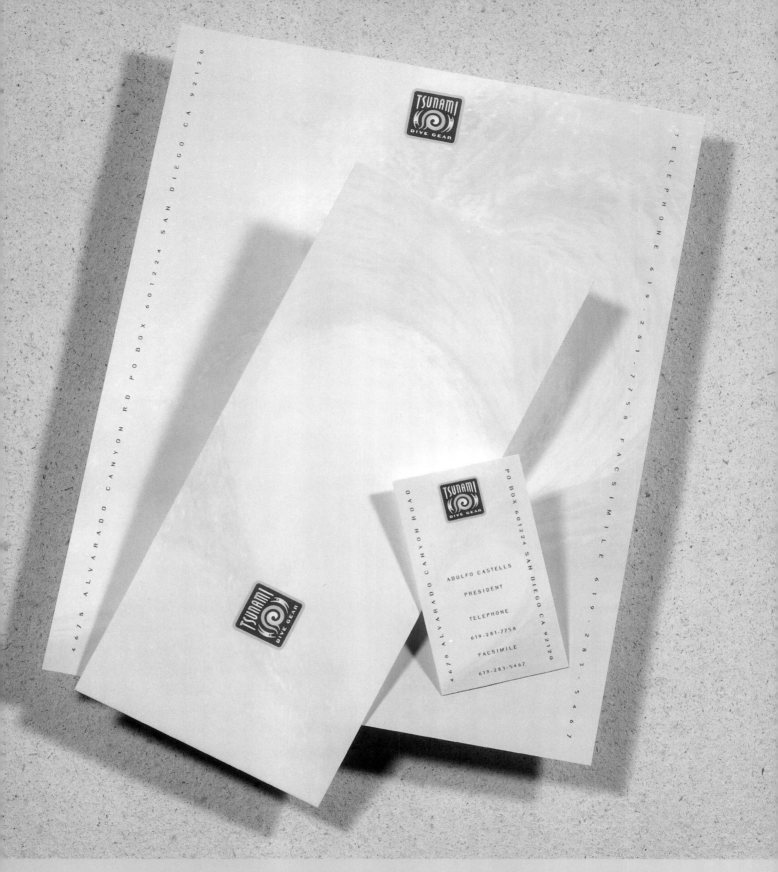

DESIGN FIRM | MIRES DESIGN
ART DIRECTOR | JOHN BALL
DESIGNERS | JOHN BALL, DEBORAH HORN
PHOTOGRAPHER | AARON CHANG
CLIENT | TSUNAMI DIVE GEAR
PAPER/PRINTING | STARWHITE VICKSBURG

DESIGN FIRM | LOVE PACKAGING GROUP

ALL DESIGN | BRIAN MILLER

CLIENT | HDC INDUSTRIES

TOOLS | MACROMEDIA FREEHAND, ADOBE PHOTOSHOP

PAPER/PRINTING | CHAMPION

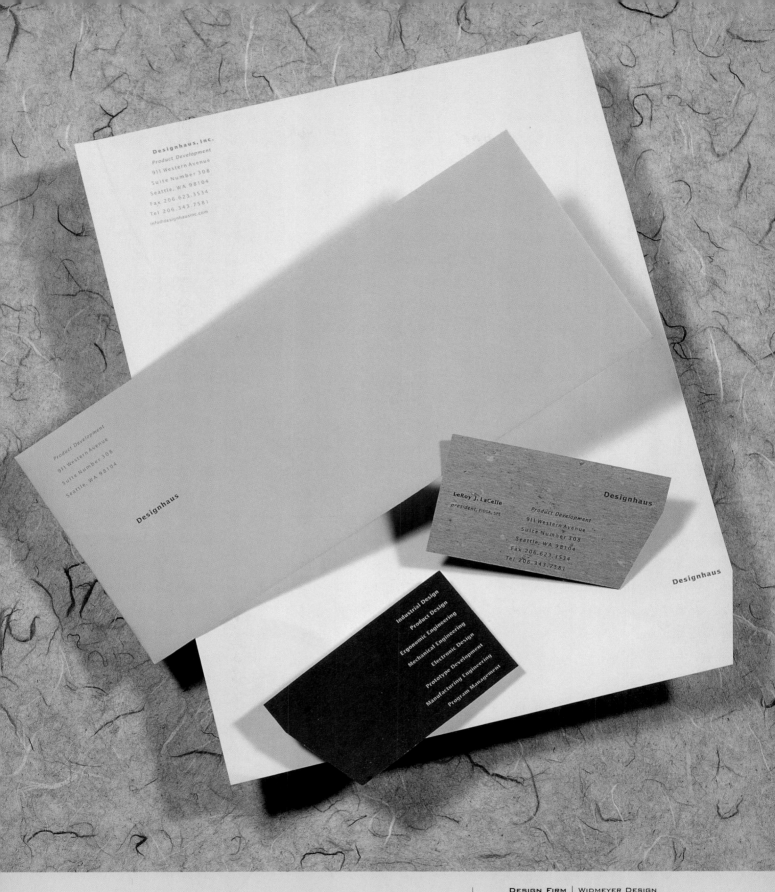

Designhaus, Inc.
Product Development
911 Western Avenue
Suite Number 308
Seattle, WA 98104
Fax 206.623.3534
Tel 206.343.7581
info@designhausinc.com

Product Development
911 Western Avenue
Suite Number 308
Seattle, WA 98104

Designhaus

LeRoy J. LaCelle
president, FIDSA, SPE

Designhaus

Product Development
911 Western Avenue
Suite Number 308
Seattle, WA 98104
Fax 206.623.3534
Tel 206.343.7581

Designhaus

Industrial Design
Product Design
Ergonomic Engineering
Mechanical Engineering
Electronic Design
Prototype Development
Manufacturing Engineering
Program Management

DESIGN FIRM | WIDMEYER DESIGN
ART DIRECTOR | KEN WIDMEYER, DALE HART
DESIGNER | DALE HART
CLIENT | DESIGNHAUS
TOOLS | POWER MACINTOSH, MACROMEDIA FREEHAND
PAPER/PRINTING | FRENCH PAPER/OFFSET

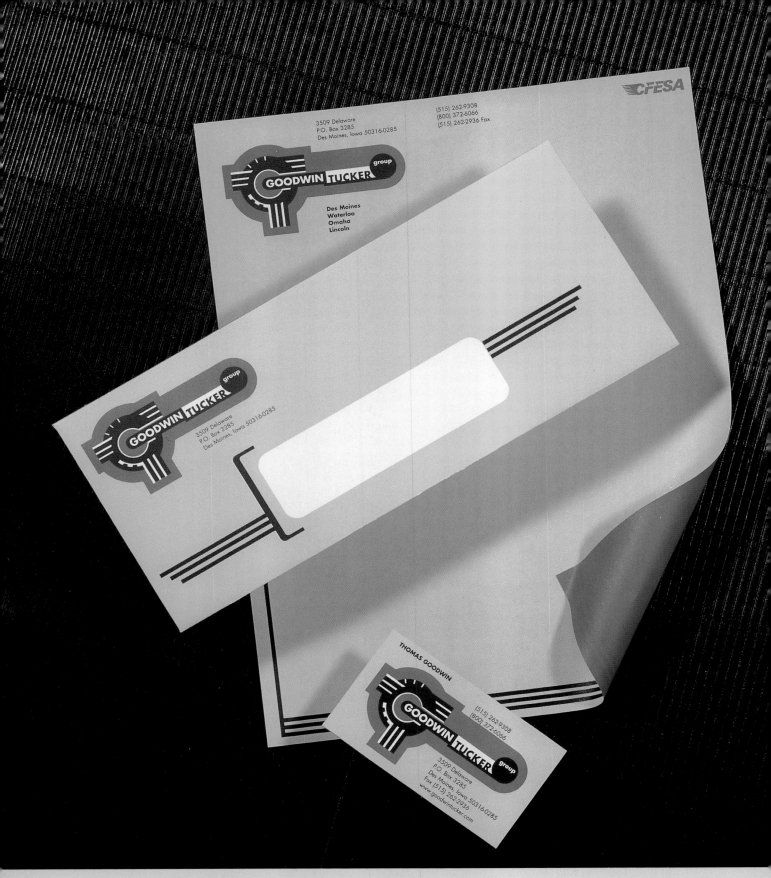

DESIGN FIRM | SAYLES GRAPHIC DESIGN

ART DIRECTOR/ILLUSTRATOR | JOHN SAYLES

DESIGNERS | JOHN SAYLES, JENNIFER ELLIOTT

CLIENT | GOODWIN TUCKER GROUP

PAPER/PRINTING | NEENAH ENVIRONMENT WHITE/OFFSET

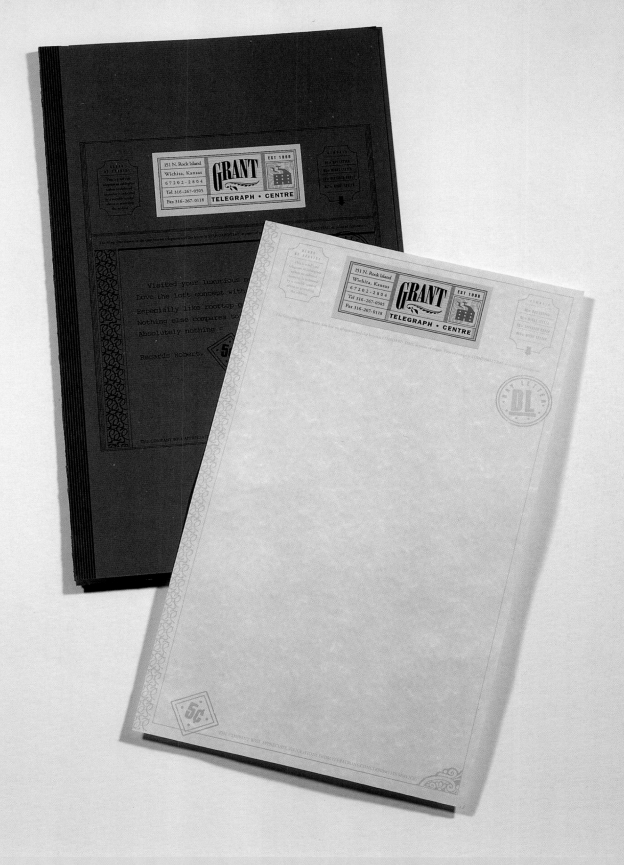

DESIGN FIRM | GRETEMAN GROUP

ART DIRECTORS/DESIGNERS | SONIA GRETEMAN, JAMES STRANGE

ILLUSTRATOR | JAMES STRANGE

CLIENT | GRANT TELEGRAPH CENTRE

TOOLS | MACROMEDIA FREEHAND

PAPER/PRINTING | ASTRO PARCHMENT, SAND +

CONFETTI SABLE BLACK/OFFSET

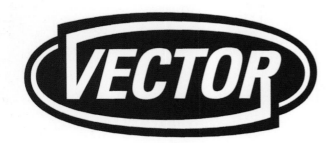

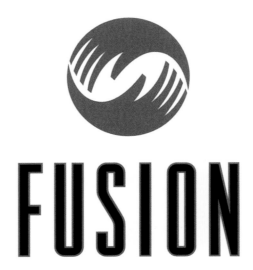

DESIGN FIRM | HANSON/DODGE DESIGN
ART DIRECTOR/DESIGNER | ANIA WASILEWSKA
ILLUSTRATOR | JACK HARGREAVES
CLIENT | VECTOR TECHNOLOGIES, INC.
TOOLS | ADOBE ILLUSTRATOR

DESIGN FIRM | MIRES DESIGN
ART DIRECTOR/DESIGNER | JOSÉ A. SERRANO
PHOTOGRAPHER | CARL VANDERSCHUIT
CLIENT | AGASSI ENTERPRISES

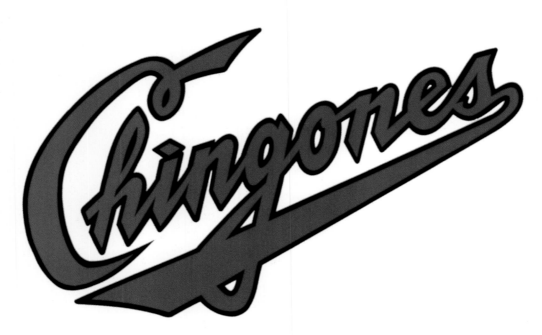

DESIGN FIRM | MIRES DESIGN
ART DIRECTOR/DESIGNER | JOSÉ A. SERRANO
ILLUSTRATOR | TRACY SABIN
CLIENT | CHINGONES

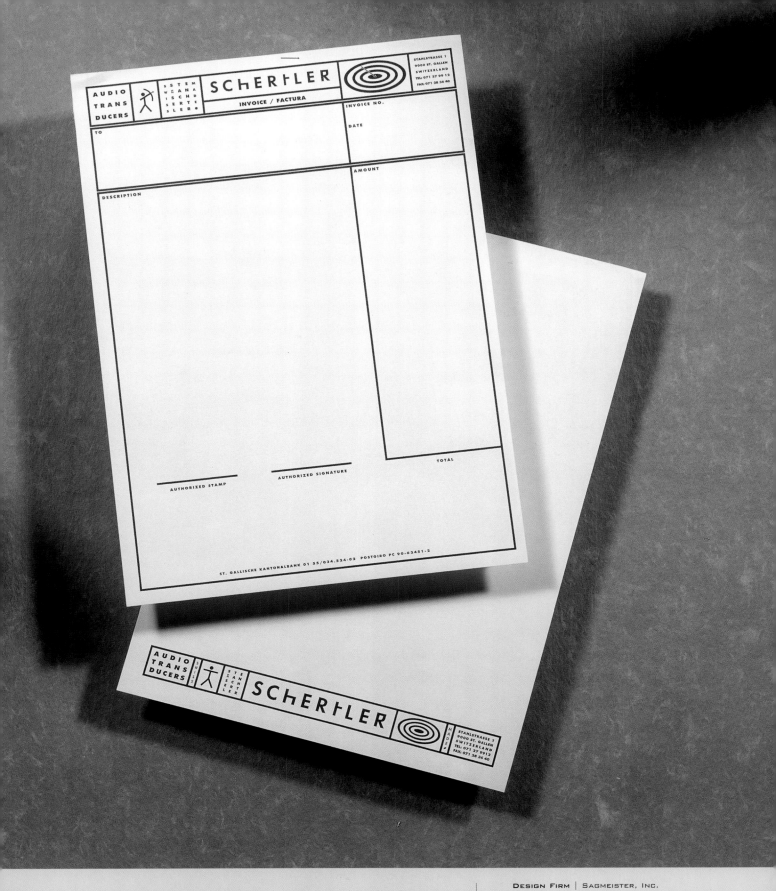

DESIGN FIRM | SAGMEISTER, INC.

ART DIRECTOR | STEFAN SAGMEISTER

DESIGNERS | STEFAN SAGMEISTER, VERONICA OH

PHOTOGRAPHY | MICHAEL GRIMM, STOCK

CLIENT | TOTO

TOOLS | MACINTOSH, 2 1/4 CAMERA

PAPER/PRINTING | STRATHMORE WRITING 25% COTTON

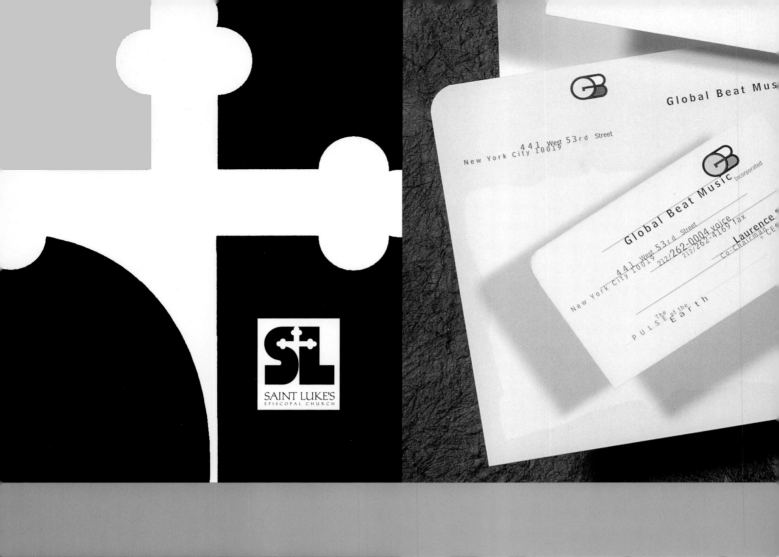

SAINT LUKE'S
EPISCOPAL CHURCH

Global Beat Music
441 West 53rd Street
New York City 10019

Global Beat Music Incorporated
441 West 53rd Street
New York City 10019 212/262-0004 voice
212/262-4109 fax
Laurence
Co-Chairman + CEO
PULSE of the Earth

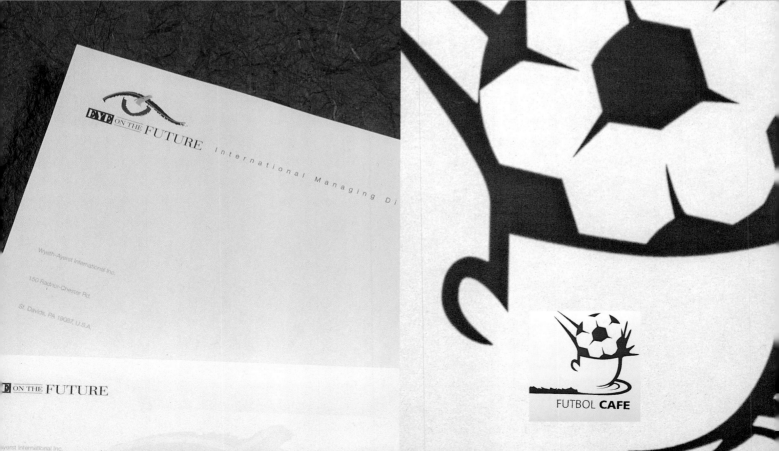

EYE ON THE FUTURE
International Managing Di

Wyeth-Ayerst International Inc.

150 Radnor-Chester Rd.

St. Davids, PA 19087 U.S.A

E ON THE FUTURE

FUTBOL CAFE

Wyerst International Inc.

UCLA *Multimedia*

PATEFA
GOLFING SOCIETY

VICTORIAN REGION

585 BURWOOD ROAD
HAWTHORN VIC. 3122

PHONE (03) 819 6144

FAX (03) 819 6292

TELEX AA23760

POSTAL ADDRESS
18-20 QUEENS AVENUE
HAWTHORN VIC. 3122

MISCELLANEOUS

WILLIAM HILL MANOR

WILLIAM HILL MANOR

501 DUTCHMAN'S LANE
EASTON, MARYLAND 21601

JOSEPH & EDNA
JOSEPHSON
INSTITUTE
OF ETHICS

DESIGN FIRM | THE WELLER INSTITUTE
ALL DESIGN | DON WELLER
CLIENT | SAINT LUKE'S EPISCOPAL CHURCH
TOOLS | ADOBE ILLUSTRATOR, QUARKXPRESS

DESIGN FIRM | WITHERSPOON ADVERTISING
CREATIVE DIRECTOR | DEBRA MORROW
ART DIRECTOR/DESIGNER | RANDY PADORR-BLACK
ILLUSTRATOR | JAMES MELLARD
CLIENT | WOUND HEALING & HYPERBARIC MEDICINE CENTER

DESIGN FIRM | SHIMOKOCHI/REEVES
ART DIRECTOR | MAMORU SHIMOKOCHI, ANNE REEVES
CLIENT | UCLA MULTIMEDIA
TOOLS | ADOBE ILLUSTRATOR

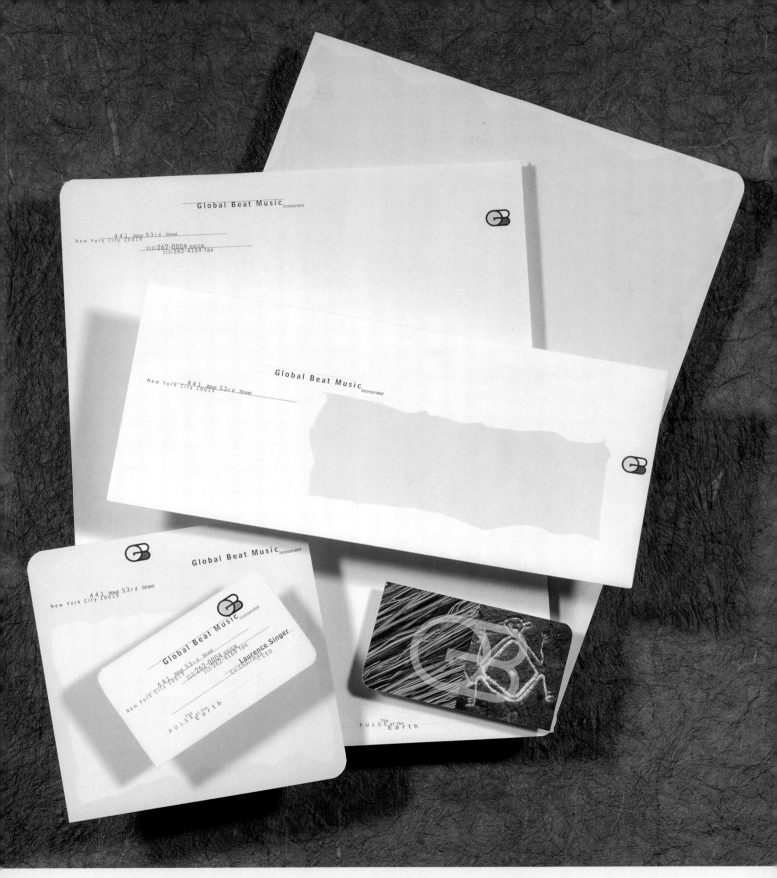

DESIGN FIRM | MUSSER DESIGN
ART DIRECTOR/DESIGNER | JERRY KING MUSSER
CLIENT | GLOBAL BEAT MEDIA
TOOLS | ADOBE ILLUSTRATOR

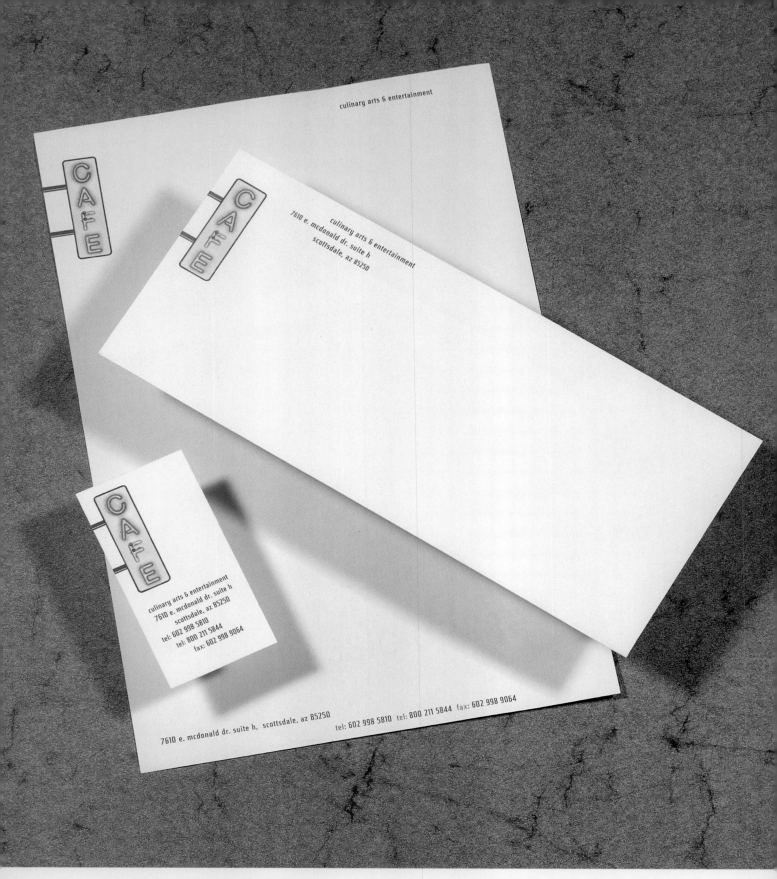

culinary arts & entertainment

7610 e. mcdonald dr. suite h
scottsdale, az 85250

culinary arts & entertainment
7610 e. mcdonald dr. suite h
scottsdale, az 85250
tel: 602 998 5810
tel: 800 211 5844
fax: 602 998 9064

7610 e. mcdonald dr. suite h, scottsdale, az 85250 tel: 602 998 5810 tel: 800 211 5844 fax: 602 998 9064

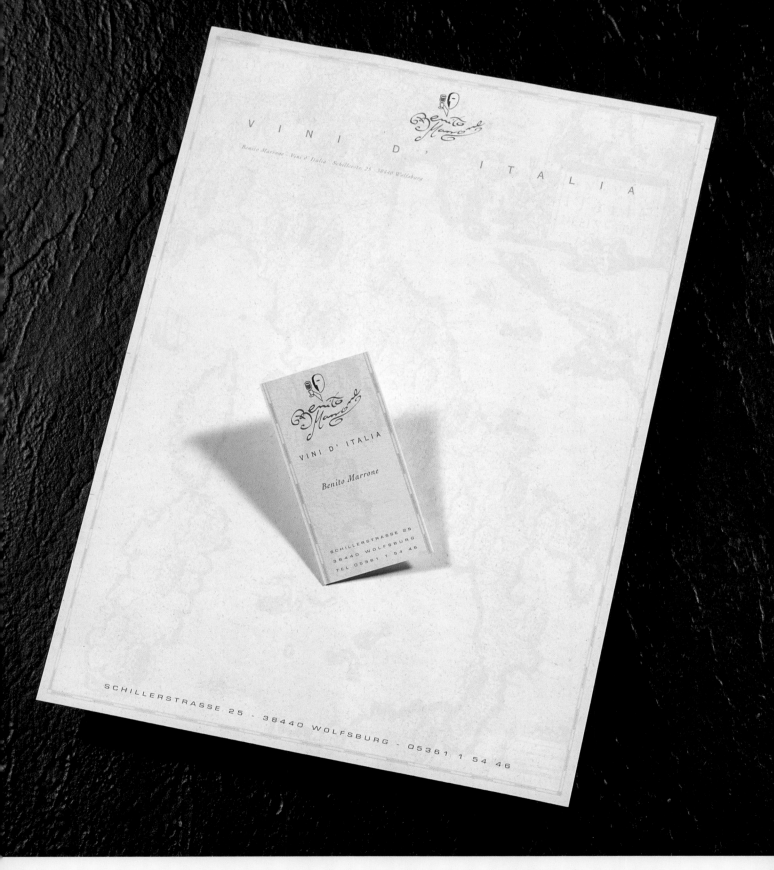

DESIGN FIRM | VOSS DESIGN
ART DIRECTOR/DESIGNER | AXEL VOSS
CLIENT | BENITO MARRONE
PAPER/PRINTING | COUNTRYSIDE

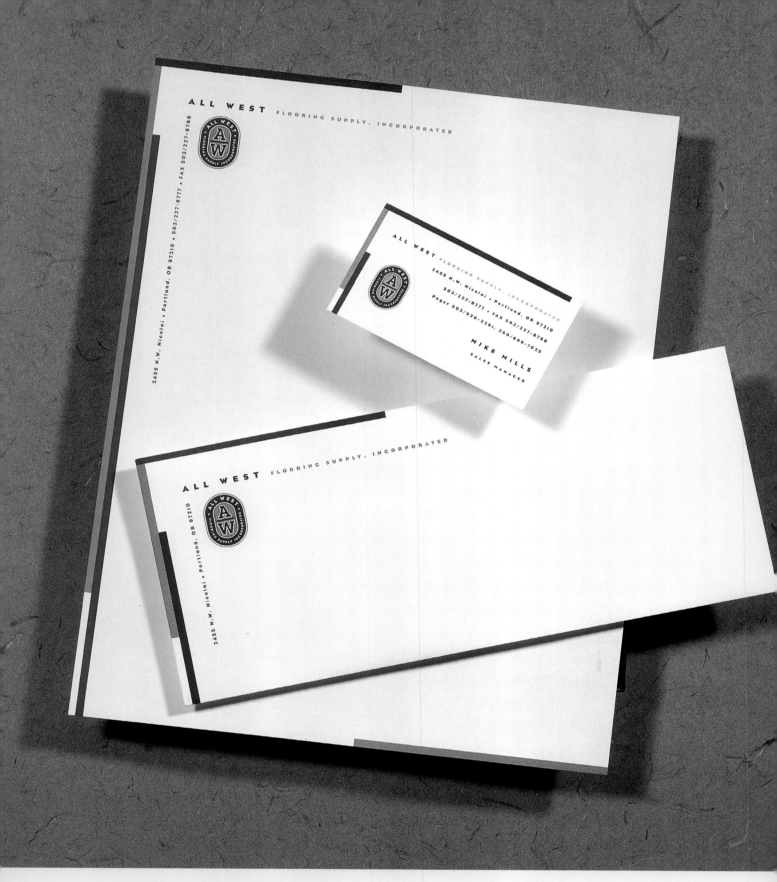

DESIGN FIRM | ROBERT BAILEY INCORPORATED
ART DIRECTOR | CONNIE LIGHTNER
DESIGNERS | CONNIE LIGHTNER, DAN FRANKLIN
CLIENT | ALL WEST FLOORING SUPPLY, INC.
TOOLS | MACROMEDIA FREEHAND, QUARKXPRESS
PAPER/PRINTING | PROTOCOL RECYCLED BRIGHT
WHITE/CNS GRAPHICS

FUTBOL **CAFE**

DESIGN FIRM | CATO BERRO DISEÑO
ART DIRECTOR | GONZALO BERRO
DESIGNER | GONZALO BERRO/ESTEBAN SERRANO
ILLUSTRATOR | ESTEBAN SERRANO
CLIENT | FUTBOL CAFE/BAR
TOOLS | ADOBE ILLUSTRATOR

DESIGN FIRM | MICHAEL STANARD DESIGN, INC.
ART DIRECTOR | MICHAEL STANARD
DESIGNER/ILLUSTRATOR | MICHAEL STANARD, DEV HOMSI
CLIENT | NORTHWESTERN UNIVERSITY

DESIGN FIRM | SAYLES GRAPHIC DESIGN
ALL DESIGN | JOHN SAYLES
CLIENT | DES MOINES PARK & RECREATION DEPT.

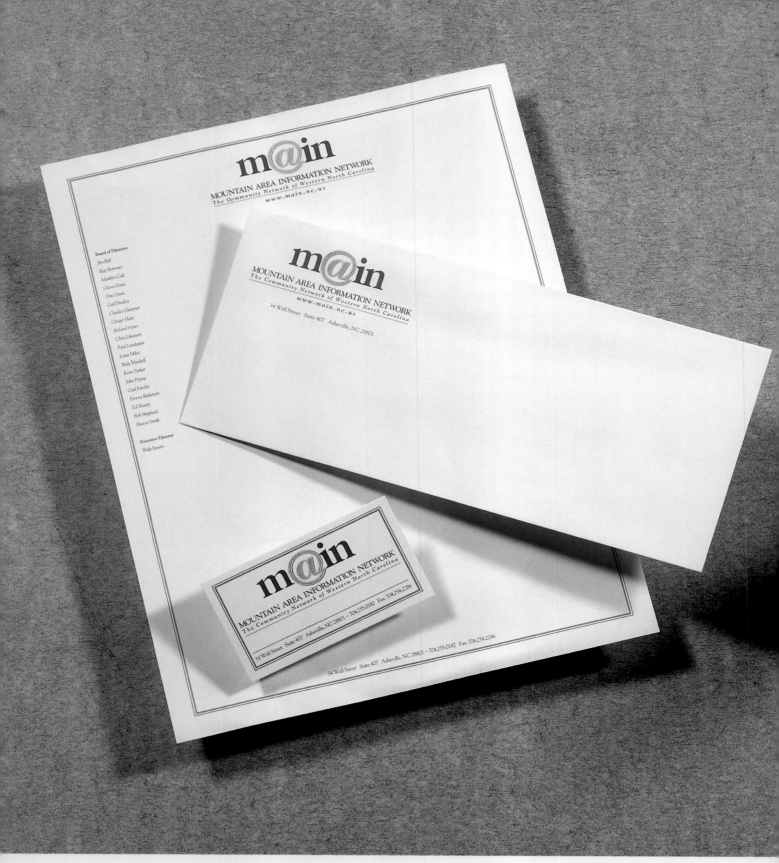

DESIGN FIRM | DESIGN ONE

DESIGNER | LYN FRANKLIN

CLIENT | MAIN

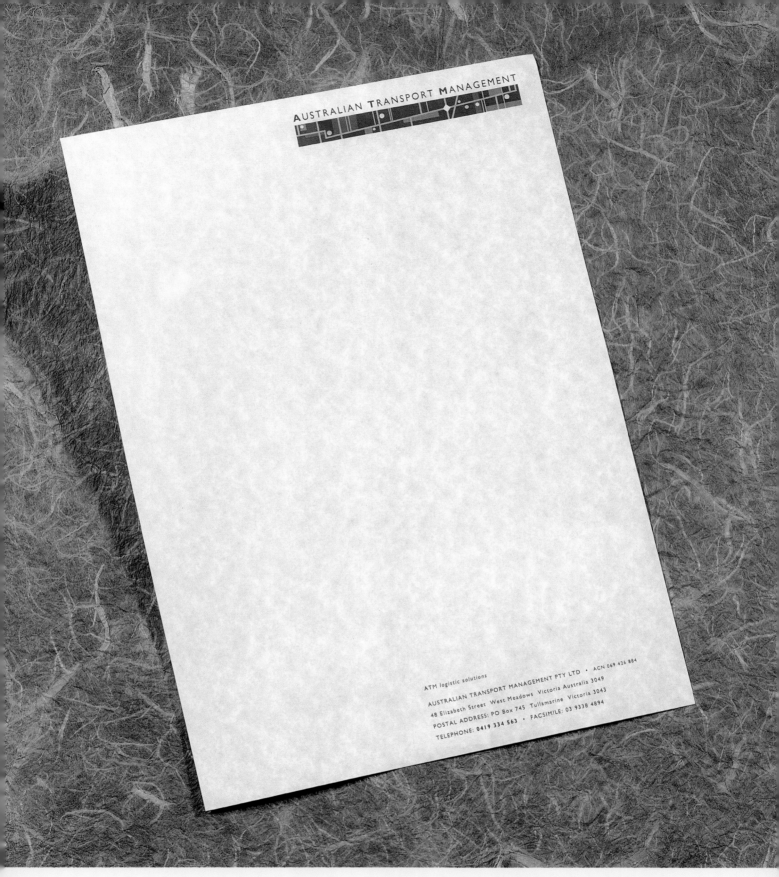

AUSTRALIAN TRANSPORT MANAGEMENT

ATM logistic solutions

AUSTRALIAN TRANSPORT MANAGEMENT PTY LTD • ACN 069 426 884

48 Elizabeth Street West Meadows Victoria Australia 3049

POSTAL ADDRESS: PO Box 745 Tullamarine Victoria 3043

TELEPHONE: 0419 334 563 • FACSIMILE: 03 9338 4894

DESIGN FIRM | MAMMOLITI CHAN DESIGN

ART DIRECTOR | TONY MAMMOLITI

DESIGNERS | CHWEE KUAN CHAN, TONY MAMMOLITI

ILLUSTRATOR | CHWEE KUAN CHAN

CLIENT | AUSTRALIAN TRANSPORT MANAGEMENT

PAPER/PRINTING | ONE PMS ON PARCHMENT STOCK

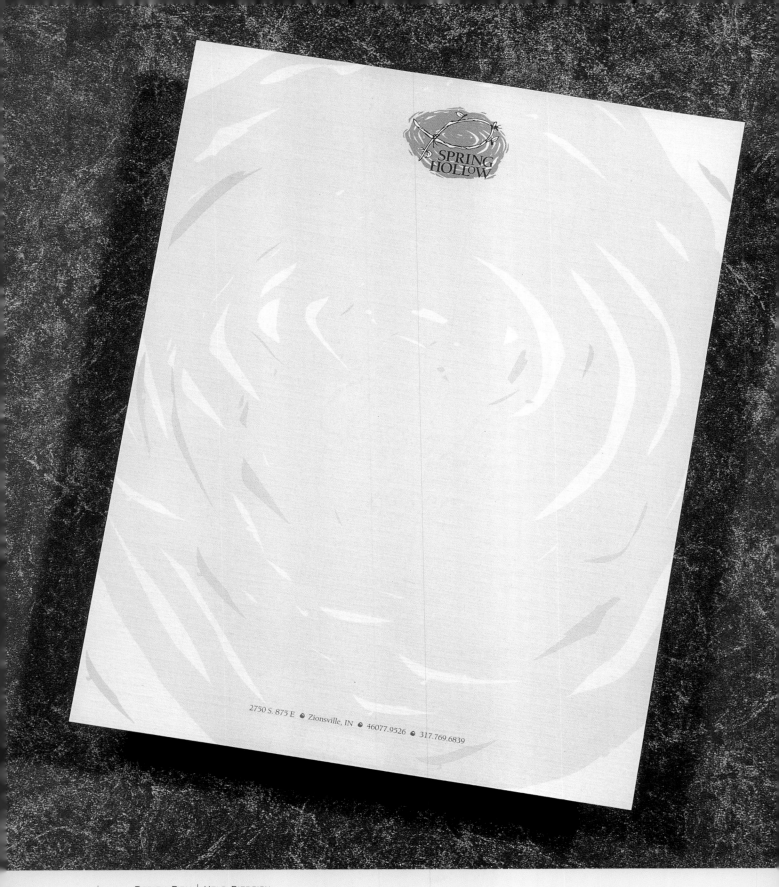

SPRING HOLLOW

2750 S. 875 E ● Zionsville, IN ● 46077.9526 ● 317.769.6839

DESIGN FIRM | HELD DIEDRICH
ART DIRECTOR | DOUG DIEDRICH
DESIGNER/ILLUSTRATOR | MEGAN SNOW
CLIENT | SPRING HOLLOW
TOOLS | QUARKXPRESS, ADOBE ILLUSTRATOR
PAPER/PRINTING | NEENAH, CLASSIC LAID,
NATURAL WHITE, LASER FINISH/OFFSET

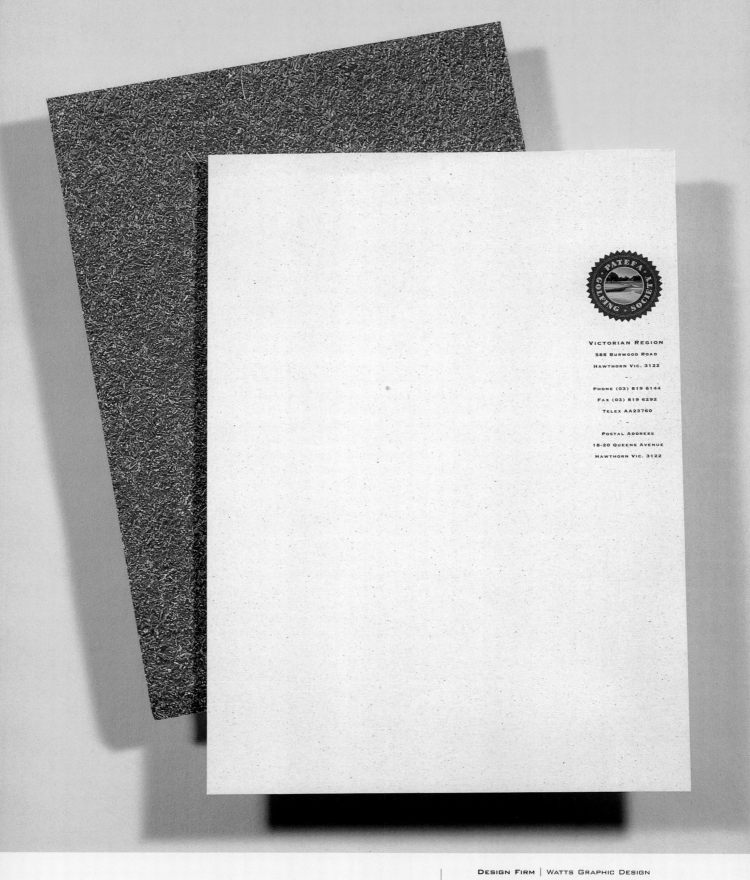

VICTORIAN REGION
585 BURWOOD ROAD
HAWTHORN VIC. 3122

PHONE (03) 819 6144
FAX (03) 819 6292
TELEX AA23760

POSTAL ADDRESS
18-20 QUEENS AVENUE
HAWTHORN VIC. 3122

DESIGN FIRM | WATTS GRAPHIC DESIGN
ART DIRECTORS/DESIGNERS | HELEN AND PETER WATTS
CLIENT | PATEFA GOLFING SOCIETY

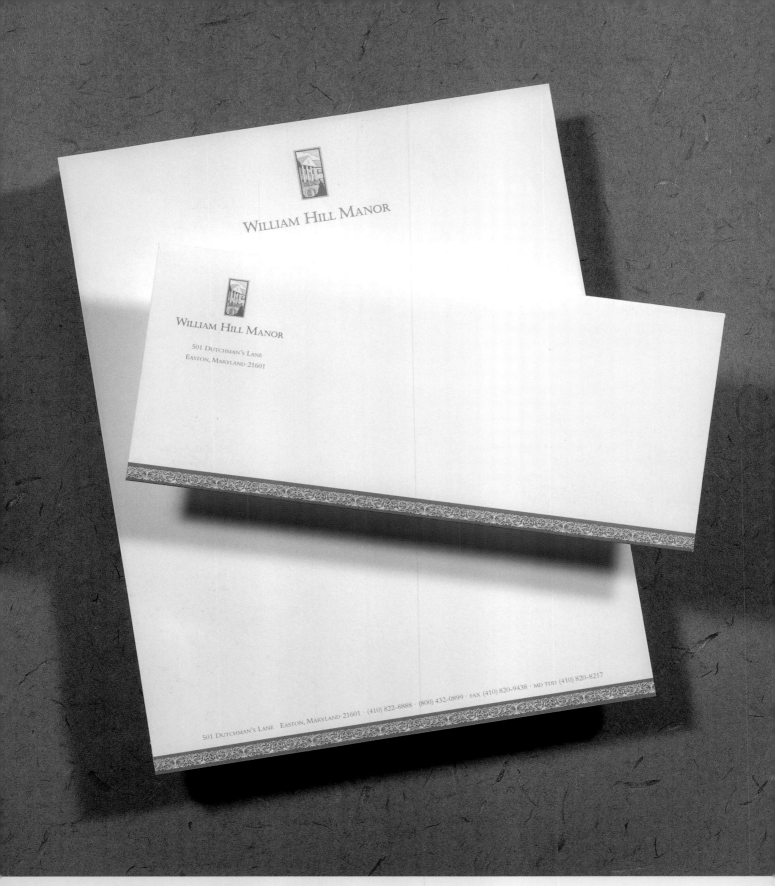

DESIGN FIRM | WHITNEY EDWARDS DESIGN

ALL DESIGN | CHARLENE WHITNEY EDWARDS

CLIENT | WILLIAM HILL MANOR

TOOLS | ADOBE PHOTOSHOP, ADOBE ILLUSTRATOR,
 QUARKXPRESS

PAPER/PRINTING | CRANES/ONE COLOR

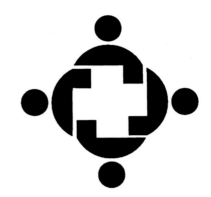

DESIGN FIRM | MUELLER & WISTER, INC.
ALL DESIGN | JOSEPH M. DELICH
CLIENT | WYETH-AYERST INTERNATIONAL
TOOLS | ADOBE PHOTOSHOP, STREAMLINE, MACROMEDIA FREEHAND

DESIGN FIRM | ARMINDA HOPKINS & ASSOCIATES
ART DIRECTOR/DESIGNER | MELANIE MATSON
CLIENT | FREDONIA HEALTH SYSTEMS
TOOLS | QUARKXPRESS, ADOBE ILLUSTRATOR

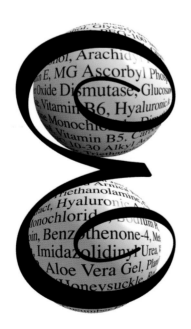

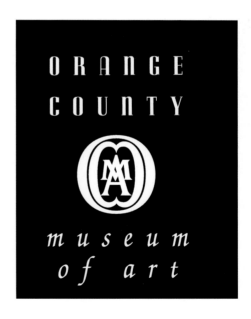

DESIGN FIRM | LOVE PACKAGING GROUP
ALL DESIGN | BRIAN MILLER
CLIENT | ELOGEN, INC.
TOOLS | MACROMEDIA FREEHAND, ADOBE PHOTOSHOP

DESIGN FIRM | MIKE SALISBURY COMMUNICATIONS, INC.
ART DIRECTOR | MIKE SALISBURY
DESIGNER | MARY EVELYN MCGOUGH
ILLUSTRATOR | BOB MAILE
CLIENT | ORANGE COUNTY MUSEUM OF ART

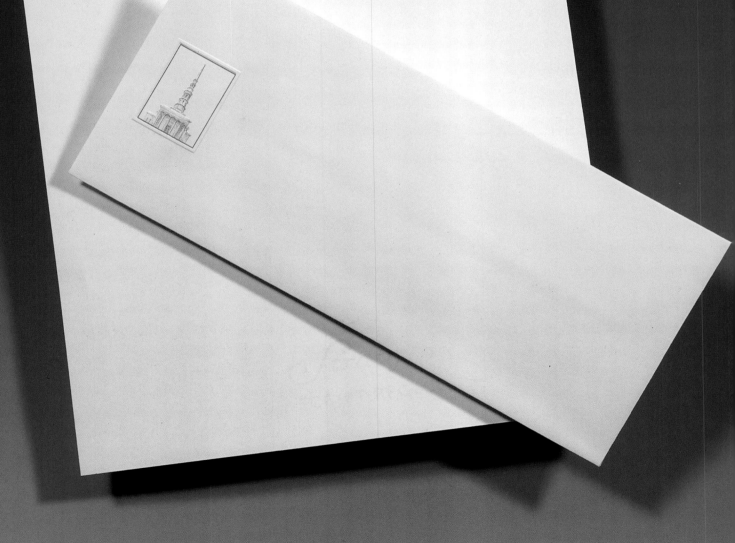

CATHEDRAL OF ST. PETER IN CHAINS

325 West Eighth Street / Cincinnati, Ohio 45202 - 1977 / Phone: 513 - 421 - 5354 / Fax: 513 - 241 - 9517

DESIGN FIRM | WOOD/BROD DESIGN
ART DIRECTOR/DESIGNER | STAN BROD
CLIENT | CATHEDRAL OF ST. PETER IN CHAINS
TOOLS | ADOBE ILLUSTRATOR
PAPER/PRINTING | STRATHMORE/HENNEGAN COMPANY

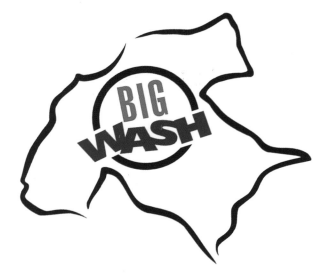

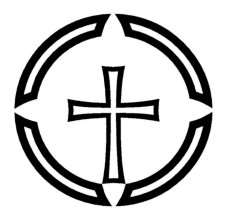

DESIGN FIRM | CLARK DESIGN
ART DIRECTOR | ANNEMARIE CLARK
DESIGNER | CRAIG STOUT
CLIENT | HOPE HOUSING/BIG WASH
TOOLS | ADOBE ILLUSTRATOR

DESIGN FIRM | RICK EIBER DESIGN (RED)
ART DIRECTOR/DESIGNER | RICK EIBER
CLIENT | COLUMBIA BAPTIST CONFERENCE
TOOLS | ADOBE ILLUSTRATOR

DESIGN FOR THE FUTURE AND
3RD ANNUAL LEARNING CONFERENCE

DESIGN FIRM | AFTER HOURS CREATIVE
ART DIRECTOR/DESIGNER | AFTER HOURS CREATIVE
PHOTOGRAPHER | ART HOLEMAN
CLIENT | CULINARY ARTS & ENTERTAINMENT

DESIGN FIRM | CECILY ROBERTS DESIGN
ALL DESIGN | CECILY ROBERTS
CLIENT | KAISER PERMANENTE/DESIGN FOR THE FUTURE CONFERENCE
TOOLS | MACROMEDIA FREEHAND, QUARKXPRESS

DESIGN FIRM | INSIGHT DESIGN COMMUNICATIONS

ALL DESIGN | SHERRIE AND TRACY HOLDEMAN

CLIENT | WORLD FITNESS, INC.

TOOLS | MACROMEDIA FREEHAND

DESIGN FIRM | CHRIS ST. CYR GRAPHIC DESIGN

ART DIRECTOR/DESIGNER | CHRIS ST. CYR

CLIENT | STREET PROJECT BOSTON

TOOLS | ADOBE PHOTOSHOP, QUARKXPRESS

DESIGN FIRM | LOVE PACKAGING GROUP

ALL DESIGN | BRIAN MILLER

CLIENT | WICHITA STATE UNIVERSITY, MEN'S CREW TEAM

TOOLS | MACROMEDIA FREEHAND

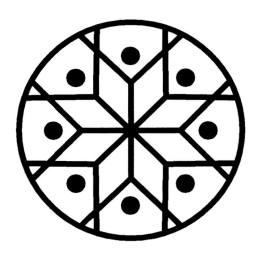

DESIGN FIRM | RICK EIBER DESIGN (RED)

ART DIRECTOR/DESIGNER | RICK EIBER

CLIENT | COLUMBIA BAPTIST CONFERENCE

TOOLS | ADOBE ILLUSTRATOR

PAPER/PRINTING | CURTIS BRIGHTWATER/TWO COLOR OVER TWO COLOR

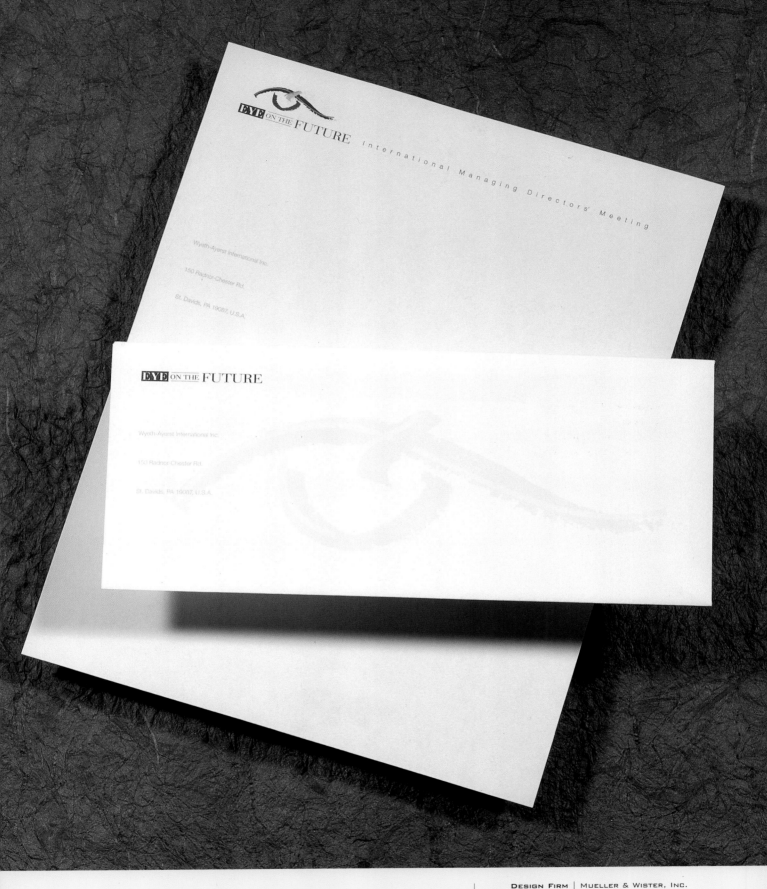

DESIGN FIRM | MUELLER & WISTER, INC.

ALL DESIGN | JOSEPH DELICH

CLIENT | WYETH-AYERST INTERNATIONAL, INC.

TOOLS | ADOBE ILLUSTRATOR

Lila Wallace Reader's Digest
URBAN PARKS INSTITUTE

Lila Wallace Reader's Digest
URBAN PARKS INSTITUTE

**Project for
Public Spaces, Inc.**
153 Waverly Place
New York, NY 10014

Lila Wallace Reader's Digest
URBAN PARKS INSTITUTE

Sarah R. Stern
Project Manager

Project for Public Spaces, Inc.
153 Waverly Place, New York, NY 10014
Tel 212.620.5660, Fax 212.620.3821
E-mail urbparks@usa.pipeline.com

Lila Wallace Reader's Digest
URBAN PARKS INSTITUTE

Project for Public Spaces, Inc.
153 Waverly Place, New York, NY 10014
Tel 212.620.5660, Fax 212.620.3821
E-mail urbparks@usa.pipeline.com

Project for Public Spaces, Inc., 153 Waverly Place, New York, NY 10014, Tel 212.620.5660, Fax 212.620.3821, E-mail urbparks@usa.pipeline.com

DESIGN FIRM | PARHAM SANTANA, INC.

ART DIRECTOR/DESIGNER | RICK TESORO

CLIENT | PROJECT FOR PUBLIC SPACES

PAPER/PRINTING | LETTERHEAD & ENVELOPE: STARWHITE

VICKSBURG TIARA 70 LB., BUSINESS CARD: STARWHITE

VICKSBURG TIARA 130 LB. DOUBLE COVER, LABEL:

BROWNBRIDGE WHITE ULTRA-MATTE CRACK N PEEL

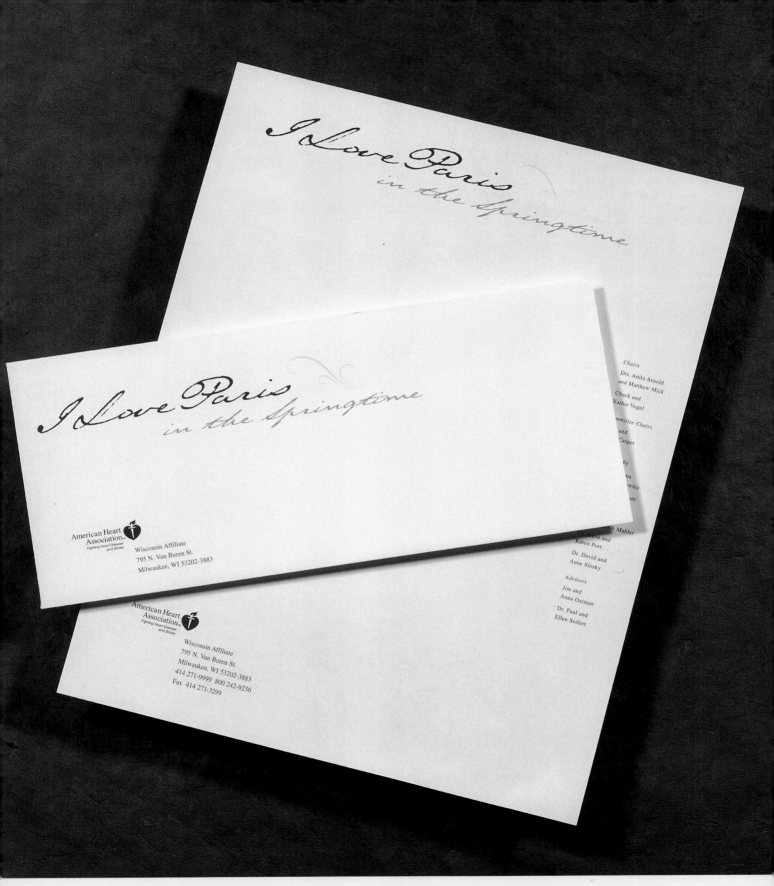

I Love Paris in the Springtime

American Heart Association™
Fighting Heart Disease and Stroke

Wisconsin Affiliate
795 N. Van Buren St.
Milwaukee, WI 53202-3883
414 271-9999 800 242-9236
Fax 414 271-3299

Chairs

Drs. Anita-Arnold
and Matthew Mick

Chuck and
Kathie Vogel

Committee Chairs

and
Casper

by

wley
nt

tah Mahler

Dr. Steve and
Karen Port

Dr. David and
Anne Slosky

Advisors

Jim and
Anna Oatman

Dr. Paul and
Ellen Seifert

DESIGN FIRM | BECKER DESIGN
ART DIRECTOR/DESIGNER | NEIL BECKER
CLIENT | AMERICAN HEART ASSOCIATION
TOOLS | QUARKXPRESS, ADOBE ILLUSTRATOR
PAPER/PRINTING | NEENAH CLASSIC CREST RECYCLED

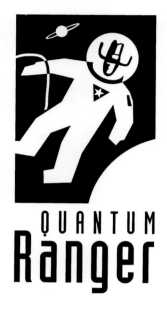

QUANTUM
Ranger

DESIGN FIRM | DESIGN CENTER
ART DIRECTOR | JOHN REGER
DESIGNER | CORY DOCKEN
CLIENT | SCIMED

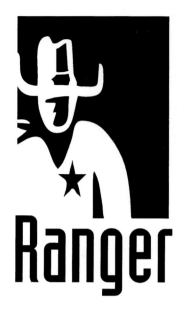

Ranger

DESIGN FIRM | DESIGN CENTER
ART DIRECTOR | JOHN REGER
DESIGNER | CORY DOCKEN
CLIENT | SCIMED

Universität Kaiserslautern

DESIGN FIRM | GEFFERT DESIGN
DESIGNER | GERALD GEFFERT
CLIENT | UNIVERSITÄT KAISERSLAUTERN

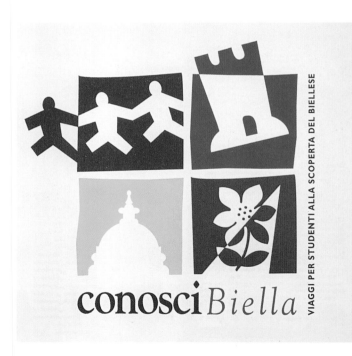

conosci *Biella*

VIAGGI PER STUDENTI ALLA SCOPERTA DEL BIELLESE

DESIGN FIRM | IMPRESS SAS
CLIENT | PROVINCIA DI BIELLA

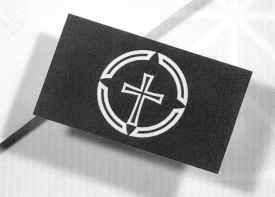

STRATEGIC CHURCH PLANTING

MATT HANNAN, DIRECTOR OF CHURCH PLANTING, COLUMBIA BAPTIST CONFERENCE
7913 N.E. 58TH AVENUE, VANCOUVER, WA 98665 360.694.4985 FAX 360.694.0219

DESIGN FIRM | RICK EIBER DESIGN (RED)

ART DIRECTOR/DESIGNER | RICK EIBER

CLIENT | COLUMBIA BAPTIST CONFERENCE

TOOLS | ADOBE ILLUSTRATOR

PAPER/PRINTING | CURTIS BRIGHTWATER/TWO

COLOR OVER TWO COLOR

INDEX AND DIRECTORY